Nicolas Whybrow is Associate Professor in the School of Theatre, Performance and Cultural Policy Studies at the University of Warwick, UK. His books include *Street Scenes: Brecht, Benjamin and Berlin* and, as editor, *Performance and the Contemporary City: An Interdisciplinary Reader.*

Art
and the
City

Nicolas Whybrow

I.B. TAURIS

LONDON · NEW YORK

Published in 2011 by I.B.Tauris & Co Ltd
6 Salem Road, London W2 4BU
175 Fifth Avenue, New York NY 10010
www.ibtauris.com

Distributed in the United States and Canada Exclusively by Palgrave Macmillan
175 Fifth Avenue, New York NY 10010

ISBN: 978 1 84511 466 4 (hb)
ISBN: 978 1 84511 465 7 (pb)

A full CIP record for this book is available from the British Library
A full CIP record is available from the Library of Congress

Library of Congress Catalog Card Number: available

Printed and bound in Great Britain by TJ International Ltd, Padstow, Cornwall

To my mother, Felicitas Whybrow, with thanks.

Contents

Figures

CHAPTER 5 BERLIN, VIENNA: PERFORMING
HOLOCAUST MEMORY

Acknowledgments

My thanks go first and foremost to Susan Lawson, my former editor at I.B.Tauris, who believed in the proposal for this book from the beginning and was very supportive and engaged – beyond the call of duty really – in pushing it along in its initial phases. In particular, she was encouraging about adapting an earlier proposal for another city book with which the publisher had not been so keen to run. Since her departure I am very grateful to her colleague Philippa Brewster for kindly picking up the baton at short notice. I am thankful, too, for the ongoing support and optimism of colleagues at the University of Warwick, not least the Department of Theatre and Performance Studies as a whole for accommodating my absences during two separate terms of study leave in 2006 and 2009 respectively. More specifically, I wish to record my debt to Carl Lavery of the University of Aberystwyth for the consistently generous interest and stimulation he has extended in the period of researching and writing this book.

In terms of funding, the Arts and Humanities Research Council deserves thanks for a grant that allowed me to visit several cities, events and artworks over a period of twelve months between 2006

and 2007, not least the *Münster Skulptur Projekte* 07. The Humanities Research Centre at Warwick was very helpful in facilitating travel to deliver papers based on my research for this book at Performance Studies International's 13th *Happening/Performance/Event* conference, New York University (November 2007) and at the *Territories Re-imagined: International Perspectives* psychogeographers conference at Manchester Metropolitan University (June 2008). Thanks also to the University of Plymouth for funding towards the keynote paper I gave at its conference *The Hidden City: Mythogeography and Writing for Site-Specific Performance* (October 2008). I was pleased also to be given the opportunity by Martin Hargreaves to test some of the material on students doing his MA in Dance Theatre at the Laban Centre, London (May 2008), as well as at a joint seminar with Claire Bishop for colleagues and postgraduates in my department at Warwick (October 2007). Related research material was also instrumental in the compilation of artist's pages entitled 'Streetscenes: The Accident of Where We Walk' for *Performance Research*, 11 (3), 2006: 123–6. This was the journal's 'Lexicon' issue, which was produced in conjunction with *documenta 12 magazines* (appearing in April 2007) and exhibited at *Documenta 12*, Kassel, Germany, 16 June to 23 September 2007.

Apart from those items already mentioned, one or two brief passages of writing have appeared (or are about to at the time of writing) in published form elsewhere. Thus, aspects of Chapter 1 have been selected and adapted for a short entry scheduled to appear in 2011 in an edited volume entitled *Performance Studies: Key Words, Concepts and Theories*. In May 2010 the new Portuguese 'sound and image' journal *EASI* published an article entitled 'Not Just a Game: Eisenman's Holocaust Memorial' in its second, Berlin-themed issue. This is culled from Chapter 5. There are also one or two excerpts – generally sentences or paragraphs – from the introductions to the several sections of an interdisciplinary reader I have been compiling concurrently, entitled *Performance and the Contemporary*

City, also appearing in 2010. These fragments are dispersed variously throughout the introduction and Chapters 1, 3 and 4, and have been indicated accordingly in the endnotes. All quotations in the book fall within 'fair use' and the photographs were all taken by me.

Introduction

TALKING ART

Invited to kick-start proceedings at a platform discussion occurring as part of a programme of sideshow events at the 2006 Frieze Art Fair in London, Francesco Bonami, senior curator at the Museum of Contemporary Art in Chicago, suggested, with a twinkle in his eye, that the medium of painting represented the pinnacle of aspiration for the contemporary artist: 'Of course, everybody wants to be a painter!', he declared. Whether he had some kind of vested interest, or was in fact gently mocking the main-house activities next door – in which the world's leading galleries were vigorously engaged in persuading hordes of affluent punters to part with many of their pounds (or dollars?), predominantly for canvases it seemed – is a moot point. Perhaps he was merely relishing the prospect of provocation in a forum entitled 'New Performativity?' If so, he may well have been taking a leaf out of the Chapmans' book of ironic playfulness: the collaborating artist brothers Jake and Dinos spent the entire Frieze Fair *performing painting*. Or perhaps that should be: *performing making money from painting*. Proposing that painting only retained

its currency via its capacity to perform in the global art market, they opened a 'studio' at the fair in which they painted clients' portraits for a cool £4,500 a throw in an installation called (deep breath): *Painting for Pleasure and Profit: A Piece of Site-specific, Performance-based Body Art in Oil, Canvas and Wood (Dimensions Variable)*. For what it's worth, on the other hand, but a month later the German artist Tommas Abts was winning the seriously prestigious Turner Prize as the first painter to do so for eight years. In a subsequent *Guardian* newspaper interview she expressed, with a form of abrupt bemusement, her utter lack of regard for the magnitude of the prize and the commercial opportunities it might yield: '"It's nice," she said, in a mild, pleasant voice as she lifted her shoulders in the international sign of "whatever"'. Abts 'considers art a calling', unlike the 'warped attitude in this regard' of many young artists, who 'think of it as a career choice, to do art; they think that it will pay off and they'll make money' (Brockes 2006: 23).

Whatever the intention, Bonami's pronouncement on painters provided enough fuel for Marina Abramovic – sitting in the front row of the audience in this forum and, of course, one of the leading pioneers, as well as continuing innovators within the field of performance – to begin her keynote lecture later that day with a scornful rebuttal, and the assertion of *her* particular medium's high importance. Faced with a practitioner who has often literally lain down her body (and, in fact, her life) for her art, the supposition that she would secretly have preferred to be a painter all along certainly appeared absurd. Abramovic's dedication recently to re-presenting 'classic' works from a range of key performance artists – the subject of her talk at Frieze[1] – as a means of reassessing the significance of an ephemeral and (therefore) inadequately documented form, is clear testament, moreover, to her utter commitment to the practice.

To be fair to Bonami, on the other hand, it would indeed have been surprising if he had 'meant what he said' in the sense implied by Abramovic's subsequent reaction. Not least since, as the curator of the major touring exhibition entitled *Universal Experience: Art, Life*

and the Tourist's Eye in 2005 – showing first in Chicago and later at London's Hayward Gallery – Bonami's interests evidently extend well beyond simply painting. In an extensive catalogue, which attempts to capture precisely the myriad unknowns and idiosyncrasies of approach involved in art-making these days, he is cited as declaring that 'artistic experience at the end of the millennium is becoming more and more complex, one of difficult balance and right scale. It is walking a tightrope with no safety net of "whys" below' (in Dahlgren 2005: 11). His introductory essay, moreover, sets out – as you would expect – the exhibition's parameters of consideration, which rest fundamentally on an interrogation of the nature of looking and experience per se: 'the way we experience the world, art, architecture, and eventually life in general [. . .] through encounters, images, objects, and spaces' (14). As such Bonami seems, in fact, to be headed somewhere else entirely: not by any means away from painting at all costs, but certainly away, first, from its enshrinement as a precooked encounter for the viewer: 'People come into a contemporary art museum and ask, "Where's the Picasso?" [. . .] We should respond, "Here you won't find a Picasso, but you will have an experience that will change the way you look at any Picasso"' (16). And, second, away from painting's subjection within the art world to the vicissitudes of exchange value and 'pure marketing' (23). Instead, Bonami's comments are suggestive – and he is very far, of course, from being the first to express such sentiments – of the encounter with art and the experiences of everyday life being intimately bound up with one another, to the extent that it is impossible and, indeed, undesirable strictly to separate out the one from the other.[2]

ENCOUNTERING ART

Retrospectively summing up the emergence of postmodernism as 'modernism in the streets', Stuart Hall goes on to elaborate as follows on this paradigm shift that occurred a while ago now but still

appears to be in the process of playing out its full implications: 'I think postmodernism is best described as precisely that; it is the end of modernism *in the museum* and the penetration of the modernist ruptures into everyday life' (Hall 2004: 288). Confirming the literal sense in which he means that, Hall proceeds, in fact, to declare:

> The notion that modernism is to be found inscribed on the face of everyday life [...] does obviously jeopardise the whole concept of gathering together the best of all this and calling it "a museum" [...] instead, we must consider the proliferation of sites and places in which the modern artistic impulse is taking place, in which it is encountered and seen.
>
> (289)

Whilst doubtless concurring broadly with the street-ward impulse of Hall's portrayal – which is recent and perhaps original in its formulation, but (again) hardly new – Bonami, as a museum curator, is anxious naturally to retain a viable sense of functionality for the institution in which he is employed. His concern, therefore, is to transform the ethos of the museum, and this is effected, in a sense, by admitting into his building the movement and vitality – or 'contaminating action' – of the street on the one hand and the pedestrian-participant on the other. As he says, 'When someone asks me if the show is going to travel, I answer, "*You* are going to travel". I have tried to make an exhibition with the potential to become an event' (in Dahlgren 2005: 20). Thus the spectator is cast not only as a kind of performer – the protagonist of his or her own 'experience' – but is also – in contradistinction to the norm of the tourist encounter, which 'reduces the complexity of the world' (14) – confronted by the unknown: with a situation supposedly of *unmediated* experiencing.[3] Importantly, Bonami's insistence, in the final analysis, is that the fruits of such an experience – what you may discover that is new – are nevertheless an illusion. But it is a 'fiction [that] can make our lives worthwhile' (16).

One obvious phenomenon can be said to emerge from the discussion so far, then (and it is one which returns us to some degree to Marina Abramovic): the unquestionable incursion of performance and/or eventhood into the making, presentation and experience of contemporary art practices. Not only is there the medium of performance art itself (including its intimate association with video) – emerging as an accepted form in its own right in the 1970s,[4] and later to metamorphose seemingly into live art (though the former term still retains currency)[5] – but there is also, more recently, what I wish to call the situational-relational impulse. This has witnessed an increased translocation of the 'place of art' to the contextual interactions of various constituencies of people, sites, objects and processes, in some cases 'forever unfinished', to borrow a phrase from one of its 'high priests', Nicolas Bourriaud (2002a: 26). At the same time, and in a related vein, there is the 'theatrical turn in post-war art production' highlighted by Gavin Butt in *After Criticism*, which 'drew the object-based practices of modernist painting and sculpture into the spatio-temporal co-ordinates of the event' (2005: 8). In an explication – more fully rehearsed, in fact, at earlier dates by Nick Kaye in *Postmodernism and Performance* (1994a: 24–35) as well as in the same author's introduction to *Site-Specific Art* (2000: 1–3) – Butt points to the crucial effect (derived from the experience of the minimalist art object) of the spectator being made

fully aware of him or herself as a 'live' participant in the actual site of the work, activating the spectator's consciousness of the whole 'scene' of exhibition and display. Thus the body of minimal art's beholder was – supposedly unlike that of the modernist painting or sculpture – already *on stage*, implicated within the theatrical space of the work.

(2005: 9)

It is important perhaps to add to this a rider from Kaye, which emphasises the transitive aspect of the spectator's role as

'confront[ing] her own effort "to locate, to place" the work and so her acting out of the gallery's function as the place for viewing' (2000: 2). Amelia Jones, moreover, also provides an illuminating analysis of the 'inter-subjective engagement' involved in the relationship between artwork, body and situation, one which proposes 'the interpretive relation as a reflexive exchange'. Citing Judith Butler, she refers to the way 'works of art are situated in space in such a way that they engage the body as an "essentially dramatic structure [. . .] the 'place' in which possibilities are realised and dramatised"' (in Suderberg 2000: 335). And Bourriaud, too, insists: 'What nowadays forms the foundation of artistic experience is *the joint presence of beholders in front of the work*', going on to explain that 'the beholder contributes his whole body, complete with its history and behaviour' (2002a: 57–9).

The prevalence of 'performance' is suggestive, then, of a rupture within the conventional perception attributed to 'houses of art' – what they are *for* and how one might act within them – but also, therefore, of a major shift in where and how art takes place. In acknowledgement of the latter, a key question also scheduled to be posed at one of the Frieze talks in 2006 – though not, unfortunately, in a forum I was able to attend – referred to the 'trans-aestheticisation' of contemporary society, demanding to know whether 'art is still art when art is everywhere?' Interestingly, this can be read in at least four different ways, some of which may be said to betray a distinct nervousness – or, indeed, mournfulness – relating to the potential dissolution promised or threatened by performance's simultaneous elusiveness and ubiquity, which has implications for both ownership and meaning. The question proposes a consideration of the possibility, first, that anything may be called art these days as long as it frames itself as such. Second, that art may still be the art that it always was, but it can occur anywhere now. Third, that art – regretfully – has relinquished its elitist ties and become 'available' to all and sundry. And, fourth, that art's relevance at a 'local' level – that is, as being intrinsic to 'the place from which it springs' – has been usurped by the demands of a

global market. For my purposes, though, I wish to concentrate for the time being on art's 'performative spillage', both on to the street and beyond, and even back into the gallery, *and*, as Butt puts it, in terms of 'the experience of art as a profoundly *em*bodied experience' (2005: 9). Importantly, the latter occurs not only as part of culture – and, therefore, presupposes the inscription of certain constitutive values and conventions – but also, by implication, in space. Thus, it is my overall concern to interrogate in this book what I perceive to be an increasing preoccupation of art directly and indirectly with the experiences and discourses that make up living within the space of the city, an impulse that has doubtless emerged as a consequence of the global fact of an ever-growing urban population.

THE URBAN BODY

There is an argument – a flippant one perhaps, in the first instance – to say the city has effectively become the 'new body'. In other words, as an object of study – to say nothing of *in practice* – it promises to supersede in significance a previous preoccupation within critical discourse with the signifying human body as both implicated and expressive locus. Instead cities, with their rising populations – the global balance of urban to rural populations having tipped in 2007 irrevocably towards the former – and complex, transitory configurations, have become the prime embodiments, and therefore indices, of a fast-changing modernity. By 2030 five billion out of a global population of just over eight billion is projected to be made up of city dwellers.[6] In Pearson and Shanks's succinct phrasing, then, 'it is the urban, the congregation of strangers, which defines our contemporary existence' (2001: 147). And, as Henri Lefebvre recognised before most, the space of the interdependent, multifaceted city, the interactions of its built environment, cultures and networks of communication – in short, its often unplanned, 'living everydayness' or, to invoke Jonathan Raban, its 'softness'[7] – *produces* manifold

possibilities of identification and realisation via a range of visible but often imperceptible interactions.

However, as I have suggested elsewhere,[8] and as Pearson's and Shanks's 'congregation of strangers' may already have betrayed, the body has not been replaced at all but *re-placed*, wandering en masse into the space of the city (and not for the first time, of course), performing in situ, a relational body or 'switching station' that acts within and is acted upon by its urban surroundings. Thus bodies can be said both to *produce* and *be produced by* the city. And whilst cities obviously contain bodies, bodies also contain cities. In fact, the city itself functions as an 'ecological' body, one that *facilitates* the circulation of particular socio-economic and cultural discourses whilst also thereby *delimiting* them. In other words, the city's practices install constitutive effects and behaviours in the body of its citizenry that implicitly render some ways of being in the city 'off-limits' or 'inconceivable' as much as conceivable.

Chapter 1 will attempt to portray what may be at stake, then, in the emerging triangulation of art, the city and human beings in the early twenty-first century, concentrating particularly on the way these components have become integrated and, indeed, mutually contingent in accordance with evolving emphases on democratic participation and practices of everyday life. Chapter 2 on the other hand is more concerned with outlining the approach to both the first-hand research and the writing that underpins the second section of the book, and includes a brief delineation of the emphases of individual chapters that follow on as self-contained entities. Thus, the book can be said to fall into two basic sections, the first of which attempts to lay theoretical foundations informing the contextual practice applied in the second, whereby the latter is premised, above all, on the recognition that the encounter with both art and the city is one that is embodied and relational.

SECTION 1

1 The future of art is urban

SEEING THE STREET

Perhaps I might begin briefly with the situationists (to whom I will doubtless feel compelled to return at intervals). In a document which paved the way towards the formation of the Situationist International in 1957 – and which momentarily brings into play again Bonami's remarks on painting, cited in the introduction – Guy Debord declared that 'something that changes our way of seeing the streets is more important than something that changes our way of seeing paintings' (in Knabb 2006: 42). It is helpful to recognise Debord is not necessarily disavowing here the practice of art (or even painting) per se – though there are those who might beg to differ in this regard[1] – but rather making the case for its central implication or activation within the business of everyday urban life, as against its confinement to autonomous art historical or critical functions with their aspirations, amongst other conservative values, to permanence and transcendence. Thus, the situationists' project of 'unitary urbanism', which Debord attempts to explain in the same document, is

defined first of all as the use of all arts and techniques as means contributing to the composition of a unified milieu. [. . .] It must include both the creation of new forms and the *détournement* of previous forms of architecture, urbanism, poetry and cinema. Integral art, which has been talked about so much, can be realised only at the level of urbanism.

(38)

Whilst art can, as such, 'no longer correspond to any of the traditional aesthetic categories' (38), one might nevertheless legitimately propose, therefore – with a nod, in fact, to Bonami's advocacy of experiences that will change the way you look at Picasso – that: 'something that changes our way of seeing the streets may change our way of seeing paintings'. However, the point of Debord's polemics related, as Greg Ulmer points out (citing the latter), to the situationists later practising 'a "realisation" (or "overcoming") of art [. . .] that extended into performance or action the "insubordination of words [. . .] Our era no longer has to *write out poetic directives*; it has to carry them out"' (Ulmer 1989: 199).[2] In other words, the subversive, if delimited, force of art (here evoked through the 'poetics of words') should be harnessed so as to be effective in drawing out or producing radical events on the street. Of course the situationists' project was, above all, provocatively revolutionary in a socio-political sense, which is what marked out the significance of its contribution to an already existing preoccupation within the art world with everyday life and space. As Simon Sadler elucidates in *The Situationist City*, though, the occurrence of the latter, effected via the 'constructed situation' – with its related psychogeographical strategies of *détournement* (diversion) and *dérive* (drift) – is

best thought of as a sort of *Gesamtkunstwerk* (total art work). Each constructed situation would provide a decor and ambiance of such power that it would stimulate new sorts of behaviour, a glimpse into an improved future social life based upon human

encounter and play [. . .] It would clearly be some form of per-
formance, one that would treat all space as performance space
and all people as performers.

(1998: 105)

The conditional tenor of Sadler's observations points to a peren-
nial sense, when it comes to contemplating the situationists' work,
of not *quite* being able to visualise what – or, indeed, how much of
what they talked and wrote about – they actually *did* (or performed).
And what exactly it 'looked like'. In spite of considerable academic
attention – periodically resurgent – involving the deft negotiation of
an array of scattered tracts, drawings and manifestoes, a fundamental
'slipperiness' seems to remain.[3] As an implicated party in this en-
deavour, Sadler himself identifies such a perception as one conjured
with a strong element of deliberation on the part of the situationists
themselves: 'Psychogeography directed us to obscure places, to elu-
sive effects and partial artistic and literary precedents for the sublime.
If we felt frustrated at the effort required to put them all together, we
had missed the point. Psychogeography was a reverie, a state of mind'
(76). But if it *was* that, it was intended as a shared dreaming of urban
space, recognising on the one hand that 'the self cannot be divorced
from the urban environment', but on the other hand that 'it had to
pertain to more than just the psyche of the individual if it was to be
useful in the collective rethinking of the city' (77). As against the pro-
totypical, immersed-but-detached, man-of-the-crowd figure of the
flâneur, revived in the early twentieth century by Walter Benjamin and
still experiencing repeated resurrection – as well as critical censure –
in reconceived form by the century's end,[4] situationist practices were
precisely 'a negation of the city as a site which invites the subject to
remain detached from the object of its gaze' (Hussey 2002: 218). As
I have observed elsewhere, the situationists' aims certainly had socio-
political change in cities in mind, but their preoccupation was with
the complex role of desire in the playing out of any such revolution.
Rather than a rational blueprint for an improved urban ecology, the

situationists proposed 'disruptive mappings' premised on spontaneous encounters and events.[5] At the same time Debord was eager to stress that chance was 'a less important factor in this activity than one might think: from a *dérive* point of view cities have psychogeographical contours, with constant currents, fixed points and vortexes that strongly discourage entry into or exit from certain zones' (in Knabb 2006: 62). For Debord, 'Progress means breaking through fields where chance holds sway by creating new conditions more favourable to our purposes' (63).

So, whilst situationism veiled itself in ambiguity, resisting a systematic categorisation of any kind to the point of denying its existence altogether[6] – a practice not unlike the 'artful trick' of declaring: 'This is not a sentence' – there is a distinct situationist impulse – a 'most radical gesture', to sample the title of Sadie Plant's book[7] – that persists and is of particular use to anyone weighing the increasingly significant relationship of art and the city. And it is one which proposes not only that art should occur on, or in response to, 'the street' but that in doing so it serve to disrupt the signifiers of the turbo-capitalist, spectacular city. Situationist practice implies, then, 'first of all a negation of the value of the previous organisation of expression' (in Knabb 2006: 67), which sounds in many ways akin to the basic tactics of deconstruction, as I have suggested elsewhere.[8] For Derrida, one of the options of the latter is: 'To attempt an exit and a deconstruction without changing terrain, by repeating what is implicit in the founding concepts and the original problematic, by using against the edifice the instruments or stones available in the house' (1982: 135). The situationist concepts of 'negation and prelude' are premised on the 'loss of importance of each detourned autonomous element – which may go so far as to lose its original sense – and at the same time the organisation of another meaningful ensemble that confers on each element its new scope and effect' (in Knabb 2006: 67). Importantly, as Andrew Hussey makes clear in an article that seeks to establish the movement's 'unfinished business', it is the city that is seen as the 'future battleground for the conflict over the meaning

of modernity', a battle that represents 'in many ways the defining moment in the development of situationist strategy' (Hussey 2002: 217). Here a key distinction emerges between the latter and the apparently related practice of *flânerie*. Where the *flâneur* favours a form of ironic detachment from the 'society of the spectacle', situationist practices are 'characterised by an active hostility to the representation of urban experience'. Instead, they are 'political acts which aim to reinstate lived experience as the true map of the city' (218). If anything, Hussey points out (citing Patrick ffrench), the *dérive* is effectively a *détournement* of *flânerie*, according to the method of negation and prelude mentioned above (219).

Moreover, as I have already mentioned, the experience of art, like the experience of the city, is *embodied*. It is dependent on participating entities who engage or interact with art, with the environing field of the city and with one another, and who are, therefore, as much *producers* as consumers or recipients. The radical move out of the museum, meant literally to some degree but also figuratively as a 'reaching out' of art generally towards incorporating both participation and the everyday – and so, capable of stomaching a 'reconstituted return' to the gallery (*pace* Bonami) – leads us neatly to consider, in accordance with the social theorist Henri Lefebvre, both 'the art of living in the city as a work of art' and, more significantly perhaps, his key declaration in the collection of essays entitled 'Right to the City' – which recalls Debord's preference for streets over painting – that 'the future of art is not artistic, but urban' (1996: 173).[9]

WORK/PLAY

Guy Debord supposedly studied under Lefebvre, although Andrew Merrifield denies this ever to have been the case in his critical portrait of the latter (2002: 86). Be that as it may, it is no surprise that

Debord and the Situationist International became substantially associated with Lefebvre in the early years of the movement's existence since, in both actuality and spirit, they certainly 'lived nearby' (100). The relationship, later described by Lefebvre as 'a sort of unfinished love affair' (Lefebvre 1996: 13), had broken down acrimoniously by 1962 owing to irreconcilable theoretical differences, as well as accusations of plagiarism.[10] However, as Ben Highmore sums up, 'It seems the most useful approach is to see their work as differently articulating a number of shared themes' (2002: 138). Key in this regard is, first, the fundamental view that 'the urban revealed the contradictions of society' (Kofman and Lebas in Lefebvre 1996: 14). In particular, as Highmore succinctly puts it, for Lefebvre 'the contemporary urban everyday of capitalism is characterised by the saturation of mass cultural forms (such as TV and radio), penetrating everywhere as an act to cover and hide the discontinuities of everyday life' (2002: 140–1). Such 'fissures in the urban fabric' – referring, for example, to 'spaces of different temporalities, outmoded spaces with distinct cultural characteristics' – existed, however, and had the potential to 'interrupt the homogenising and hypnotising effects of capitalist standardisation through their cultural and historical differences' (141). Thus, it was felt – in a view which reveals clear synergies with Walter Benjamin's earlier thinking on the phantasmagorical nature of modernity – that the 'city that evidences dereliction and decay alongside glamour and wealth is a city that can capture the false historicism of modernity' (141). For Benjamin the 'promises of continual progress and endless improvement [were] among the mystifications of capitalism', with the 'endless stream of identical artefacts and the cyclical character of fashion' producing what might be called a phantasmagorical 'eternal return of the same' (Gilloch 1996: 11–12). The significance for Benjamin of an object's afterlife (or a building's ruination) was, according to Gilloch, that its 'truth content [. . .] is released only when the context in which it originally existed has disappeared, when the surfaces of the object have crumbled away and it lingers precariously on the brink of extinction' (14). As Steve Pile

suggests, for Benjamin artefacts embodied the redundant dreams – the desires and fears – of modernity, but if arranged in certain conceptual configurations – in 'a space which contains two apparently unconnected ideas' – he 'thought it would be possible to induce a shock that would wake up the moderns' (in Bridge and Watson 2003: 79).[11]

Central to a tactical, embodied response to the normative urban scene, as Lefebvre saw it, was the notion of a ludic city. Whilst the situationists developed the critical practice of psychogeography – rooted, naturally, in surrealism – as a playful means of recovering lost energies and re-signifying the city (as we have seen), they simultaneously shared with Lefebvre an interest in *play* as manifest in the form of the 'festival' (or 'collective game'), seeing it as the ultimate expression of social revolution. Staking his position on the city as the place in which use value is potentially preserved, resisting its subordination to exchange value – 'an urban reality for "users" and not for capitalist speculators', as he puts it (1996: 167–8) – Lefebvre outlines his desire to 'restitute the *fête* by changing daily life' (168). In *Right to the City*, which, as the title suggests, polemically asserts the urban dweller's claim to participatory citizenship, he writes that such a 'renewed *fête*' was 'fundamentally linked to play' and involved, in an echo perhaps of Hall's 'modernism in the streets', 'subordinating to play rather than to subordinate play to the "seriousness" of culturalism [. . .] Only relatively recently and through institutions has theatre become "cultural", while play has lost its place and value in society' (171).[12]

Thus, approaching Lefebvre's conclusion (with which we began), that the future of art is urban, 'theatre' – having been co-opted and institutionalised effectively by a privileged, complacent constituency of society – needs to be both re-situated and sought (or encountered) on the street. As regards the latter, Lefebvre states: 'to city people the urban centre is movement, the unpredictable, the possible, and encounters. For them it is either "spontaneous theatre" or nothing' (172). Lefebvre may here be reiterating the tenor of a notion he had previously identified as that of the 'momentary' experience of

everyday urban incidents read as having social implications. Bearing noticeable affinities with the Brechtian theatrical trope of *Gestus*, epitomised by the playwright's theorisation of the scene of an accident on the street,[13] David Harvey describes the Lefebvrian 'moment' as encompassing

> fleeting but decisive sensations (of delight, surrender, disgust, surprise, horror, or outrage) which were somehow revelatory of the totality of possibilities contained in daily existence. Such movements were ephemeral and would pass instantaneously into oblivion, but during their passage all manner of possibilities – often decisive and sometimes revolutionary – stood to be both uncovered and achieved. 'Moments' were conceived of as points of rupture, of radical recognition of possibilities and intense euphoria.
>
> (in Lefebvre 1991: 429)

As far as situating art in the city is concerned, this does not mean 'to prettify urban space with works of art' or monuments, but: 'leaving aside representation, ornamentation and decoration, art can become *praxis* and *poiesis* on a social scale' (Lefebvre 1996: 173). An intriguing conflation of supposed opposites appears to present itself, then, involving conceptions of 'play' and 'work'. On the one hand, the city in itself is a 'work' (of art), or œuvre, which invokes the citizen's right to participation (or public appropriation) as play. On the other hand, art – which, as Johnstone points out, acts for Lefebvre 'as a kind of "play-generating yeast" in the everyday; an action that suggests both the splitting down into simpler substances and the process of fermentation, agitation and disruption' (2008: 14) – can 'usefully' be *put to work* in the city as a means of *bringing into play* that which is *taking place*.

There is a productive link perhaps to be made here, too, with Jean-Luc Nancy's critique of 'community' as described by George van den Abbeele (in Miwon Kwon's citation):

In Nancy's overall project [. . .] 'community is neither a community of subjects, nor a promise of immanence, nor a communion of individuals in some higher or greater totality. [. . .] It is not, most specifically, the product of any work or project; it is *not* work, not a product of projected labour, nor an *œuvre*, but what is un-worked, *dés-œuvre*'.[14]

(Kwon 2004: 153–4)

Community is premised effectively on its 'impossibility', then, on recognising its limits and limitations or, indeed, its 'lack of identity'. As Nancy himself puts it: 'Being *in* common has nothing to do with communion, with fusion into a body, into a unique and ultimate identity that would no longer be exposed. Being *in* common means, to the contrary, *no longer having, in any form, in any empirical or ideal place, such a substantial identity*' (1991: xxviii). Being 'inoperative' – the English translation for Nancy's use of the term *désœuvre* – implies a self-reflexive un-working or un-doing in which the self-imposed *questioning* of the terms by which a given social grouping establishes its own legitimacy is the only thing, indeed, that might confirm it as legitimate. So art's function within the context of urbanity is to facilitate, as Kwon puts it, a 'critical unsiting' (2004: 155). In other words: a being put to un-work in the city.[15]

Almost in the same breath that the human body is declared, in its intersection with the city, to act as the site of the latter's construction (as I proposed in the introduction), one can invoke the regret expressed by a commentator such as William Taylor (cited by Tallack), that a major, advanced city like New York 'no longer visually registers the dramatic impressions' of its shifting economic life: 'Much of what was once fully visible and above ground, on the streets and in the air surrounding its tall buildings, now takes place out of sight, fiber-optically, electronically' (in Tallack 2005: 8–9). As such, both visuality and physicality – and, therefore, *art* – are radically challenged as signifying entities within the realm of everyday life. Compiling his

collection of essays for 'Right to the City' in the 1960s – at which time he was obviously holding out (along with countless others) for a socialist urban future – Lefebvre can thus begin to sound quaint and irrelevant in the twenty-first century. On the other hand, he was fully aware even then that a neo-capitalist organisation of urban space 'no longer gathers people and things, but data and knowledge. It inscribes in an eminently elaborated form of simultaneity the conception of the whole incorporated into an electronic brain, using the quasi-instantaneity of communications' (1996: 170). All the more reason perhaps to insist on keeping in view the body's continuing functionality in the city. Moreover, as Tallack is quick to point out – in response to both Taylor, and to Jonathan Crary's theoretical underpinning of the latter, in which he declares that 'visual images no longer have any reference to the position of an observer in a "real", optically perceived world' and predicts that 'visuality will be situated on a cybernetic and electromagnetic terrain [. . .] consumed, circulated and exchanged globally' (in Tallack 2005: 9) – the questions precisely of 'invisibility and shifting perspectives have always been a preoccupation of visual artists' (9). Thus, art may be radically changing its modus as well as locus operandi – which may render certain forms effectively redundant – but its fundamental role as interrogator of, or worrier at, the concepts of 'being and seeing', as well as 'becoming', is not thereby erased.

The futurist thinker Paul Virilio would probably beg to differ, having explicitly and dismissively stated in conversation with Sylvère Lotringer that art simply 'no longer plays its role' (Lotringer and Virilio 2005: 72). However, his argument is directed at the perceived 'failure' in the twentieth century of the arts of sculpture and painting in the face of both technology and the mass market: 'the art of the motor has surpassed the static nature of the plastic arts' (58), which 'have experienced a total accident' (60). Not only have the visual arts been superseded by electronics, 'they have [also] masked [this] failure or accident with commercial success' (64). In other words, the failure from which nothing has been learned is

effectively one of not keeping up to speed with technological change, whilst preserving market value as a form of fetishised consumer relic. In place of the visual arts Virilio substitutes his notion of the 'vision machine' which emerges in fact as an argument for the way advances in digital technology – spelling the 'end of the analogical' – will alter the structure of perception per se: 'it's a machine that's reconstructing sensations pixel by pixel and bits by bits' (66–7). To put it starkly, as Virilio subsequently does, vision (or perception) is being *given to the machine* and this is what constitutes the 'never-before-seen' with which the visual arts cannot compete. It is no longer the eye or the retina that does the work of seeing but the post-organic optical capacities of the auto-electronic machine, which incorporate, moreover, 'the *correction* of sensations' [my emphasis] (69–70). In other words, the machine *creates* what it sees or gives to be seen.

Importantly, however, as sculpture and painting are declared to 'have gone terribly astray, not to call them totally obsolete', a 'line of resistance' is identified as running specifically through performance and land art, which 'need a *place* and work with *bodies*' [my emphasis] (45). Whilst land art has evolved as a generic form arguably concerned explicitly with the rural and, perhaps more importantly here, the *natural*, one might nevertheless suggest that Virilio is gesturing towards physical *space* as a paramount site of articulation and control (and, therefore, also of resistance) and, as such, includes *urban* land within such a view. Moreover, as Rendell points out, 'much land art was intended as a critique of the gallery system and the role of art as commodity' (2006: 25), factors which can be said similarly to preoccupy the street-ward impulse of urban art. Perhaps, then, where Virilio and Lotringer conclude in their exchanges that art 'no longer plays an artistic role', we are not that far from Lefebvre's 'the future of art is not artistic, but urban' (1996: 173) – a notion which incorporates, as we have seen, the ludic (or performing) body. And, moreover, we may be a little further in our exploration of the 'theatrical turn' in contemporary art.

CITY-SPECIFIC ART

Lefebvre's 'slogan' implies, for my purposes, art that is sited or 'plays some part' in the 'culture' of the city and that is produced as a response to – and therefore, importantly, contributes to producing in turn – city existence. At the same time I am interested, as I believe I have intimated, in the notion of the city itself as a performing and performative entity or cultural product based on how people and other phenomena act, are seen to act or, indeed, are permitted to act, within it. Of course, these various instances of relationships between art and the city have been the subject of theorisation – to an ever increasing degree and from a range of disciplinary points of view – and they are fraught with 'difficulties'. Not least I take note of Rosalyn Deutsche's critique of art history's 'several traditional ways' of categorising this relationship: 'The city can be a work of art. The city, or the experience of the city, influences the subject matter and form of works of art. And, of course, there are art works situated in the city – public art' (2002: 80). Despite noises by some critics – Deutsche cites one case in particular – in the direction of a *new* public art 'immersed in, rather than aloof from, metropolitan life', such delineations always seem to collapse back into assumptions of aesthetic essence and, indeed, transcendence which 'ignore the city's social processes and their effects on the everyday life of residents' (80–1). For Deutsche urban space is – and here she clearly takes a leaf out of Lefebvre's book[16] – not only socially produced but *agonistic*. Thus, the practices of urban societies – what its various constituencies *do* or are *allowed* to do – define or create the space of the city,[17] and such space is dependent for its very condition of existence on that which is produced by 'conflicting interests'. As Lefebvre himself puts it with regard to the abstract space of modernism and capital: 'Inasmuch as [such space] tends towards homogeneity, towards the elimination of existing differences or peculiarities, a new space cannot be born (produced) unless it accentuates differences' (1991: 52). It follows that the function of art in relation to the city should be to evince rather than efface sociocultural

contradictions. Moreover, Deutsche says, the 'spatial tactics developed in postmodern art', which include site-specificity, institutional critique and critiques of representation, have provided the means by which artists can 'reveal the social relations that constitute both aesthetic and urban spaces' (Deutsche 2002: xvii).

Malcolm Miles suggests Deutsche's methodology offers 'a model of criticism which could be applied to many other developments' (1997: 242), and her thinking has without question been seminal in challenging complacency around notions of designated *public* space thereby automatically being *democratic* space, as we shall see in Chapter 3. The points were set by her, then, for a genuinely new negotiation of how public art might be defined, and the tab picked up amongst others by Deutsche's one-time graduate student Miwon Kwon. In the introduction to her highly influential book on site-specific art, *One Place After Another* (2002: 1–9), Kwon clearly indicates – as we have seen already to some degree – not only her desire to shift the understanding of site as a fixed, physical location but also 'to reframe site specificity as the cultural mediation of broader social, economic, and political processes that *organise urban life and urban space*' [my emphasis] (3). Drawing on Deutsche's distinction between assimilative and integrated site-specific art, in which the production of 'a unified "harmonious" space of wholeness and cohesion' is paramount, and an interruptive model, 'in which the art work functions as a critical *intervention* in the existing order [. . .] through some form of disruption' (170), Kwon develops the case for what might be called a 'radical new unsiting'. Paradoxically, this renders precisely the specificity of site – the necessity of its physical presence and permanence to the emplaced artwork[18] – questionable. Instead, the relationship between the artwork and its location is premised on 'the recognition of its fixed *impermanence*, to be experienced as an unrepeatable and fleeting situation' (24). The language that customarily defines the time-based conventions of *performance* is unmistakable here, but this view also points towards the artist's new-found *role* as 'cultural-artistic service provider' (rather than merely a 'producer

of aesthetic objects'), whose tendency is self-reflexively to *perform criticality*. In other words: through the artwork to 'trouble the construction and commodification of urban identities' (4) in a way that implicitly or explicitly draws in spectators as engaged participants and directs attention to the mechanism or movement of its own 'labour' or 'coming into being'.

Not surprisingly various definitions, positions and movements have evolved from such an urban-performative turn. Suzanne Lacy's *Mapping the Terrain* (1995) did much to establish the (US) case of the so-called new genre public art. Clearly seeking to signal the departure from traditional notions of sculpture in public places, she gathered together a series of essays by influential critics, as well as data relating to key artists involved in performing the reconfigured role of 'service provider'. Writing a decade later, however, after several years as director and curator of New York City's Public Art Fund, Tom Eccles unflinchingly speaks out against 'every new approach to contemporary public art practice, whether it was "site-specificity", "community-responsiveness" or the "integration of art and architecture"' (2004: 8). Bewailing 'each twist and turn on the evolving paradigm' as 'pull[ing] public art further away from the artist, and ever more into a set of programmatic requirements that effectively eviscerated the vitality of art itself' (8), Eccles presents the fruits of his curatorial labour in a publication ironically entitled *PLOP*. Referring, of course, precisely to the modernist 'turd in the plaza' school of public art, against which the 'new genres' he was criticising were reacting,[19] Eccles sought to enable artists nevertheless to 'occupy the territory of "public art" while challenging, to varying degrees, many of the underlying assumptions for commissioning artists in the urban environment'. As such 'his' artists have produced interventions that are 'distinctly urban, and conceived of as a dialectic between the physical, social and psychological power of the built environment' (8). Whilst Eccles makes a very valid point – directed I suspect largely towards New York City's 'rival' Percent for Art programme, which tends self-consciously to situate its work in specific 'community' contexts such

as schools[20] – it would be too easy to divide the practices in question into the cliched 'high art' versus 'socially-engaged' dichotomy that seems to be implied. In truth, the supposed lines of separation are nowhere near as clear. For example, artists such as Vito Acconci and Ilya Kabakov have produced work under the auspices of *both* Percent for Art and Public Art Fund initiatives. What remains significant, for this study at least, is the conceptual as well as actual tendency of such work – regardless of categorisation – to revolve around *the city*.

In the London-based Institute of Contemporary Arts' (ICA) 2006 Becks Futures exhibition, which presents – annually and in competition – the work of selected, emerging UK-based practitioners, the contextual German artist Stefan Brüggemann's installation *Show Titles (2000–)* amounted to a 'live archive' of over 700 hypothetical exhibition titles listed in neat columns on four walls of a temporary room. As the exhibition's accompanying pamphlet explained: 'These are offered for the use of those conceiving and organising exhibitions', and the ICA show itself duly adopted one: 'Can't Wait for Tomorrow' (no. 287). Obviously tongue-in-cheek, the titles nevertheless presented a serious portrait of twenty-first-century art world 'pet themes and concepts' that could easily have been determined by Jacques Rancière's identification of 'four major types of contemporary exhibition: the game, the inventory, the encounter and the mystery' (in Bishop 2006a: 88). (Whilst Brüggemann's installation itself arguably conformed most closely to the inventory, many instances of all four types might be found generally as having co-opted or, indeed, as *being* utterly dependent upon the city as its arena of operation.) Emphasising the turn of contemporary art towards the participating spectator and 'theatrical show', the titles seemed to steer viewers from the sublime to the ridiculous and, further still, to the 'repressed abject' (no. 159 was 'Don't Give a Shit'). Moreover, they lead visitors to contemplate, first, the way curatorial trends rise and fall – the titles, it was implied, allocating arbitrary meaning to artistic activity via such labelling, and clearly engaging in a theatrical process of vying for

public attention – and, second, the way that artistic practice itself, or the subtextual *attitude* or demeanour of artists as conveyed by their work, can often be summed up in such sound-bite titles.

It is sobering, then, in the light of the case I am trying to make, that I spotted at least a dozen such show titles – and I didn't go through them all – referring in some way, and from some perspective, to 'city art'. There were, for example, the plain 'City Life' (no. 450), the dourly sociological 'Urban Problems' (no. 256), the ploddingly academic 'Urban Definition of Place' (no. 396) and the unashamedly light and romantic 'Walking Along the Street Thinking of You' (no. 277). However, fun-poking aside, I cannot help but interpret seriously the prevalence here of city titles in accordance with what Deutsche refers to affirmatively as the 'present intensity and ubiquity [of the] "urban aesthetic" or "spatial-cultural" discourse' (2002: xi). In other words, whether art in the city or the city in art, or the city *as* art, I would wish to suggest that the phenomenon of urban living evidently *matters* more and more both in the art artists endeavour to make and in *that which is held to come within the province of art*. Not only that, but this impulse is indicative of an important, complex and differentiated conflation of orientations around minimalism, conceptualism, situationism, social practice, the built environment and, ultimately, performance. As the artist Jeff Wall proposes in an essay on his artist colleague Dan Graham, the latter

> establishes the primacy of social subject-matter as *the* historically essential problem to be posed by conceptualism, and at the same time identifies the single grand subject which will remain central to the development of the movement's historical self-consciousness: the city. [. . .] Graham recognises that the conceptual critique indeed has an inherent subject, which he explicitly begins to investigate – the historical development of the city as site of cultural conflict.
>
> (in Johnstone 2008: 59)

RELATIONAL ART

One person who has embraced the perception of the city's increasing importance and, indeed, significantly theorised the evolution of this occurrence, is the curator and critic Nicolas Bourriaud. His book *Relational Aesthetics* amounts to the consolidation of a position – albeit one that would regard itself, in keeping with the phenomenon, as decidedly 'ongoing' – that has been promoted since the early 1990s via the magazine *Documents sur L'art* (of which he was an editor). It sets out the terms by which artworks are seen as a cluster of practices 'which take as their theoretical and practical point of departure the whole of human relations and their social context, rather than an independent private space'. Thus, they are judged 'on the basis of the interhuman relations which they represent, produce or prompt' (2002a: 112–13). Aspiring to a 'radical upheaval' in contemporary art, Bourriaud attributes such a paradigm shift to 'the birth of a world-wide urban culture' in the latter half of the twentieth century and to 'the extension of this city model to more or less all cultural phenomena' (14). Based essentially on a rapid increase in *movement* – that is, in the possibilities of social communication and exchange, as well as individual mobility – Bourriaud effectively describes the turn from the artwork as object (a 'lordly item in this urban setting') to that of event:

> ... the development of the function of artworks and the way they are shown attests to a growing *urbanisation* of the artistic experiment. What is collapsing before our very eyes is nothing other than this falsely aristocratic conception of the arrangement of works of art, associated with the feeling of territorial acquisition. [...] It is henceforth presented as a period of time to be lived through, like an opening to unlimited discussion. The city has ushered in and spread the hands-on experience: it is the tangible symbol and historical setting of the state of society, that '*state of encounter imposed on people*'.
> (15)

So, in what appears to be an embracing of the cultural turn implied by Hall's 'modernism in the streets' – as well as bringing into play once again Pearson/Shanks' urban 'congregation of strangers' mentioned in the introduction (2001: 147) – relational art and, indeed, the associated phenomenon of 'new situationism' subsequently identified by Claire Doherty direct us to practices in which transitivity, involving the prompting of active relations between 'parties' and 'phenomena' within given social contexts, is central or, in fact, *constitutes* the artwork.[21] In *Contemporary Art: From Studio to Situation* Doherty outlines 'new situations' as describing 'the conditions under which many contemporary artworks now come into being. By "situated", we refer to those artistic practices for which the "situation" or "context" is often the starting point' (2004: 7). As she continues, context is not 'purely a discreet category of public art discourse, nor is it concerned with "contextual practice" as an artistic genre. Rather, it is concerned with "context" as an impetus, hindrance, inspiration and research subject for the process of making art, whether specified by a curator or commissioner or proposed by an artist' (7). Bourriaud's term 'critical materialism', meanwhile, includes as part of its definition the notion that the new art 'does not present the outcome of a labour [but] is the labour itself or the labour-to-be' (2002a: 110). Overall, then: 'Art produces a specific sociability. It remains to be seen what the status of this is in the set of "states of encounter" proposed by the city' (16). Importantly, the transitivity in question introduces 'that formal disorder which is inherent to dialogue'. As such, it 'denies the existence of any specific "place of art", in favour of a forever unfinished discursiveness' (26).

As a curator, Bourriaud evidently has a stable of 'exemplary artists' and collaborators, many of whom he cites in his book. Both he and they have been rightly taken to task – in a protracted debate spread over the pages of several journals[22] – for developing a theory and practice that prioritises too vaguely or, indeed, 'mistakenly' the notions of continuous open-endedness and viewer participation, at the expense of posing searching questions relating to the actual nature

and outcome of the dialogical relations they would seek in such encounters between spectator, location and work. Thus, as Claire Bishop argues forcefully in her article 'Antagonism and Relational Aesthetics', Deutsche's important emphasis, referred to earlier, on democracy coming about where 'relations of conflict are *sustained*, not aroused' (Bishop 2004: 66), threatens to become dissipated. Instead, using the work of Thomas Hirschhorn as indicative, Bishop concludes: 'The tasks facing us today are to analyse *how* contemporary art addresses the viewer and to assess the *quality* of the audience relations it produces: the subject position that any work presupposes and the democratic notions it upholds, and how these are manifested in our experience of the work' (78).

Interestingly, Bishop's critique as a whole is premised here effectively on the (antagonistic) opposition of two pairs of artists, the couple whose work she champions, literally for their 'better democracy', emerging as having a 'tougher, more disruptive approach to "relations"' (77). As such, one might say that the notion of a relational art practice need not be entirely lost to Bourriaud's particular association with certain artists. In other words, its theorised precepts – based on being located explicitly 'within the culture at large' and 'beholden to the contingencies of its environment and audience', as Bishop puts it (54) – are simply open to practical interpretation and application.

So, an example – worth quoting here in detail – which encompasses open-ended but consequential interaction, and at the same time quite literally enacts Hall's image of postmodernism, is given by the work of the Colombian Colectivo Cambalache, who run a 'street museum' as a barter and informal redistribution initiative:

Originally founded in an area of downtown Bogotá known as El Cartucho, the museum provides a process of encounter and disencounter through trade and the circulation of second-hand merchandise. The museum consists of a wooden porter's cart (the Swift) which contains a stock of artefacts and objects that

have been obtained on the streets through chance, through scavenging refuse dumps and through bartering with passers-by. [. . .] Drifting through urban spaces the street museum parks up to display and trade its contents. Visitors are invited to take something that they desire in exchange for something that they themselves no longer have a use for. Showing the museum in the street is in acknowledgement of a public that is often overlooked by city authorities and museums alike: illiterates, the homeless, junkies, the unemployed, beggars. [. . .] The museum is without walls, without a collection policy and without a fixed location. The paradoxical collection that it 'contains' can therefore be read as a testimony to the streets, to the people and to the kind of social relations that are in operation within material culture – not as a static representation but as a wealth that is constantly being redistributed and redefined. The project celebrates exchange and the street as a space for the circulation of knowledge.

(Blamey 2002: 261)

RELATIONAL BODIES

Echoing precepts articulated by both Deutsche and Kwon, such relational or situational art may be said to contain the potential of revealing a form of ongoing renegotiation or, indeed, troubling of its chosen sites: on a recognition of identity informed by site (for which read 'the city') being not only subject to multiple possibilities and complexities of construction but also permanently in transition.

As Kwon broadly argues, amongst artists and cultural theorists the understanding of site has been diverted from a fixed, physical location to somewhere/something constituted through social, economic, cultural and political processes. Paradoxically, therefore, to be situated might mean to be *dis*placed in fact (or between physical sites), the new condition of being recognising itself as a

form of 'belonging-in-transience'. The act of moving between or within places – situated artworks, cities, social contexts – serves as a paradigm, then, for how we engage in constantly evolving processes of identification. As Rendell points out, languages of critical and artistic discourse – often concerned with questions of identity, difference and subjectivity – are frequently spatial (for instance, mapping, locating, situating, positioning, crossing boundaries, transgressing):

> For those concerned with issues of identity – race, gender, sexuality and ethnicity – spatial metaphors constitute powerful political devices which can be employed as critical tools for examining the relationship between the construction of identities and the politics of location. In such ongoing theoretical disputes as the essentialism/constructionism debate, positionality provides a way of understanding knowledge and essence as contingent and strategic – where I am makes a difference to what I know and who I can be. (But I am not going to be [t]here forever.)
>
> (Blamey 2002: 46)

Such itinerancy encapsulates the manner in which we may come to know and be transformed by a variety of 'unknown things'. It also implies that the city's tendency is to evolve increasingly away from a settled or 'sedimented' constitution and towards trans-urban networks that are dependent more on movement and action.[23] As Andreas Ruby suggests in *TransUrbanism*: 'Urbanity is transforming into an atmospheric condition which is no longer necessarily bound to place or space [...] It can certainly no longer be planned, for it occurs only if we perform it' (in Brouwer 2002: 28). Such networks take into account both migrations or displacements of peoples and advances in digital communications technologies on a global scale. The question, then, of where you are situated – of what your global coordinates happen to be – has acquired a paradoxical fluidity or multiplicity of intersecting possibilities. In other words, to be located

somewhere is no longer necessarily to be in one place but rather 'here, there and elsewhere'. As Arjen Mulder proposes in the introduction to *TransUrbanism*:

> A city produces a series of 'localities'. It is no longer a single public domain but a concatenation of diaspora-related public domains in which numerous 'cultures' or 'contexts' are settled but linked via the media to similar [ones] elsewhere. 'India' is located not only in India but also in the Gulf States, in London, in the Caribbean and in your street. 'America' is to be found all over the world, although less and less often in the United States.
>
> (in Brouwer 2002: 9)

The Internet and electronic media generally have not just facilitated global communication networks but have, of course, become sites themselves. So, there is a vast range of constituencies that have gathered for any number of reasons, conglomerations of people reminiscent of urban concentrations: virtual or cyber cities.[24] At the same time, actual cities have been recreated virtually, again for a range of reasons whether that be to replicate or enhance the tourist experience, as backdrop for game-playing scenarios, or for archaeo-historical research purposes.

As we have already witnessed, Paul Virilio is nothing if not one of the foremost visionaries of our time, who – as is the fate of visionaries – has met with criticisms of exaggeration, utopianism, pessimism or simply incomprehension in the period of time in which it has taken the rest of us to catch up with him. 'The Overexposed City' (in *Lost Dimension*), first published in 1984, goes some way to vindicating the validity of his general claims; many of his predictions in it appear to have come to pass or are still central to contemporary debates on the future of urbanism. Virilio's concern, above all, is with *speed distance*, which 'obliterates the notion of physical dimension' (1991: 18). Advances in telecommunications and mobility mean that space has simply shrunk rapidly. For Virilio 'distinctions of

here and *there* no longer mean anything' (13), having been replaced
by a certain

> overexposure in which the difference between 'near' and 'far'
> simply ceases to exist [...] The new technological time has no
> relation to any calendar of events nor to any collective mem-
> ory. It is pure computer time, and as such helps construct a
> permanent present.
>
> (13 and 15)

As such the city is now becoming part of an electronic topology
in which entry to it is marked not by

> a gate nor [by] an *arc de triomphe* but rather [by] an electronic
> audience system [...] Where once the *polis* inaugurated a po-
> litical theatre, with its *agora* and its *forum*, now there is only a
> cathode-ray system where the shadows and spectres of a com-
> munity dance amid their processes of disappearance.
>
> (11 and 19)

If the screen represents the new city square for Virilio, implying
an increasing dematerialisation of corporeality, the anthropologist
Arjun Appadurai – speaking at a much later point in time – attempts
to retain the sense of a 'participating body' in his interview with
Arjen Mulder. The abstraction of the 'electronic ether', of global
cyberspace, is precisely the factor that calls for the need to ensure
that a sense of 'hereness' remains, without thereby tying people to
place: 'We don't necessarily need what used to be called face-to-
face communities, but we need communities whose presence we can
experience in a material, embodied, sensory manner. That's the key,
rather than the idea that people need roots' (in Brouwer 2002: 34). As
opposed to being seen as a single locality, cities should be recognised
as a 'complex of localities', a circulatory nervous system of trans-
local flows in which conventional lines of demarcation relating, for

example, to nationhood or ethnicity dissolve or become porous. With
the global growth of the city it can both absorb cultural diversity as
a 'local site' and reach out across the world. Thus, as Mulder has
already hinted, London exists in New York or Mumbai as much as
it does in London, England. Above all, it is

> in the work of the imagination [. . .] that the cultural dimension
> now really lives [. . .] I inhabit a terrain of possibilities, con-
> structed through the work of the imagination, in some social
> context which I inhabit, which allows me to infuse my life with
> meaning, with value, with belief.
>
> (45)

At the same time Appadurai is concerned to question whether
such a perception of trans-urban fluidity, of inhabiting several 'places'
simultaneously, is in fact a privilege: the urban poor of Mumbai, for
instance, live lives of enforced mobility – 'floating material' – so 'for
them something like secure tenure, even ten feet of land, is abso-
lutely central [. . .] a human claim to stability' (33). For Appadurai,
then, reconciling these two experiences is the principal challenge to
imagining a global future for cities.

2 Relational writing

SPATIAL PRACTICE

My interest in the notion of relationality extends beyond that which may be attributed strictly to the socio-aesthetic principles set out by Bourriaud (or, indeed, discontented adaptations of his theory). For me the term presents an opportunity to view art as containing the potential to be seen to be *doing work* or to be 'serious play' – as performing contextually, if not necessarily *in context* – as well as for that work/play to be seen to come about, or come into its own, as the product of an encounter with an interlocutor or spectator. Importantly, as I have hinted there, the notion of *context* does not confine itself to immediate space – and, therefore, exclusively to instances of sited public sculpture or monuments in the conventional sense (or even specific 'institutional networks') – but seeks, first, to accommodate kinds of art – quite feasibly presented within a gallery setting (as an installation or video work, for example) – that have come about as an engagement with city living and which can, therefore, be said to be making some form of incursion, however implicit, into the question of the urban or what it means to live in a city. And,

second, context takes into account a broad conception of the urban itself as a multipli-city of possible locations and practices. On the one hand, the latter may involve the interaction of tangible phenomena: locations, people, 'objects' of various kinds (vehicles, buildings, 'street furniture'); on the other hand it may entail more abstract, even invisible ones relating to movement and morphology: wide-ranging, rhizomatic exchanges, flows, overlaps, tactics and filters of human communication, expression and experience in the city. The concepts of 'filters' and 'tactics' in particular underpin the formal structure of a co-edited publication that is highly pertinent here: *The Unknown City: Contesting Architecture and Social Space* (Borden 2002). The introductory first chapter defines 'filters' as 'epistemological mediations of existing urban conditions', whilst 'tactics' are 'a more provocative response to the city [which] aims to make a difference'. The editors view both as 'necessary parts of urban living, working dialectically as ways of knowing, thinking and acting' (13). The artwork can be said, then, to insert itself or come into being somewhere in between or 'around and about' such activity, either in an immediate, in situ way or as a form of implicit evocation – that may, as I say, be framed by the boundaries of the art institution – of that which is going on or, indeed, *taking place*.

By the same token, the interlocutor also moves amidst the terms proposed by the artwork: engaging with its problematic, making connections, recognising disjunctions and, ultimately, participating in a productive process of assembling provisional meaning around the question 'what does this artwork *do*'? The role of the writer (about art) – that is: me, here, now – represents an analogous extension of this form of situational encounter. In other words, and at the risk of sounding a little simplistic, it takes into account both a subjective and a cultural position inasmuch as the artwork – which 'filters' or incorporates the abstract or specific city – presents itself as the object or site of my experiencing as well as the means by which I may navigate around or embark upon a process of 'implicated reflection' or 'tactical response'. In turn, such an encounter is contingent upon how I have

come – consciously or unconsciously – to be constituted: in other words, what I may 'bring' and the degree to which I may be inclined to allow myself to be affected, questioned and perhaps transformed. Returning us to the context of the urban, the reciprocity or, indeed, 'Socratean premise' of such an interaction is captured beautifully by Italo Calvino in *Invisible Cities*, one of several 'mythical exchanges' he engineers between the explorer Marco Polo and the ruler Kublai Khan in which they attempt to reflect on the nature of cities:

> [Marco Polo:] 'You take delight not in a city's seven or seventy wonders, but in the answer it gives to a question of yours'.
> [Kublai Khan:] 'Or the question it asks you'.
>
> (1997: 44)

In her book *Art and Architecture: A Place Between*, Jane Rendell has made the incisive case for the introduction of a new term to encapsulate the triadic relationship of art, place and writing, namely 'critical spatial practice'. Referred to by her in other publications as both 'architecture-writing' and 'site-writing',[1] this

> allows us to describe work that transgresses the limits of art and architecture and engages with both the social and the aesthetic, the public and the private. This term draws attention not only to the importance of the critical, but also to the spatial, indicating the interest in exploring the specifically spatial aspects of interdisciplinary processes or practices that operate between art and architecture [. . .] When I write I work between a number of points, laying theoretical ideas alongside artworks and architectural projects, creating constellations and correspondences, connections and separations between them. For me, this writing process has constructed as well as traced 'a place between'.
>
> (2006: 6 and 193)

The notion of embodied, situated experience as the basis for a critical practice is one which similarly preoccupies the pragmatist

philosopher Richard Shustermann, who recalls, moreover, one of the fundamental, if frequently cited, antecedents, of the debate surrounding its implementation: Benjamin's differentiation of the 'lived through sensation' of *Erlebnis* on the one hand and the self-reflective encounter implied by *Erfahrung* on the other (Shustermann 2000: 18). In establishing the criteria for his own methodology, Shustermann goes on to suggest that:

> Experience is inevitably contextual, since it involves the interaction of an experiencing subject and the environing field, both of which are in flux and are affected by their interaction. But this contextuality of experience does not entail a hopeless subjectivism that precludes generalisations. For human subjects and environments share many contextual features. Nonetheless, a philosophy that argues from experience and recognises its contextuality should be reflective enough to declare its own experiential situatedness.
>
> (2000: 96)

Shustermann appears intent on portraying Benjamin as advocating *Erfahrung* over *Erlebnis*, whilst in a more comprehensive discussion Ben Highmore is inclined instead to see a fusion in which the former is what makes the latter 'socially meaningful; it is the point at which experience is examined and evaluated' (2002: 67). Thus *Erlebnis* becomes enframed by *Erfahrung*, marking the synthesis of experience as 'that which is simply lived-through and experience as something that can be accumulated, reflected upon and communicated' (66–7). It is, moreover, vital that such a synthesis take place, otherwise, as Giorgio Agamben has warned: 'Modern man returns home at night exhausted by a hodgepodge of events – amusing or boring, strange or familiar, agreeable or atrocious – and none of them has transmuted into experience. It is precisely this impossibility of translating our everyday life into experience that makes it so unbearable, more so than ever before' (in Grand 2001: 66). For Lefebvre, meanwhile, affirming Rendell's

plea to take the spatio-physical into account, the balcony on to the street appears to him to be *made* for ensuring adequate reflective possibilities. In developing his late theory of rhythmanalysis as a means of apprehending how cities (and, indeed, bodies) are constituted, he appears to be echoing a similar tension between the immediacy of urban encounters (experienced as 'rhythms') and the need for objectivity in weighing them up. On the one hand 'to grasp a rhythm it is necessary to have been *grasped* by it; one must *let oneself go*, give oneself over, abandon oneself to its duration' (2004: 27). On the other hand, in order to 'analyse rhythms, it is necessary to get outside them'. So, 'it is therefore necessary to situate oneself simultaneously inside and outside. A balcony does the job admirably, in relation to the street, and it is to this putting into perspective (of the street) that we owe the marvellous invention of balconies' (27–8).[2]

For my purposes as writer, I wish to capitalise, in my experience of artworks of or about the city, on the sensation of being 'pulled out of the familiar toward the strange', as Rendell puts it in her discussion on spatial encounters (in Blamey 2002: 49). It is difficult to avoid identifying in this as well shades of the 'experience "from within"' of psychogeographical research, as Vincent Kaufmann describes it (in Johnstone 2008: 100), and which Debord himself famously defined as 'the study of the exact laws and specific effects of geographical environments, whether consciously organised or not, on the emotions and behaviour of individuals' (in Knabb 2006: 39). However, as I hinted at in Chapter 1, the situationists' 'constructed situation' is, in Bourriaud's interpretation at least, intended, above all 'to replace artistic representation by the experimental realisation of artistic energy in everyday settings' (Bourriaud 2002a: 84). Artistic practice as Bourriaud would advocate it, on the other hand, corresponds to a 'relational world': 'it is always a relationship with the other, at the same time as it represents a relationship with the world' (85). In the final analysis Bourriaud is prepared to concede situationism's influence on relational aesthetics, not least in the latter's decisive 'turning' of the former – '[t]he work that forms a "relational world", and a social

interstice, updates situationism and reconciles it, as far as it is possible, with the art world' (85) – and it is perhaps somewhere in between the city (as social site or place), the artwork (as sensuous map) and the interlocutor (as embodied participant and writer) that the relational triad I would seek to establish here operates.

SITUATED ENCOUNTERS

Essentially I see my position as writer as a performing role, one which aligns itself with what Gavin Butt refers to in his introduction to *After Criticism* as 'the *event-ness* of the critical encounter [. . .] an "immanent", rather than transcendent, mode of contemporary criticality' (2005: 7). In a sense what follows in Section 2 of this book amounts to a series of 'situated encounters' with a body of artworks – and, in some instances, with the artist themselves – as they correspond to certain governing behaviours, acts or tropes of urban life: walking, playing, memorialising. As such, far from indulging in a quasi-art historical – that is, retrospective – project of scholarly recognition, interpretation and classification of artists and works based on the preservation of art as a discrete form, which would probably entail the 'communication of a prior sense', as Greg Ulmer puts it – or, to invoke Shustermann again: 'relying on a priori principles or seeking necessary truths' (2000: 96) – my account will strive to favour *'the discovery of a direction by means of writing'* [my emphasis] (Ulmer 1989: 90). In *Teletheory* (1989), Ulmer invents the new critical writing genre of 'mystory', which intertwines the personal (autobiographical), popular (community stories, oral history, popular culture) and expert (disciplines of knowledge) in an attempt to find an adequate form for the cognitive structures of the electronic age. There is much that might be adopted from Ulmer's particular triangulation of these writing discourses, not least the fact that 'mystory emphasises precisely what *I happen* to unearth' (83). What I miss in this delineation of component parts is mention specifically of spatiality, although, it has

to be said, Ulmer clearly develops his methodology arou
tions of place (as well as movement). The reference to 'uneal
is particularly significant here because one of the most resonant ex-
plications of how mystory can work – at least for my ends – emerges
in an analysis of a well-known written account by the 'earth artist'
Robert Smithson of a 'tour of the monuments of Passaic, New Jer-
sey' (175–84). Calling the account a 'performance of the problematic
informing teletheory' (176), Ulmer shows how it is dependent not
only on an actual bus trip to the locations in question but also on a
'filmic framing' of them: 'Smithson frequently discussed his site se-
lections in terms of how he might make films of them, as settings for
films. [. . .] His work, that is, may be understood as an enactment of
filmic thinking' (176). Smithson's writing – the 'direction' he would
discover for himself – appears to be premised, then, on an imagined
inhabitation of the structure of the artwork (film) he might make
about the place he encounters.

To finesse the approach I am attempting to develop with a sprin-
kling of Roland Barthes, to whom many if not all of these notions
under discussion here are indebted somewhere along the line: 'the
unity of a text is not in its origin but in its destination' (1989: 54).[3] In
his seminal essay, 'The Death of the Author', Barthes actually implies
a form of 'double death': first, in the author's relationship to writing
and, second, in the text's to the reader. In other words, the author
disappears or 'enters into his own death' in writing: it is language that
performs as opposed to the author, thereby restoring the reader's place
(49–50). As such, 'every text is eternally written *here* and *now*', involv-
ing the production of a 'field without origin' or 'multi-dimensional
space' within which the reader, in turn, 'writes' for him/herself (52–
3). Thus, in being performed (by being read), the text too can be said
to enact its 'death'. I am aware, of course, that Barthes is talking here
explicitly about the writing and reading of fictional works (Proust
in particular). However, the broad principle of such a 'double move'
is one that I wish to invoke here, not least because Barthes himself
went on to practice such a 'creative criticism'. It simultaneously brings

with it, as Catherine Belsey observes (referring to Barthes's approach to writing *S/Z*), a self-reflexive 'affirmation of "*ourselves writing*" in defiance of the limitations imposed by culture' (2005: 122). These possibilities are effectively seized upon by the writer Geoff Dyer in the preface to his highly evocative book about jazz musicians, *But Beautiful* – which he describes as being 'as much *imaginative criticism* as fiction' (1992: preface) – and, indeed, his more recent work on photography, *The Ongoing Moment*. In both books Dyer casts the 'author' – that is, himself – in the role of self-conscious 'speculator' or 'discoverer': 'the person doing the learning is the person writing the book as much as the person reading it' (2005: 7). Moreover, in his afterword to *But Beautiful*, Dyer provides further gloss on this role (referencing George Steiner's *Real Presences*), couching his definition in terms reminiscent of 'implicated witness to events': 'the performer "inserts his own being in the process of interpretation". Such interpretation is automatically *responsible* because the performer is answerable to the work in a way that even the most scrupulous reviewer is not [. . .] all art is also criticism' (Dyer 1992: 165–6).

WRITING ART AND THE CITY

The chapters that follow in Section 2 are effectively self-contained, as I mentioned at the end of the introduction. That is, there is neither a linear argument nor a conclusion to the book as a whole. Having said that, each chapter will add a further 'striated layer of possibility' in the understanding of art's relationship with the city, and this in itself is intended to produce an overall sense of development and 'usable insight'. It is important to add, moreover, that although there are references to and emphases on specific cities – above all London, it has to be said – this is not an attempt at a categorical account of those cities *in particular*. A previous book of mine, *Street Scenes* (2005), would serve as an example of the latter, being explicitly about Berlin 'as a whole' at the turn of the millennium and very much dependent on

my presence there and the local topographical knowledge that such a positioning afforded. When it comes to which cities figure here, there is an evident bias towards certain cities as well as certain *kinds* of cities, not least those of which I have direct and regular experience. And that means, as it happens, both a western and European focus. It also implies an emphasis on certain kinds of issues and discourses around those cities at the expense of others in other parts of the world, but the aim is not to circumscribe the discussion by deliberately positioning it regionally in any way. The intention, then, is not to provide some form of comparative survey or representative portrait of sample cities across the globe (or *any* broad geographical constituency). Apart from being virtually impossible for one person to undertake meaningfully without falling into several obvious traps relating to 'colonialist' or, to re-invoke Silverman, 'cannabalistic' tendencies (see Introduction, note 3) – to say nothing of limited available time in which to conduct credible first-hand research – it is in any case very much the aim to begin with the suggested form of *artworks* or *art events*: in a sense to navigate or manoeuvre inside or around the structures they offer in order to identify how they 'perform city-ness'. In a sense it is the story of that affective experience that matters, so my personal encounter with works and sites is invariably the point of departure.

In describing Kate Love's approach to writing about art, Gavin Butt sums it up in a way which seems to accord fundamentally with such intentions (without relating explicitly to urban matters):

> Love takes as her point of focus the 'experience' of the work of art and attempts to put experience *to work* in her text in order to open up closures around art production and interpretation [. . .] Love attempts to write *with* the experience of art in order to capture in her writing what it might mean to experience a work of art: to open up the meanings of experience to the processes of writing, and, by the same token, to open up the processes of writing to the vagaries of experience.
>
> (2005: 15)

n the words of Love herself, 'the experience of art' emerges 'as
..ʊ... of criticism itself' (in Butt 2005: 157).

Of course, having concealed my approach behind a rather abstract
notion of the city, I have to remind myself – and I attempted to make
this clear earlier – that a significant part of what concerns me is
precisely the process of how artworks both *connect* with and *produce*
cities; that is, how they perform them into being. As such it will
prove largely nonsensical, not to say counterproductive, to ignore the
specificities of the place that the artwork would appear to be about.
What I cling to here – and it is in part a corrective to or defence of
non-residency – is the fact that artists are frequently commissioned
to make work for places and cultures to which they do not strictly
'belong', and that this might prove to be a useful advantage. To give
one example: Rachel Whiteread's Holocaust installation in Vienna's
Juden Platz, the so-called *Memorial to the 65,000 Murdered Austrian
Jews*. This sparked the most protracted local and national political
wrangling imaginable, as Chapter 5 shows, and nearly resulted in the
artist's withdrawal through shear frustration at the lack of progress.
The course of events epitomises the notion of an artwork performing
a troubling or un-working of site: both the bringing into play of
that which lurks in the shadows – in this instance before the piece
itself has even materialised in space – and the precipitation of 'new
circumstances'. Here, alone the promise of the artwork provokes
the activation of remembrance in the present of an unresolved past.
What is particularly relevant for my position is the way this case
demonstrates how both the making of an artwork – that is, from the
artist's point of view, including what Christo calls the 'software stage'
of agreeing terms with various implicated parties – and the eventual
experiencing of it (from the spectator's standpoint) can function as
a means to *discover* and *produce* place, or to negotiate the terms by
which it operates, precisely as an outsider from 'elsewhere' (as opposed
to the conventional assumption of *knowing intervention*). Moreover,
as the artists (and, here, co-editors) Tacita Dean and Jeremy Millar
appear to suggest in their joint introduction to *Place* (2005), there

is also a way in which such encounters can point constructively to a significance *beyond* themselves:

> Both place and art can lead us to a greater understanding of both of these things, what we might mean by them and why they might be considered important [...] Indeed, what becomes apparent is the permeability of both concepts [...] Both place and art might be said not to contain – and be contained by – boundaries, then, but rather an innumerable series of thresholds, which extend far beyond the physical limits of either the site or the art object.
>
> (19–20)

That 'beyond', like Rendell's 'place between', is where writing might be said to come into its own.

Chapter 3 concentrates on the phenomenon of walking in the city, which in recent times has become a noticeable source of inspiration for many artists in a whole range of ways. At the same time urban walking in itself – as an everyday activity, rather than artistic practice – represents a means of interacting with the city and can take many different forms or have many different 'reasons'. Alone the politics of where and how you are permitted to walk as a pedestrian, and who may or may not be watching you, is revealing of the nature of the particular city – and, by extension, the culture or society – in which you happen to find yourself. In some respects the simple act of walking may suggest itself as one of the few remaining 'natural, democratic freedoms', in defiance not least of technologies – if not tyrannies – of the car and screen: an activity that 'costs nothing' for a start, that most ordinary people can undertake without too much trouble and that, therefore, amounts to the assertion of a form of 'bodily self-expression' that is, moreover, good for your health. But, of course, walking is circumscribed by all manner of socio-cultural coding that may not render it quite as free and easy as it at first appears.

The chapter looks at the relationship of urban walking to art from three points of view, then. First, in relation to the British artist Richard Wentworth whose practice – in terms of its immediate relevance here – encompasses both alternative 'tour guides' around parts of central London and 'street photographs' taken on his personal walks round cities. The latter are startling, above all, for the way they suggest the presence of discrete pockets of urban activity without imaging people, whilst the former amount to performances to small groups of people in which a part of the city is effectively 'spoken into existence'.

The second artist is the Mexico City-based Francis Alÿs, whose work is similarly driven by street activity and performance but from the point of view of 'engineered actions' generally documented and presented filmically. Thus, his work records incursions into the cityscape, based occasionally on the observation of existing patterns of behaviour – the particular movement of pedestrians over time, for instance – but more usually on the instigation of some form of basic stimulus involving his own walking persona, or that of other specified individuals or groups, enacting a brief of some sort. The actions implemented are not only highly revealing of city living, they can also be said to 'make tracks' that temporarily define the built environment.

Third, I concentrate on the phenomenon of the *Sculpture Projects* in Münster, Germany, an event occurring only once every decade for a period of some three months, though aspects of it also possess a life well beyond the scheduled event itself. Here a whole city is 'taken over' by sited artworks from a distinguished range of international artists. Whilst walking is not *necessarily* a prerequisite for the experiencing of this event, I argue that it represents the most rewarding way in which to partake of it because it permits a form of cross-town dialogue to take place between the artworks concerned, these being dotted all over the city. Inevitably, these relational conversations, which are contingent upon the figure of a 'walking interlocutor', spin a form of urban narrative web that is very particular to Münster. The artworks also serve as a means to navigate the city. Artists upon whom

the section focuses include Mark Wallinger, Dominique Gonzalez-Foerster, Pawel Althamer, Gustav Metzger, Guy Ben-Ner and Valérie Jouve. Some artworks, it should be said, such as Althamer's *Path*, which leads you out of the city, are in fact premised precisely on the act of walking.

Finally, with regard to Chapter 3, it should be noted that, with all the instances of 'walking art' considered, there is an implicit engagement with the question of what art is and where it should be taking place. Whilst none of the examples given fit under the rubric 'street art', far less 'street theatre', almost all of them in their own way – but, admittedly, some more than others – propose a questioning of the institutional gallery or museum as the sole or rightful 'place of art'.

Without setting out to do so specifically, the writing of Chapter 4 ended up discovering all manner of related arts activity within a fairly confined area of central London. The chapter's point of departure was the phenomenon of play (or playing), which, like walking, has also experienced an increased methodological application in a number of ways within different art forms, as I suggested in Chapter 1. More often than not these instances of play are dependent on the quotidian city as their playground. And they are dependent also on a participating public whose roles vary, though. One thing I began to realise, as the writing in this chapter roamed from railway stations to squares to the space of CCTV surveillance footage, was the way there appears, increasingly, to be a highly fertile, if only implicit, dialogue taking place between 'unofficial practices' such as flash mobbing, free running and other forms of underground art making, and those of high-profile artists such as Antony Gormley or Martin Creed, who are usually gallery-based in their work, but who also seek consciously to perform in and amongst or with an urban public.

Beginning with an instance of mobile clubbing at Liverpool Street Station, the chapter wanders to the site of Trafalgar Square where critical linkages are discovered between a 'frozen mob' event, the square's nineteenth-century statuary – including, naturally, Nelson's Column – and the recent activation of a rotating programme

of artworks sited on the so-called 'Fourth Plinth'. The latter focuses specifically on Mark Quinn's sculpture *Alison Lapper Pregnant*. Concentrating then on a series of 'renegade practices' in a more general sense, from the urban writing of graffiti – incorporating the raw 'throw-up' as well as the 'authorless' subtlety of a Banksy – to 'video sniffing', the chapter attempts to tease out the importance in the enactment of these practices – and it applies similarly to flash mobbing – of treading a fine line between observing and breaking the law. That tension, invoked through the very playing out of such 'risky games', in itself raises questions about the freedom and accessibility – indeed, supposed 'public-ness' – of urban space.

Seeing a potential association between the radical poetry of free running and Martin Creed's recent 'running work' (*No.850*) at Tate Britain, Chapter 4 winds up by identifying the way artists are either incorporating aspects of 'the street' or developing playful visions or articulations of the cityscape in the work they make, in a way that is always dependent upon a consciously situated or participating spectator. Crossing the river, the chapter's playing fields are extended to the South Bank area of the city with a consideration, first, of Gormley's 'populating' of the rooftops with his scattered, human-size figures in the piece *Event Horizon* and, second, of Carsten Höller's *Test Site* slides at Tate Modern, which were conceived precisely as 'usable prototypes' being tested for their potential implementation in urban situations involving the public. As in Chapter 3, an ongoing negotiation of the 'rightful place of art' underpins all of this work.

Chapter 5 introduces the time-based factor of the 'past in the present' to the book's triangulation of art, city and participant. Comparing two of the most recent and significant urban sites of memory and commemoration in the early twenty-first century, the chapter strives to concentrate on the immediate physical encounter with these memorials as the point of departure for reflection, as against the raging controversies that preceded their actual materialisation. At the same time the chapter recognises that these installations are so heavily freighted, that they inevitably embody and continue to perform the

debates that predated their physical emergence. What is important about both of the memorials is, first, the way in which their configurations facilitate for the visitor a performance of cultural memory in the present. In other words: as a historical moment that continues to play in the present and that is subject to constant public reappraisal and, therefore, a form of 're-writing'. Second, both sites are located centrally in their respective European cities: literally and in terms of the implicit way they *carry* their urban pasts. As such, they are deeply implicated specifically in those cities, being produced by that which has gone on in them but also contributing to their reconstituted definition in the present day.

The memorials are both Holocaust sites, concerned with the general legacy of the national socialist past and specifically with the deportation and extermination of Jews. But they are in different cities and, indeed, countries – Berlin, Germany and Vienna, Austria respectively – and if there is one thing that can be said to characterise the nature of the responses provoked by these installations, it is the contextual differences that arose in each case. Without going into detail here, one of the governing factors in this respect was doubtless that Germany has generally shown a far greater willingness to confront the Nazi past than Austria, which has tended to hide behind a myth of innocence and, in fact, victimhood. Thus, the debate over Peter Eisenman's *Memorial to the Murdered Jews of Europe* in Berlin centred on fundamentally vexed questions around Germany's relationship to the Nazi legacy, whereas Rachel Whiteread's *Memorial to the 65,000 Murdered Austrian Jews* in Vienna uncovered deep-seated cultural denial of Austrian implication and culpability. If nothing else, the emergence of such strains of public consciousness and unconsciousness in themselves make the case for the absolute necessity of such urban artworks.

SECTION 2

3 Walking with Wentworth et al.

Sometimes it seems as though we are not going anywhere as we walk through the city, that we are only looking for a way to pass the time, and that it is only our fatigue that tells us where and when we should stop. But just as one step will inevitably lead to the next step, so it is that one thought inevitably leads to the next thought [...] so that what we are really doing when we walk through the city is thinking, and thinking in such a way that our thoughts compose a journey, and this journey is no more or less than the steps we have taken.

Paul Auster, *The Invention of Solitude*

TALKING THE WALK

Richard Wentworth has not appeared for his afternoon rendezvous with us at Tate Britain. We, a random group of perhaps 15, mostly unacquainted individuals, have gathered at 2pm on this Friday afternoon in late June to walk with the artist to Tate Modern. Tate to Tate. When he finally arrives, half an hour late, one of the first things he mentions is the potential for the occurrence of com-*pan*-ionship

on such occasions: the way that this term relates literally to sharing bread with 'fellow travellers'. An impromptu, ambulatory tête à tête. As he walks, he chats away with just such lightly worn erudition and an infectious curiosity about the this-and-that of everyday London street life to whomsoever he may find himself beside. He dislikes, in fact, being seen as a historian of this city (an oral version of, say, Peter Ackroyd),[1] but he knows, or has deduced, a seeming plethora of quirky things about it. Perhaps 'urban explorer' is a more apposite description. Or 'cartographer', given his installation-as-mapping of the Kings Cross district of the city, *An Area of Outstanding Unnatural Beauty*, back in 2002, just as the developers came swooping to transform it into a quarter befitting of 'a vibrant and successful world class city', as the corporate publicity put it. On the other hand, maybe that artwork had more to do with archaeology or archiving, with its ambition to uncover and record undetected layers of the area.[2] Whichever it may be, and there are certainly further possibilities, there is doubtless a strong element of 'measurement' in his approach: 'ways of *calibrating* our path through the city', as he says, which, by extension, permit us to 'gauge the *calibre* of a place' (in Borden 2002: 389). Paradoxically, perhaps, for Wentworth the pleasure of the street is 'the fact that it's out of control [. . .] a kind of free theatre' (403) that affords him the opportunity to discern and frame unplanned rhythms and patterns: 'all those practices which are actually world forming, and which in turn we respond to – how cars are parked affects how you are as a pedestrian – all those kinds of essentially urban conversations between people and things' (389).

Today he is mostly the storyteller perhaps, narrating the city – or thinking it aloud – as he walks. An alternative tour guide, pausing at intervals to regale his audience with unknown pearls of walking wisdom. These often aphoristic observations, discharged with casual ease, can verge on possessing the lyrical poignancy and economy of a poet. But then there is also the dramatist's instinct to orchestrate the interaction of people. In some ways these group walks are the antithesis of Wentworth's street photographs (on retrospective display

that summer at Tate Britain).[3] In the latter there are no people at all, merely traces of their existence, 'making do and getting by' (as part of the exhibition was entitled): signs of life in what are in fact densely populated urban environments; after-images of beautiful accidents relating to where and how people live. The photos oscillate between the discovery of functional improvisations on the one hand to incidental configurations on the other. On a kerbside in Nicosia a single brick and slab of wood bear testament to the builder's provisional construction of a little ramp for his wheelbarrow, whilst a piece of paper stuck to the street in Barcelona records the tread-mark of the tyre that flattened it into the patterned tarmac. A double imprint. This is what Walter Benjamin might have meant when he referred to the *flâneur's* practice of 'botanising the asphalt' (1997b: 36). For the *flâneur* (as well as the masses) the everyday effects of the street functioned as ready-made substitutes for the artefacts of official bourgeois culture:

> . . . glossy enamelled corporate nameplates are as good a wall-decoration as an oil painting is for the homebody sitting in his living room, or even better; the fire walls are their desks, the newspaper kiosk their library, letter boxes their bronze statuettes, benches their boudoir, and the café terrace the bay window from which they can look down on their property. Wherever asphalt workers hang their coats on iron railings, that's their hall; and the gateway that leads from the row of courtyards into the open is the entrance into the chambers of the city.
>
> (Benjamin 1999: 264)

Thus, as Esther Leslie observes, 'this street furniture provides a bureau and drawing desk on which he [the *flâneur*] can assemble the pieces of litter, the fragments of city lives, into images and narratives. The trash of the everyday metropolis is re-valued in the artwork' (in Coles 1999: 85). As we have seen, Wentworth's photographs frequently record

unorthodox adaptations he has stumbled upon: ordinary things given a recharged function out of need. In Geoff Dyer's view, 'Wentworth likes things that don't work. We tend to be oblivious to efficiency so maybe we notice things more when they don't work than when they do. By stopping working a thing becomes – is reincarnated as – something else' (in Johnstone 2008: 214). But it needn't necessarily involve a broken object, as Dyer adds:

> A shoe stops being an item of footwear and becomes something to keep a window at bay. We speak of a foot in the door, so why not a shoe in the window? Visual puns and reversals of function and intent hold Wentworth's world together.
>
> (214)

Ultimately, it is the potential for 'visual riffs' to emerge from such found situations that seems to interest Wentworth: the poetry of co-incidence, as well as the tactical disordering of order effected, which, in turn, produces its own quirky 'new order'. For Dyer, moreover, the work 'feels like an ongoing comedy of manners with things standing in for people' (215). But whilst the artist 'may not photograph people [. . .] his world is human, all the more human for being uninhabited' (216).

Whilst a walk with Wentworth does, by contrast, involve people, arguably its artistic concerns are not fundamentally different from his images: a time-based encapsulation or poetic framing of chance events, as well as the extension of an invitation to notice the extraordinary within the ordinary in a form of defiance of the urban spectacular. How delighted he is when a member of our Tate to Tate group unexpectedly bumps into her husband outside the Imperial War Museum on Lambeth Road where the fellow has been spending his afternoon. Wentworth is just telling us about the building's former life as the infamous mental institution Bedlam, known in the nineteenth century for its exploitative staging for visitors of 'real-life scenes of madness', and immortalised subsequently, of course, as a

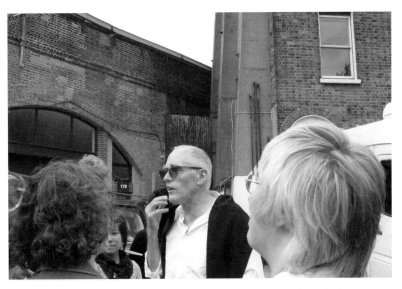

1. Walking with Richard Wentworth, Lambeth Road, London, 29 June 2007.

term describing pandemonium or chaos. The process of change in both the function of this building (from 'mad house' to museum) and its former name – originally Bethlehem, then shortened to Bethlem, before settling on Bedlam – epitomises, of course, precisely the kind of 'turning' action – in this case historical – whose resonance so intrigues Wentworth.[4]

One 'historical gem' he does not mention on this walk, though it is more likely than not that he is aware of it: Tate Britain's British landscape galleries were, as the artist Francis Alÿs discovered, built on the very spot of Jeremy Bentham's panopticon prison experiment (Alÿs 2005: 36). Within this 'institutional site', then, the discipline of the gaze (looking at paintings) has superimposed itself in the course of time on the *disciplining* gaze (looking at/watching over prisoners or, indeed, prisoners watching over themselves). Potential analogies around the regulation of behaviour via 'regimes of looking' present themselves through this form of historical overlaying, not least when related to modern-day institutional surveillance mechanisms. Museum visitors as well as London pedestrians these days can

assume – and the slight doubt expressed in this is, of course, crucial – that they are being monitored in some way. Security guards looking at images of people looking at images. Francis Alÿs's 2005 film installation *The Nightwatch*, for which he released an urban fox into the rooms of the National Portrait Gallery in London, was dependent, both in its making and in its conceptual concerns, on the presence of CCTV surveillance. As the artist explains: 'Instead of keeping secret their operating system of cameras like most institutions do, their system is based on the preventative power of showing to the public that they are constantly being filmed by integrating some monitors in the exhibition rooms. It's all out there in public' (36). Whilst the public may self-consciously 'watch its step' as a result, the oblivious fox roams without inhibitions, thus utterly confounding the panoptic gaze of the institution. In other words, it simply does not accede to the surveilling gaze and can, therefore, escape it to some degree. Moreover, as James Lingwood suggests:

> The idea of the fox looking back at these paintings of important, powerful people in the Eighteenth and Nineteenth century galleries is a magnificent inversion of the normal balance of power. The fox has been hunted by the land-owning classes for centuries – until precisely last year, when the Government has tried to ban fox-hunting. Maybe there is something quite triumphant about the fox materialising in this place.
>
> (in Alÿs 2005: 36)

As he tells us about Bedlam, that other 'place of looking' (to say nothing of the 'clinical gaze' it may have been facilitating),[5] Wentworth has allowed the group unashamedly to crowd the whole pavement. A mild ripple of uncertainty ensues – not exactly 'pandemonium', then – as passers-by are forced self-consciously to negotiate a route past or through us. Where a tour guide may have sought, anxiously, to keep the group in check so as not to offend the 'locals of the manor', Wentworth seems unperturbed. It strikes

me as a form of provocation: the potential 'making of a (street) scene'. Very little actually happens, and nothing is said, but everyone concerned is 'aware', both witness to and participant in what is going on. A different cast of players or location may well have produced a tense confrontation. If you dislike dealing with people and unforeseen incidents, the city is not for you, Wentworth later asserts.

I am reminded at this point of Richard Sennett who, in *The Uses of Disorder*, maintains precisely that disorderly, even painful encounters in the city are a necessary part of learning to handle conflict satisfactorily. Being forced to engage with otherness beyond our defined boundaries of selfhood in fact has a civilising effect on social life. In other words, 'naturalising' the experience of disruption prevents a city's inhabitants from becoming alienated, intolerant of the concept of disorder to such an extent that their responses turn all the more aggressive when situations of conflict *do* happen to arise (Sennett 1996a: 44–5, 131–2). It makes me wonder whether such a 'street-level' perception of interaction within urban space might chime with the 'democratic paradox' of agonism in the public sphere, as advocated at the more abstract level of political science by Chantal Mouffe (and highly influential upon Rosalyn Deutsche's thinking).[6] The paradox in question concerns a democracy based not on *resolving* difference in social relations and/or values held, and thereby effacing or 'overcoming' it, but *permitting* and, indeed, *sustaining* it as a recognised and necessary aspect of a pluralist society (Mouffe 2000: 33). Thus, the democratic process should afford 'agonistic pluralism' the space to play itself out continuously, confrontation – or 'friendly adversity' – being the very condition, or constitutive of, existence in the public sphere (101–3). Mouffe's view is premised, of course, on the post-structuralist recognition of identity – individual and/or cultural – being defined as much by that which it is *not* as much as by that which it is. Selfhood cannot approach being cognisant of what it is, and cannot therefore constitute itself, other than through that which it lacks (following the well-known Lacanian axiom).

Thus, difference is essential to 'identifications' coming about in any shape or form. As Phelan succinctly formulates it:

> Identity is perceptible only through a relation to an other – which is to say, it is a form of both resisting and claiming the other, declaring the boundary where the self diverges from and merges with the other. In that declaration of identity and identification, there is always loss, the loss of not-being the other and yet remaining dependent on that other for self-seeing, self-being.
>
> (1993: 13)

So, as Bishop points out (referencing Mouffe's earlier collaborative work with Laclau), the subject remains 'irremediably decentred and incomplete' since the presence of the 'other' unavoidably prevents it at the same time from being 'totally itself'. As such, 'the presence of what is not me renders my identity precarious and vulnerable, and the threat that the other represents transforms my *own* sense of self into something questionable' (Bishop 2004: 66).[7]

As Deutsche and others have recognised, so-called public space carries with it wrong-headed assumptions, first, of democracy being in operation (in it) as of right – that is, by virtue of it being 'open to the public' – and, second, of democracy itself possessing, of necessity, unifying properties. In other words, that it is egalitarian, accessible and just, thereby ensuring freedom of opportunity for all. Mouffe, though, has shown that democracy is not delivered via circumstances of arriving at unity and consensus, which tends to imply naturalising exclusions or ignoring difference (2000: 49). Such 'unifying eliminations' or elisions inevitably occur as part of that which is mistakenly held to define the democratic process and, by extension, the unfettered use of public space. In other words, it is in the interests of liberal practices of power – state or private – to maintain a positivistic idea of 'the possibility of democracy' (and its spatial manifestations), based on harmony and accord, at the expense of a necessary contestation.

As Mouffe puts it in a later essay entitled 'Art and Democracy: Art as an Agonistic Intervention in Public Space', 'the dominant tendency in liberal thought is characterised by a rationalist and individualist approach which is unable to adequately grasp the pluralistic nature of the social world, with the conflicts that pluralism entails [...] One of the main tenets of this liberalism is the rationalist belief in the availability of a universal consensus based on reason' (in Seijdel 2008: 8). For Mouffe, democracy can only play itself out by accommodating agonistic pluralism which, paradoxically, is dependent on accepting the impossibility of a fully constituted social identity. Thus, where liberalism may indeed embrace an *agonism* of consensual, 'resolved disputation', the point is that it takes no account of the 'ineradicability of *antagonism*' (11, my emphases).[8] As Deutsche, in turn, elucidates:

> Democracy and its corollary, public space, are brought into existence, then, when the idea that the social is founded on a substantial basis, a positivity, is abandoned. [...] This abandonment also means that society is "impossible" – which is to say, that the conception of society as a closed entity is impossible. For without an underlying positivity, the social field is structured by relationships among elements that themselves have no essential identities. Negativity is thus part of any social identity, since identity only comes into being through a relationship with an "other" and, as a consequence, cannot be internally complete.
>
> (1996: 274)

Far from such a position – in which it is dissensus and the unveiling of that which 'dominant consensus tends to obscure' that is fomented (Mouffe in Seijdel 2008: 12) – being 'an invitation to political despair', it is in fact 'the starting point of a properly democratic politics' (Deutsche 1996: 274).

Richard Wentworth's late arrival on this day, Friday 29 June 2007, is perhaps perfect, then. Without realising it the urban theatre

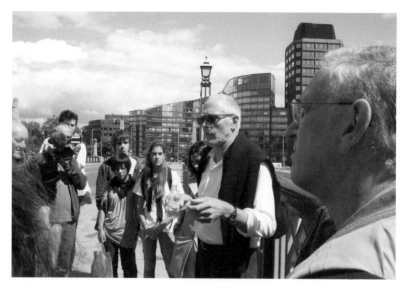

2. Walking with Richard Wentworth, Lambeth Bridge, London, 29 June 2007.

of happenstance and antagonism, in which we are all performers in some capacity, is already under way. The artist's delay, we are informed, is down to the discovery of two massive car bombs in the Piccadilly Circus/Haymarket area. A security cordon has been thrown around those sectors of the city and Wentworth, on his way from Oxford, cannot get through. As we find out, he has had to abandon his car and take the tube. Later, tumbling down the main steps of Tate Britain as we head first for Lambeth Bridge, the city is awash with the wail of sirens and clacking of helicopter rotor blades. A state of emergency. Chaos, disruption and, above all, *noise* accompany us all the way. The artist can barely make himself heard at times. One aside I manage to catch as we set off: 'everything you see and hear in the city is the consequence of a decision. Cities are made by humans, every bit'.

And, I would suggest, *unmade*. The consequences of two massive car bomb blasts around London's Piccadilly Circus – placed deliberately around busy clubbing venues and timed to detonate as these emptied – would, of course, have been devastating. Is this part of the

'performance of agonistic pluralism' or 'necessary disorder' – or its inevitable consequence – which ought therefore to be permitted a time and a place? Commonly, terrorism is held to obliterate the possibility of due democratic process. Politicians invariably refuse any form of negotiation with its protagonists – at least openly – whilst debate is not what the latter would appear to be seeking either (for different reasons). In his recent history of the car bomb, *Buda's Wagon* (2008), the renowned urbanist Mike Davis refers, in the word of one reviewer, to the 'unanswerable weapon' that 'gives claws to the weak' (Rule 2008: 13). Whilst that might point towards the underhand bullying tactics of the coward – often the view proffered of the terrorist's actions – for John Berger, for instance, it signifies the last desperate resort of the excluded and disfranchised: 'a way of making sense of and thus transcending despair' (2001: 7). In other words, it is an example perhaps of what can eventually happen when difference is not admitted to the social space of democratic engagement. Who or what carries responsibility for the terms by which that exclusion takes place is a far more complex matter, though, for it would be too easy *simply* to point to a failure of western neoliberal or conservative democracies. By the same token who exactly 'the excluded' represent is similarly moot. As Caroline Kennedy-Pipe, one of the UK's leading researchers into the use of so-called 'improvised explosive devices' (IEDs), regrets, there is no watertight, explanatory profile for the actions of such terrorists: 'Their motivations are not always clear, it seems to me' (in Arnott 2008: 9). It has emerged subsequently, of course, that the two failed Piccadilly bombers, who were also involved in an attempted bombing at Glasgow Airport the very next day, were, respectively, a doctor with a responsible hospital job in the UK and a doctoral student in engineering. Hardly obvious members of a disfranchised community you would think, though they themselves may well have seen their role to be that of an 'active intelligentsia': vanguard representatives of an oppressed people.

Further on in the walk, on Borough Road, Wentworth is talking on his mobile phone. It seems oddly inappropriate. Not just because

he is mid-performance, as it were, but because shortly before he has confessed rather proudly to his lack of conversance with modern information and communications technology. This whilst licking his lips over the look and feel of an 'old-style' Royal Mail pillar box, one of those double-barrelled ones with two slits, 'usually manufactured in Glasgow', as he claims. A champion of the tactile and material, you might say, of the textured, *physical* interconnectivity of things and people. The entire time-lagged ritual of writing and posting a letter from A to B doubtless has a pleasing, cause and effect tangibility to it which the instantaneous, barely perceptible and eminently delete-able electronic communication of super-modernity simply lacks. This may make Wentworth sound quaint and nostalgic, but it is not pain or mourning that he expresses. Instead, it is a fascination with the way the configuration of 'things' carries the potential to produce narratives. As we stop at some wrought iron bollards, he explains that they are made from war detritus: old cannons to be precise. They're probably not more efficient than the 'cheaper offspring' he compares them to – 'basically metal tubes filled with concrete' – but certainly more interesting in the manner in which they embody and tell of the city's (imperial) past. But it is, above all, the unorthodox interdependency of *things*, incorporating the mundane and the 'grandiose', to which Wentworth wishes to draw attention:

I grew up in a world held together with string and brown paper and sealing wax, and that's how it was. I slowly realised that this is the underlying condition of the world, and there's nothing I like more than when, for example, there's been a near disaster at NASA and they say: 'If it hadn't been for the chewing gum . . . '. It's not because I want to fetishise chewing gum or the aesthetics of gum pressed over some break or membrane; it's because we have the intelligence to think: 'Hey, there's a malleable, mastic material and we can use that'.

(in Johnstone 2008: 213)

As I spy Wentworth up ahead, conducting his call, I want to catch up with him and ask about his take on mobile phone culture: its decisive – often irritating – effect on public behaviour and movement on the street. Surely it goes against the grain of 'spontaneous interfacing' between human beings, as well as the pedestrian's attentiveness to detail, that he would seek out in the city, displacing people, as it does, into an antisocial 'bubble of obliviousness'. As things go I never get the opportunity to put it to him. On reflection, though, these 'walking conversations with absent people' he conducts might, alternatively, be viewed as wholly consistent with his overall practice: unrehearsed street scenes, enacted, whether as recipient or instigator of a call, on impulse, and conveying a fragmentary snippet of everyday urban lives. The antisocial, unwanted incursion it might represent to the non-participating witness – through the banality of overheard information, the self-important tone of the too-loud voice, or the self-absorbed lack of awareness of the proxemics of public space – might be said to correspond, moreover, to that sense of 'necessary adversity': of dealing with the disruptive challenges of the modern quotidian city as a way of affirming your state of being alive. Whimsically perhaps, I am more inclined to suggest we are dealing here with a milder, unthinking form, paradoxically, of 'unanswerable weapon', depending naturally on how the user conducts him or herself. For, as with the terrorist, the distracted state of the mobile phone user precludes any possibility of *immanent* social interaction. It is one way – and CCTV surveillance is another – in which technology has 'selfishly' redirected, if not stolen, the attentive, responsible, even antagonistic, gaze in public space: Virilio's perception of 'vision being given to the machine' that was mentioned in Chapter 1. Interestingly, for Wentworth – in another throwaway sound bite – texting is the revolutionary communications tool *par excellence* since no-one predicted its extraordinary popularity. This 'mobile writing', these 'foot-notes', truly came from no-where, he says. As we round the last corner of our walk, we arrive at the ignored backside of

Tate Modern. In the middle of this broad expanse of 'grassland in waiting', like a piece of contemporary public art or a 'living icon for our times' that the museum's curators forgot to site out front, squats the solitary figure of a young woman utterly absorbed in a texting trance.

FOOTPRINTS

The last time bombs failed to go off in central London was a little less than two years before the occasion of Wentworth's Tate to Tate excursion. On 21 July 2005, to be precise. At 1.47pm on that day Francis Alÿs overheard the following half of a mobile phone call on Oxford Street:

> Everyone's really mad . . . What direction is Covent Garden? . . .
> I'm calling just to check that you are . . . I could do with the
> exercise . . . Excuse me do you know the way to (unintelligi-
> ble) . . . You can go by the park but . . . Heard about the bomb-
> ings? . . . There is a hell of a hell of a lot of people on the
> street and they are . . . I think that station has been shut . . .
> How many bombs again? . . . Summer is here . . . Mais non, pas
> maintenant . . . I'm sorry I wasn't myself . . . Where is (unintel-
> ligible) . . . No, that was a helicopter but . . . No, I enjoy the
> walking . . . I think that it's that way . . .
>
> (Alÿs 2005: 136)

Alÿs includes this 'mobile writing' in a so-called 'personal repertoire of possible behaviour while walking the streets of London Town'. It forms the final section of the publication, *Seven Walks*, which doc-uments a major 'London project' commissioned by Artangel and is made up of a range of discrete if thematically linked 'takes' on the city. Walks as takes. One of Alÿs's 'possible behaviours' is predi-cated on a form of thesaurus entry of the infinitive 'to take', typed

out as a column on what appears to be an 'old-style' manual type-writer. In full it incorporates: '- to collect, - to steal, - to name, - to document, - to attract, - to look, - to ask, - to beg, - to appropriate, - to kill, - to subtract, - to assimilate, - to absorb, - to catch, - to consume, - to learn, - to erase, - to remember, - to touch, - to break' (132). One of several such synonymic entries, the 'repertoire' as a whole is indicative of a significant breadth of possibility when it comes to walking in the city. Even where the activity involves an urban fox as protagonist, meandering through the rooms of one of London's most prestigious museums – in the example we have already encountered – it is still essentially walking that underpins Alÿs's artworks. Either his own walking, or walks prescribed by him for others to follow, or the observation of habits of walking in urban space. Thus, where Wentworth takes you for a walk, and 'talks that walk', Alÿs tends to provide – with a nod to the practices of Fluxus and Happenings – templates or 'recipes' for walks or walking 'actions' – sometimes involving the mobilisation of considerable numbers of participants – in which certain narratives, formations or rhythms emerge. This can be as 'straightforward', for example, as the artist pushing – over the course of a day – a large, heavy oblong of ice through the streets of Mexico City where he has lived for many years, though he is Belgian by birth. By the end of this event he is left dribbling an ice cube with his feet, until it eventually melts into a puddle on the pavement, to the amusement of some neighbourhood kids. Effectively, the first part of a work entitled *Paradox of Praxis* (1997) – presented as a video – it represents the enactment of the subsidiary statement 'sometimes making/doing something leads to nothing'. The antithesis of this, 'sometimes making/doing nothing leads to something', informs the second part, which is seen by the artist as an 'ongoing' project. Originally the latter showed Alÿs in a public square, peering fixedly at a point in the sky. As passers-by began to take an interest, wondering what he was looking at and vainly searching the skies themselves, the artist slipped away. Creating smoke without fire might be another way of putting it.

Alÿs himself has identified the 'ongoing' principle of 'nothingness to somethingness' in the second part of the work as applying also to the *Guards* film for his London project (2005). In this, 64 marching Coldstream Guards – real ones with rifles, not actors – gradually begin, having set out on their own, to locate one another on the streets of the financial City district of central London. Forming themselves first into sub-clusters, then into an entire company, they are channelled finally on to Southwark Bridge where the strict grid formation disperses once more. Rosalind Krauss begins her celebrated critique of 'modernist myths' in avant-garde art with an analysis of the ubiquity of grids. For her the emergence of the grid formation in the twentieth century 'announces, among other things, modern art's will to silence, its hostility to literature, to narrative, to discourse. [. . .] The relationships in the aesthetic field are shown by the grid to be in a world apart and, with respect to natural objects, to be both prior and final. The grid declares the space of art to be at once autonomous and autotelic' (1986: 9–10). Arguably, Alÿs is engaging, in both parts of *Paradox of Praxis*, with modernism's myths via the dissolutive tactics of movement and performance. Part of that which helps the work towards realising the paradoxical claims of its title may be that it is simultaneously homage and critique. Thus, in *Guards* the form of modern art's grid is adopted, representing the 'end' of this particular 'making' or 'doing', but in activated form. Where the grid's will may be to silence, Alÿs's version *arises* from 'nothingness' and, moreover, introduces a kind of temporary narrative into the city. Not only is the grid produced and presented on the streets, as opposed to the studio and gallery, but it also ultimately undoes itself again (though it may have the potential to re-form). As such claims to a discrete space of art and 'finality of objecthood' are displaced into a performance that is both elusive and ephemeral as well as contingent upon the context of the city (or, in this case, the City).

Alÿs himself has identified the large-size block of ice in Mexico City as a 'coming to terms with certain sculptural forms, like minimalism' (2005: 30). Setting out with the 'perfect minimalist

cube', Alÿs's act of 'making/doing', requiring maximum physical effort, paradoxically leads 'no-where', an exercise in Sisyphusian futility. Quite apart from performing the allegory of the human condition evoked by that particular myth, it is also re-enacting, as Saul Anton suggests, 'the reduction of the art to the object, but reminding us that a block of ice is only frozen water, something that lacks fixed form' (2003: 36). Again, the implied act of dissolution – between something and nothing – opens up a narrative space of performance, beyond the object itself. The kids' playful reaction to the 'sad puddle' at the film's close – an audience's final verdict – signifies both the end of the object and the point at which minimalism's desire to draw attention to the 'space around the object', including the witness's 'own effort "to locate, to place" the work', is made clear (Kaye 2000: 2). Importantly, then, the urban space of praxis (or movement) that is emphasised here, between nothingness and somethingness (and vice versa), represents, as Anton proposes, 'a void between two things in which art becomes possible, and it must be marked each time, for it is what art "is", a mere "nothing" that isn't nothing since it happens' (2003: 37).

The nothingness of art that 'happens' urges us, then, to take 'one more step [. . .] in the direction of meaning' (37). In the same elemental way that water is transformed from frozen to liquid and evaporated states, so empires built by human beings turn metaphorically to sand. And such transitions only come about via enormous expenditures of energy, of mobilised *labour* (relative, naturally, to their scale). The unlikely sight of Coldstream Guards being let loose on the streets of London's financial district not only required an inordinate degree of planning and coordination in order to bring about the event itself but, in doing so, formally replicated the implied 'seismic dislodging' of the hardened vestiges of a certain British institutionalism: these lost souls, anachronistic, caricatured guardians – who would ever trust one of them actually to fire one of their rifles? – of a post-Empire, postcard condition (malaise, if you will), desperately searching for a home, a place, a formation that would make sense to them, within

the very labyrinth of the City whose wealth has been built upon the exploitations and plundering of imperialism and colonialism. And, perhaps irony of ironies, the documentation of this event, deliberately captured from several CCTV vantage points – though not in the end able to make use of actual CCTV footage as had been intended – produces a narrative of 'panoptic state security' in this most-surveilled nation on earth, recording a 'perfect crime' of entropy: a last gasp of aristocracy and empire that finally expires on Southwark Bridge.

The supposed displacement of modernism toward the space of social discourse that is the street is perhaps most clearly performed by Alÿs's 2002 New York City work, *The Modern Procession*. In some respects it prefigures the symbolism of Wentworth's collective London walk between the two institutional art houses that are the Tates Britain and Modern. But where Wentworth's critical impulse may be said to have consciously deflected attention away from the official 'art of the house' exclusively toward the spatio-temporal, everyday one of the street, Alÿs opted effectively to take the art with him. (And when I say 'take', I am mindful of the possibility that any one of his listed synonyms for that verb may apply.)

Proposed by the artist to mark the Museum of Modern Art's (MoMA) temporary decampment in 2002 to the city's borough of Queens whilst its central, Manhattan base was renovated and re-configured, *The Modern Procession* paraded replicas of iconic modernist artworks through the streets and across Queensboro Bridge to the museum's interim home. Incorporating a Peruvian brass band, a riderless horse, a motley collection of 'friends and acquaintances' (Alÿs himself adopted a low-profile role on the fringes of the procession), as well as four formal teams of palanquin-bearers, the works on display represented versions of Picasso's *Demoiselles D'Avignon*, Giacometti's *Standing Woman*, Duchamp's *Bicycle Wheel* and a so-called 'living icon', the well-known New York performance artist Kiki Smith. Under police escort the procession took three hours of a sunny Sunday morning in June to meander its way from MoMA across the 'boundary' of the East River to 'another borough'.

Originally, Alÿs had requested to use the actual artworks them-
selves, but MoMA had considered the risk too great for reasons of
insurance and potential damage. Rather than pressing the issue to
make a point, Alÿs actually ended up embracing the use of replicas
since he found out that the religious icons paraded in the popular
Latin American street processions, on which his conceit was based,
were in any case customarily idolatory 'substitutes': referred to, in fact,
as 'little brothers' or 'ambassadors'. In a sense, then, using 'versions' –
which is what these were in actual fact, since they were deliberately *not*
'the real thing' in size, for instance, or in the materials of which they
were made – served to superimpose rituals of artistic and religious
veneration, questioning, for example, the place of the 'sacrosanct' in
modern art as well as what distinctions between 'idols' and 'icons'
might be (Alÿs 2004: 84–6).

The longer one contemplates *The Modern Procession*, the more
layers of potential significance begin to emerge, and the dedication
to this one event of a whole comprehensive publication, with a wide
range of contributors, including the artist himself, is perhaps testa-
ment to its complexity.[9] For my purposes I would wish to point to the
central, recurring engagement with functions of modern art. Whereas
works by Alÿs discussed above *imply* such a move, here it could not
be more explicit. Although MoMA encouraged and part-sponsored
The Modern Procession (along with New York's Public Art Fund), the
purpose of the event was evidently to challenge that institution's very
raison d'être as a collector and keeper of the 'most important works of
modern art'. In short the basic question being posed to MoMA was:
how contemporary is modern? By its own definition the museum
identified itself as a guardian of the modern classic's unique aura and
autonomy. Thus, as Tom Eccles reports, while the museum wished
to commission – via its so-called Projects Committee – contemporary
works from living artists, 'it would not commission works that re-
presented or reinterpreted works within its collection' (in Alÿs 2004:
14), believing itself to have a responsibility 'to act as a protective force
on behalf of the original work' (82).

As ever Alÿs was operating between homage (even pilgrimage in this case) and critique. His approach, as artist, was not antagonistic as such, but by holding in tension these opposing positions, the *situation* itself began to reveal 'some things'. As Robert Storr, a senior curator at MoMA at the time, outlines, the museum was effectively already 'in crisis', conducting debates with itself over its policies and practices. Specifically, these related to the restriction of its responsibility to the preserving of an agreed canon of great modern art, which would draw a line at the advent of postmodernism, as against a contemporary approach which would 'reclaim the participation of the audience on the grounds that they and the curator are engaged in an immediate response to something that is happening right in front of everybody, for which different angles of interpretation and types of presentation will and should follow' (96). Alÿs's mobilisation of icons – frozen like blocks of ice within the institution – literally took modernism into the streets (to let Hall's phrase reverberate once again). In effect it seized the moment of MoMA's in-between state prior to its projected relaunch – in terms of both *location* and *policy* – to raise questions about what kind of MoMA it eventually wished to come home to. As Storr puts it with regard to policy, the choice lay 'between documenting a history and actually participating as an institution in that history' (90). Whilst an icon (or should that be idol?) of the New York art world (Kiki Smith) served as an emblem of necessary, 'embodied liveness' – which also highlighted MoMA's lack of engagement with the performative turn in contemporary art of the last half century – the processional 'montage' of images in the street invoked an art of that which Nicolas Bourriaud has theorised as 'postproduction', involving artworks made on the basis of pre-existing ones:

> [A]rtists' intuitive relationship with art history is now going beyond what we call 'the art of appropriation', which naturally infers an ideology of ownership, and moving toward a culture of the use of forms, a culture of constant activity of signs based on a collective ideal: sharing. The Museum like the City itself

constitute a catalogue of forms, postures, and images for artists – collective equipment that everyone is in a position to use, not in order to be subjected to their authority but as tools to probe the contemporary world.

(2002b: 9)

The city emerges, then, as the province within which the possibilities of art in the 'real world' are interrogated via a form of 'migration'. Not only is Manhattan's renowned modernist grid system temporarily 'undone', subject to the shambling disruption of a carnivalesque, traffic-stopping procession, but this act of marking out a transgressive 'route into temporary exile' from one upmarket district to what Alÿs discerned to be 'commonly perceived' as its downmarket periphery, simultaneously draws out discrepancies of access and privilege – amounting to the predominant centralisation of power and control – that do not restrict themselves to the domain of art.

RosaLee Goldberg points to the fact that Alÿs originally practised as an architect within urban planning projects. This is actually what first took him to Mexico City. A research exercise conducted in this capacity, involving the photographing of street installations and urban squats, ended up unexpectedly with a public exhibition, marking the moment at which he made the transition to becoming an artist. For Alÿs the practice of art held distinct advantages:

The freedom in the art field is enormous. You can act quickly, which is impossible in the heavy architecture-machine, and even less so in the bureaucratic urbanist system. You can improvise on the spot and invent guerrilla tactics as you go and still maintain relative control of the process, or at least a certain integrity with the original intention.

(Alÿs 2004: 101)

Whilst Alÿs tells Goldberg that he has 'in a way maintained the methods of my architecture days' (101), it is important to identify the shift of mode in operation. Effectively, it is from the fixed *footprints*

of buildings (or the built environment) to those made by human beings, which produce, as de Certeau has famously suggested of the paths taken by pedestrians in the city, 'unrecognised poems' (1988: 93). Both sets of footprints involve the laying down of certain markers, but the latter is premised crucially on a spatio-temporality that incorporates spontaneity, unpredictability, elusiveness and ephemerality. In general terms, though, it is movement in (urban) space that makes the difference, implying a form of ongoing displacement. But whilst all of these 'unstable' properties just listed may be in play, they are counterweighed by a simultaneous 'will to form' that recognises rhythms, patterns and narrative tracks. In this itinerant space between two points or *conditions*, things happen and things change, and they never really end or complete themselves. So whilst point B of any given walk may be reached – MoMA Queens, a puddle on the pavement, Southwark Bridge – foot*prints* remain as the tale of that which has taken place: rumours or urban myths that continue to abound and reverberate, and that also, in their own way, *build the city*. And *unbuild* it.

This kind of temporal writing or implicit marking out of public space is perhaps best exemplified by Alÿs's 12-hour film *Zócalo* (1999), which is set in Mexico City's eponymous main square: the 'nerve centre of the capital' that has served frequently as the artist's 'theatre of operations', not least since he lives close by (in Grand 2001: 16). Between sunrise and sunset the film documents the movement of citizens in relation to the tall flagpole at the heart of the *Zócalo*, which is constituted of a vast paved terrain, flanked by government, civic and commercial buildings. It begins with the ceremonious raising of an enormous red flag and ends with the descent of this national emblem as dusk falls. The film observes, from a fixed camera angle, how pedestrians in the *Zócalo* make use of the long, straight shadow cast by the flagpole as a form of shelter from an unforgiving sun, where none is offered elsewhere in this massive square. So, an ever-shifting, single-file line of shade-seekers effectively gives human form to the 'hand' of this accidental 'sun-dial' as it gradually creeps its way round

the square over the course of a day. This 'place of sanctuary' produces a kind of 'irregular order' – a temporary stillness – amidst the random criss-crossings of pedestrians occurring in the rest of the *Zócalo*. For Jessica Morgan 'the shadowy figures have intuitively created a place out of something as ephemeral as the absence of light, rather than the substance of architecture. This occupation, however fragmented, suggests a kind of affirmation, recalling the public purpose of the site' (Morgan 2004: 15). Paradoxically, then, this 'national monument', which seeks to assert its dominance over the square day after day, majestically demanding from its 'subjects' attendant values of patriotic allegiance and unity, is turned implicitly into a ritualised 'people's monument' in which the flagpole is still of central importance, still 'venerated' in a sense, but for its *decentred* shadow. As such, symbolic 'coveting' has been superseded by pragmatic need – an act of everyday displacement that would doubtless interest Richard Wentworth – producing a 'national narrative' that proposes a higher order of importance for the populace of its instinct as species to protect itself and survive, rather than genuflect reverently to imposed 'regimes' of nationhood.

MÜNSTER FOOTWORK

Three weeks after my London rendezvous with Richard Wentworth I find myself in the German city of Münster, which is hosting its fourth *Skulptur Projekte*. Taking place for the first time in 1977 it has been held every ten years since during the summer months, rapidly gaining a reputation as one of the most significant, if infrequent, international art world events. In fact, it came about to some extent as a form of sculptural counterpoint to the quinquennial *Documenta* held in Kassel – not a million miles away – coinciding now with every second staging of this major exhibition, which seeks to give curatorial impetus to the 'global direction of art'.[10] But if *Documenta* asserts a position of international influence, it clearly does so for the most part

3. George Rickey, *Drei Rotierende Quadrate,* Münster, 19 July 1975.

from within the exclusive, institutional confines of the art museum. *Skulptur Projekte,* on the other hand, presupposes the commissioning and siting all over the city of artworks from a range of renowned and emerging artists. So, whilst the curatorial aim is still to claim international art world importance, it is also broadly to open out and engage the city of Münster as a whole in an experience of art. Initially involving but a handful of artists – amongst others from 1977: Donald Judd, Claes Oldenburg and Joseph Beuys – the decennial class of 2007 totalled 33. In addition, many commissions from previous decades were still in place, and were therefore incorporated into the official mapping of this latest event. Münster boasts a rash of public art, then, an occurrence made all the more extraordinary given that a further impulse for the *Skulptur Projekte* when it was first launched was the attempt to prove the value of such art after deep-seated public resistance to the siting in the city of a George Rickey kinetic sculpture in 1975 (which is, in fact, still very much there).

In 2007, one piece, entitled *A Münster Novel,* by the French artist Dominique Gonzalez-Foerster, has actually choreographed a

4. Dominique Gonzalez-Foerster, *A Münster Novel*, Münster, 20 July 2007.

kind of *Skulptur Projekte Münster in toto* (1977–2007): a miniature theme-park or 'open zoo' of previous artworks, scaled down 1:4 in size – one for each decade perhaps – and arranged around a shallow, amphitheatrical grass clearing by the old city wall on the south side of Münster. Effectively a three-dimensional mapping, the work embodies imperatives of both relationality and postproduction – to plunder terms from Bourriaud (2002a and 2002b) – that might be said to hold for the *Projekte* as a whole. The plot of this Münster novel unfolds not only between present and past – the miniature toy-like forms evoking a sense of 'remembered playthings' – but also between individual sculptures, implying not least the necessary movement or active engagement of a walking spectator. Or 'reader'. As the artist says in her proposal: 'visitors will be able to go from one sculpture to another without having to wait ten years or walk for kilometres, just like in a novel' (in Franzen 2007: 105).

Arguably, the artwork that truly recounts the continuing story of *Skulptur Projekte Münster* (1977–2007), though, is Michael Asher's *Installation Münster (Caravan)*. Shown at the very first event and

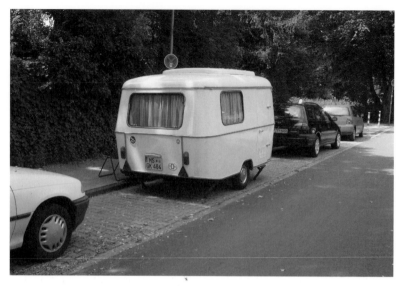

5. Michael Asher, *Installation Münster (Caravan)*, Münster, 21 July 2007.

subsequently recommissioned each time with the exact same proposal, it involves the parking of a small caravan in a series of changing locations around the city. Meant, according to Kasper König, as 'a metaphor for a city undergoing change' in its first incarnation, it is the fact of its repeated appearances from decade to decade that now would seem to perform this metaphor (in Seijdel 2008: 86). Paradoxically, however, one might argue that its repetition – the deliberate replication of the exact same proposal – condemns it to perform an 'eternal return of the same' that is the antithesis of change. Another form of continuing or, in fact, as-yet-untold storytelling is Jeremy Deller's 2007 'sculpture project' *Speak to the earth and it will tell you*. Concerned with the highly organised and widespread phenomenon of allotment associations in Germany, Deller has initiated a work that will only come to fruition at the *next Skulptur Projekte* in 2017, assuming there is one. Interested in the synergy between the cyclical nature of the event itself and the seasonal one of these small-scale 'urban paradises', Deller has persuaded the 54 associations in Münster to maintain a form of 'living archive' or 'urban natural history in the making':

Each association is given a diary into which they are to en-
ter notes and observations concerning the seasonal variations
of flora and fauna, such as seed and flowering times, the
appearances of insect types, and bird migrations. In this way
Deller links in to the long tradition of recording and observing
specimens in botany. The empirical data gathered by the gar-
deners are to be documented and private observations collected.
Over the course of the coming years the diaries will become ref-
erence works on life in Münster's garden allotments. In 2017,
all the diaries and records will be collected centrally and made
accessible in the form of an archive.

(in Franzen 2007: 62)

The conversation effected with modern (art) history by all of
these pieces in varying ways is intriguing, amongst other things, for
the way it throws into sharp relief how the notion of public sculpture
has evolved. In truth, Münster's decennial *Skulptur Projekte* has long
outgrown the assumptions of its founding title: most of the city-wide
works on display in 2007 are not sculptures by any stretch of the

6. Donald Judd, *Untitled* (1977), Münster, 20 July 2007.

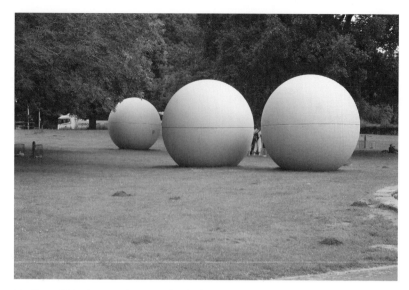

7. Claes Oldenburg, *Giant Pool Balls* (1977), Münster, 20 July 2007.

imagination but installations – sometimes involving film, as we shall see – or participatory events. As Gustav Metzger, one of the contributors in 2007, replied upon being asked whether he thought of his work as sculpture: "Not really. However, in my installations I usually work in three dimensions" (in Franzen 2007: 150).

As for those artworks still in place from previous decades, what may have begun life as a sculpture in the twentieth century can frequently be seen to have transmuted into a time-based installation in the twenty-first. These works bear the traces not only of 'natural history' – the unchecked encroachment of foliage and weeds – but also 'human use' in the hackneyed form of graffiti or the blackened remains of camp fire vigils, for example. Unavoidably, they tell the story of their lives as changing entities within the city of Münster, as much as they might evoke a particular aesthetic or spatial engagement with the urban landscape. These works have thus become what they are accidentally over time, in impromptu dialogues with 'unfolding circumstances'. In 2007 an acute awareness of this state of affairs plays itself out in two main ways. First, in a self-conscious identification, as

WALKING WITH WENTWORTH ET AL. 81

central theme, of the nature of the relationship with works of the past (as we have seen with *A Münster Novel*), a move rendered all the more resonant for the fact that the medieval city of Münster was flattened in the Second World War and, as is common historicist practice in Germany, restored brick by brick to its former state. Second – and more pertinent to my purposes – is the implicit enshrinement of a situational-relational or *participatory* paradigm of encounter with the various works displayed. That is, the *Skulptur Projekte* as a whole can be said to *work* not only by establishing a multiplicity of conversations between sited installations and their immediate urban surroundings but also by proposing that they may speak with one another 'across town' as well as across time. To this end the spectator – in this case: me, walking, as it were, with the spectres of Wentworth and Alÿs hovering over my shoulder – facilitates or institutes potential linkages. *Walking* thus becomes a form of seeing or mobile 'note-taking' (in the sense of 'taking note'): an active realisation of associations as well as disjunctions.

We have witnessed both Wentworth and Alÿs developing specific relationships between the art house and the street. The former's Tate to Tate walk *was* the artwork, composing itself as that in part through its deliberate refusal of the 'shelter' of a formal 'home of art'. Thus, the museum buildings themselves merely served as points of departure and arrival, meeting and dispersal. At the same time, however, this uncoupling can be said to have been dependent precisely on the art houses in question in order to have come about in the first place. In other words, it could only exist by defining its difference as a state of temporary in-between-ness. So, the walk-as-artwork is asserting its desire to be both independent of and recognised by the institution. Whilst Alÿs's *Modern Procession* was also a refusal of sorts, it sought simultaneously to commemorate the time-distance between the art house's exile and return, as if to ask: (how) will you be changed whilst you are away? The *Skulptur Projekte Münster*, by contrast, turns the entire city into the art house itself. Unlike the discrete museum, the artworks on display 'contend' in a very direct way with the city itself.

They also contend with one another; to a degree all these works are implicitly defined, via the common space of the city, by their relationship to each other. And it is the linking, thinking figure of the spectator on foot on whom the onus is placed to perform this process of 'cross-pollination'.

As it happens, being conceived and contained concentrically, being also cowpat flat, and boasting a dense university population, Münster is first and foremost *cycle*-city. *Projekte* visitors are encouraged to avail themselves of hire-bikes or to join one of the official guided bike tours to reach the various sites, and many do just that. Most artworks are indeed to be located within a form of 'inner circle' whose boundary is demarcated by the *Promenade*, a tree-lined cyclists' paradise that traces the contours of the old city wall. But there are also several to be found beyond the centre, predominantly to the west of the city in the parkland around the proportionally vast Lake Aa (or Aasee).

One artwork, Guy Ben-Ner's *I'd give it to you if I could, but I borrowed it* – a line lifted from the 1967 Syd Barrett-penned Pink Floyd song *Bike* – is, as its title suggests – both in being borrowed itself and being about being borrowed – a piece concerned with referencing: referencing art history, popular culture and the city of Münster, all in specific relation to the bicycle. Ironically, the bicycles concerned in the first instance are of the sort that isn't going anywhere. Visitors are invited to clamber on to one of three workout bikes situated in a replica fitness centre – complete with banal city vista – which turns out, in fact, to form part of the local tax office. As their feet begin pedalling, they realise their 'work' activates a film on a flat screen attached to the handlebars. Not only that, the cyclist controls the speed at which the film runs. (It can even go backwards.)

The film itself tells another Münster tale, one involving the artist and his two kids plundering 'the museum' of certain iconic ready-mades that happen to incorporate bike parts: Picasso's *Bull's Head* (saddle), Duchamp's *Bicycle Wheel on a Stool*, Tinguely's *Cyclograveur* (frame and wheel) and Beuys's *Zerstörte Batterie* (which yields

a pump). Assembling a reconstituted bike from these parts, the three 'bicycle thieves' ride through the city, occasionally bumping into sited *Projekte* sculptures from previous years. As with Gonzalez-Foerster's piece, then, a tongue-in-cheek, 'postproductive' relationship with recent art history is invoked – which, intriguingly, also recycles the Duchampian bicycle wheel, as Francis Alÿs did in *The Modern Procession* – witnessing the reversal of modernism's framing of the *objet trouvé* as art. Here, the functional-object-rendered-useless by just such a 'plundering' is effectively rescued and restored – like the magnanimous angler's returning to the river of the not-quite-dead fish – to its 'rightful place', which is on the street. So, one might say it represents a well-meant stealing *back*, which is essentially for the good of the public at large. In fact, though, it is not merely a return but a repositioning of the *object* of art (as in both artefact and purpose): the ready-made is restored to the everyday from whence it came, not only as the object it once was but also as the object that it has become in the meantime. In other words, it amounts to a translocation of art, akin to Alÿs's remobilisation of MoMA's icons. The coincidental, postproductive sharing here of *Bicycle Wheel* is particularly significant, of course, since Duchamp's work has performed precisely the historical journey from radical proposition – challenging the museum to reframe the everyday, common object as art – to sacrosanctification as institutional possession whose status must be preserved. Like the taxes 'borrowed' (or 'stolen') by the city or state authorities from its citizenry (apparently for the collective good of the latter) and utilised subsequently in ways that may not in fact be beneficial to the majority, Ben-Ner's installation enacts a form of reclaiming of public property on behalf of the public in the unlikely and arguably antagonistic 'public space' of the local tax office. Crucially, it is the cyclist-viewer, though paradoxically appearing to be 'going no-where', who not only 'performs' this institutional dismantling but also dictates the pace at which the energy required for this act is expended. In contrast to new-fangled path-finding devices such as GPS or satnav, machines that alleviate the individual's responsibility of *working out how to get*

somewhere, Ben-Ner's installation works off a premise of implicated endeavour. The emblem *par excellence* of popular transport within the city of Münster functions, then, as an active and metaphorical vehicle to undo sclerotic notions of where both art and its interlocutors should be seated, as well as raising questions about the extent to which the common good is truly enacted in public space.

If the cyclists' *Promenade* forms a warped ring around the kernel of the city, Mark Wallinger proposes a slightly enlarged circumscription in his work *Zone*. Depicted on the *Projekte* map as a perfect circle, five kilometres in circumference, this 'installation in the sky' is characterised, above all, (as it were) by its imperceptibility in practice. Supposedly, a cord passes several metres over our heads, building to building, but also, for instance, at some height over Lake Aa. Despite assiduously peering at the heavens here and at several other points along the marked circle – and, I have to say, no passers-by felt inclined to join me, as they did Francis Alÿs in *Paradox of Praxis* – I can only testify to its invisibility. The sole location at which I finally succeed in detecting the cord is in the University grounds around the Palace (*Schloss*) where it is suspended between trees. Even having established this segment, though, I quickly 'lose the thread' again. In a way it appears to me as if Wallinger is deliberately indulging in a game of tease the spectator. The demarcated ring is there for all to see on the map, suggesting, inasmuch as it encloses the bulk of the *Projekte* artworks, a kind of temporary, multifarious ludic zone: here you may play. At the same time the material work itself is elusive – its depiction on the map probably representing its most plastic manifestation, in fact – to the point of making you wonder whether the cord even exists as a complete encirclement. As such, a twofold status is proposed for *Zone*: first, as an imaginary, metaphysical boundary, there to be observed – in the dual sense of 'contemplated' and 'heeded' – 'in theory' by the initiated spectator, but also potentially transgressed; and, second, as the demarcation of a border whose purpose is to *facilitate* rather than prohibit. In fact, one of Wallinger's points of reference for *Zone* was the Talmudic *eruv*, which it is recommended 'should

be an integral part of the city and invisible to the untrained eye' (in Franzen 2007: 257). In concrete terms it 'refers to a fence – either real or symbolic – that surrounds a Jewish neighbourhood' (257). Within it certain prohibitions on public behaviour, imposed by the Sabbath, are cleverly circumvented by a 'creative interpretation', as the artist goes on to explain: 'This loophole allows for a designated public space to become domesticated by cord stretched as "lintels" above "doorways" into a communal home' (257). Wallinger contrasts the 'creative permissiveness' of the *eruv* with the 'coercive communality' of the *ghetto*, which is designed, consciously or unconsciously, precisely to contain freedom of movement. A further, related reference point for *Zone* is the concept of the *pale*, which is, in actuality, the stake that forms part of a perimeter fence. Historically, the term has been applied to describe 'the area that is enclosed and safe [and] accepted as "home"' (259), implying a zone in which the civilising powers that be exert control at the behest of a willing populace. Hence, to go 'beyond the pale' was not permissible and, as modern usage suggests, an intolerable and dangerous affront to obedient civic life.

It is surely no coincidence that Wallinger's Münster proposal was made round about the time that he was also preparing his London piece *State Britain* 2007.[11] In fact, Wallinger initially stumbled upon the *eruv* – an actual, operational one – within a Jewish community in a part of North West London. Subsequently, sliding down the map a little way into central London this improvised demarcation served as a resonant counterpoint to another kind of zone, an official, prohibitive one that had been decreed by the British government in 2005, namely the Serious Organised Crime and Police Act. This, as Wallinger explains, 'included the provision of an exclusion zone banning "unauthorised protest" within a 1 kilometre radius of the Houses of Parliament. [. . .] Within this zone the police have discretionary powers to arrest those who "disrupt the life of the community", however that may be defined' (257). The immediate target of Section 132 of this legislation was the 'dug-in' protestor Brian Haw. Since the UK government's decisions, first, to impose economic sanctions

on Iraq in 2001 and, second, to go to war in 2003, Haw had been assembling an ever-expanding, ramshackle campaigning installation of agit-prop placards and banners on the pavement opposite Parliament at the Palace of Westminster, over which he held vigil day and night. Finally, given permission to curtail Haw's unrelenting civil protest, the police radically reduced the artefacts of his Parliament Square encampment to an area measuring three by two metres on 23 May 2006. Working out that the circumference of the 1km exclusion zone ran right through Tate Britain, Wallinger resolved to reproduce Haw's installation precisely on this boundary line in the Duveen Galleries of the museum. As it happens, *State Britain 2007* was on display immediately beside the designated meeting-point for the start of Wentworth's Tate to Tate walk. His delay that Friday afternoon in late June 2007, owing to the discovery of the two car bombs, afforded me an unexpected extra half hour in which to contemplate Wallinger's re-creation. Whether or not the terrorists who parked the cars that day were aware of it themselves, the very same perimeter line stipulated by the new Act and highlighted at Tate Britain also ran right through the Piccadilly Circus/Haymarket area in which the bombs had failed to detonate earlier that day.

State Britain 2007 incorporates Tate Britain within both its title and its 'contested zone', thereby referring us back to questions raised already by both Wentworth and Alÿs in their critiques of the art house as institution. Although coincidental, the Tate is located tantalisingly on the edge, suggesting it is neither 'in' nor 'out' but in a position of *potential* as a museum of modern British art. (Cynically and flippantly, of course, you could say it was sitting on the fence.) More significantly, perhaps, *State Britain's* 'pale' also brings into play issues around the democratic practices of a nation right in the very seat of the (ancient, founding) institution that supposedly would exist to enact them: parliament. In his proposal notes for his Münster installation, Wallinger begins with a series of rhetorical questions posed to an imaginary audience. They appear to escalate into a form of manic, accusatory rant (worth reproducing in full here) in which

the word 'zone' takes on an Orwellian sinisterness in its constant repetition:

> What are you doing here? Do you know where you are? Are you inside or outside the zone? Are you inside the zone but wish to be outside? Are you on the outside looking in? Do you want to be on the inside? Are you prepared to say that you would rather be outside? Can you lose yourself in the zone? Is it possible to pass through the zone unnoticed? Do you belong in the zone? Do you believe in the zone? If you don't believe in the zone, what do you believe? Are you saying the zone doesn't exist? Do you mean to say you have never heard of the zone? Do you have permission for entry and exit to the zone? Do you know the rules? Have you any idea of the full extent of the zone? Are you a trespasser? Can you trespass unknowingly? Do you find the zone threatening, or do you find it a source of strength? Do you feel afraid?
> Do you comply?
> We comply.
>
> (257)

Evidently, then, the 'inside' that is the zone can be equated with those 'more or less coercive controlling powers' with which we may or may not believe we are compelled to acquiesce (257). In the case of *State Britain's* pale it is clear that the version of democracy now taking place within it cannot live with the notion of this public site performing contradictory meanings: of accommodating a necessary agonistic pluralism in the manner advocated by the likes of Mouffe and Deutsche. As such the positioning of the car bombs, those 'unanswerable weapons' of the supposedly disfranchised and excluded, on the perimeter of this 'totalising zone' is so very significant symbolically. Ultimately, of course, the question for the spectator is: where do you position yourself?

As we have seen, at Münster Wallinger's *Zone* paradoxically gives you licence to 'go beyond'. It is related to the threshold of the *eruv*,

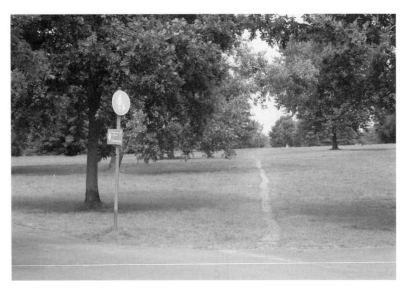

8. Pawel Althamer, *Path*, Münster, 20 July 2007.

merely a notional boundary, and one that suggests 'creative permissiveness'. In its own way, then, this 'urban lintel' directs one *away* from the city's centre – into the 'sublime wilds of the unknown' – to where, as it happens, several of the most intriguing installations are located.[12] Frequently, the appeal of these 'wayward works' is generated, first, by necessitating a questing journey on foot – which leads you gradually to become acquainted with the contours and textures of the wider cityscape – and, second, by the fact of them and you having more space to breathe.

The Polish artist Pawel Althamer's *Path* seems directly to pick up the baton of Wallinger's challenge to venture beyond the pale. Conceived supposedly according to the perception that the good (mainly Catholic) burghers of Münster have a rather pronounced habit of sticking to prescribed paths – on foot, by bike – in their quotidian use of public space, Althamer provides a specially prepared 'beaten track' out of town to take you, again paradoxically, *off* the beaten track. Originating in neatly kept parkland around Lake Aa, a narrow, rutted footpath, with the appearance of being a 'tactical short-cut', leads

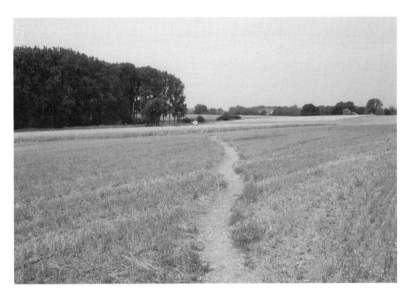

9. Pawel Althamer, *Path*, Münster, 20 July 2007.

off in a vaguely westerly direction. Barely drawing attention to itself as an artwork, there is nothing really, save plain old curiosity, urging me to follow it. In fact, my conditioned instincts as a visitor-tourist are the opposite, since nothing paves the way for what I may be in for: Where am I heading? How long will it take? What can I expect to take place? (You could say I leave point Aa without the slightest inkling of where point Bb might be.) As I am led further and further out of the city, the landscape, and therefore the complexion of the path, changes. I arrive at the side of a road where a yellow sign saying 'Münster' tells me this is the official perimeter of the city. Another zone I'm leaving behind, then. On the pavement opposite someone has parked a bike at the point where the path recommences. Not far off, amidst the knee-high stalks of the cornfield beyond, a solitary figure is approaching me. When we eventually pass by one another he mutters, '*Bonjour*'. I am taken aback, but my reflexes return the same greeting, for which I am glad. (How pompous it would have been to insist on German, or worse, English.) Has he come all the way from Belgium, or even France? Turning round a few moments

later, I glimpse him riding off on the bike. He is the only person I encounter as I keep walking: on and on in the sweltering midday sun, through long, lush grass, past the wind-rushed trees of a small wood, across a ramshackle wooden footbridge of rough planks and broken furniture, and over the low muddy humps of a tilled field. Finally, a 'T-junction': a gravelled tractor track at right angles to the path, flanked by a dense jungle of a tall crop I cannot identify. In case it is not obvious, a red and white striped warning tape strung across the point at which the path might have continued insists: no further. The choices are threefold: left, right or back were I came from. So, the adventure is not exactly over. And I must decide whether to raise the stakes for myself or continue by the same rules (in reverse).

If it wasn't already mine, the artwork – this path – has thereby been *given over* to me. A gift of sorts. If I wish, I may effectively restart the 'pilgrimage into the unknown', though, with no *necessary* end in sight this time, the dynamic would surely be altered. Turning back, on the other hand, would in the meantime be 'going over old ground'. Having ventured what I estimate to be about one and a half kilometres from the city's periphery, and being required at least to retrace those steps, I feel I've come as far as I would wish. I also sense that the palpable exhilaration I have experienced so far has been generated largely by always knowing there would have to be an ending of some kind, and wondering what or where it might be. (That and the fine sunny weather. A thunderstorm I experience in Münster city centre later that afternoon, in which I witness streets turned literally into rivers within the space of half an hour would probably have sent my spirits plunging in the opposite direction.) In other words, the work is dependent for its performance tension on imposing a spatial limit. It has its own 'pale'. Were you to break off your walk halfway, you might still glean something of the thrill at being led into the unknown through pleasant natural surroundings on the edge of a city, but you would miss out on the 'pay off'. This is not by any means the proverbial pot of gold at the end of the rainbow, but simply, though profoundly, the satisfaction of *believing*

in the inherent value of this walk-work, or of witnessing yourself *stick the course*: the reward for having taken the risk and trouble just to *see what happens*. In that respect *Path* counters precisely the banal instinct of the city centre pedestrian, either to go from A to B – usually for pragmatic reasons, and as speedily and efficiently as possible – or, conversely, to drift aimlessly in a form of consumer delirium. Here a route is offered *away* from such 'entrapped states', ultimately into an intensely pure 'communion with nature': a 'being-in-the-landscape'. It is rural land art, yet the experience of it remains stubbornly defined by its relationship with urbanity, by being deliberately not-urban. As it happens the countryside surrounding the city is literally called Münsterland, gesturing towards just such an interdependency. It is this environing land that permits you temporarily to turn your back on the claustrophobia of the city without entirely leaving it behind, not least since you are bound to return. By following the path you are implicitly 'reminded' how to walk and breathe, and led, perhaps, to 'find and compose yourself again' or simply *be*. As Ulmer points out, Lacan notes 'a knot in the conjugations of *suivre* (to follow) and *être* (to be), both conjugated in the first person singular as *suis*: "I follow/I am". This knot becomes entangled in another one, the plurality of *sens* – "sense", "meaning" and "direction"' (Ulmer 1989: 168).[13] Perhaps it makes complete sense, then, that the only 'other' I encountered on this path hailed me in French (and I reciprocated).

Münsterlands is, as it happens, the title of another *Skulptur Projekte* piece. As I make my way back along Althamer's path I'm reminded of this work by the French artist Valérie Jouve, because it also involves walking towards the city. A film shows three strangers from France – but not the man who greeted me – arriving separately by diverse means of transport (barge, train and car) somewhere in the countryside on the fringes of Münster. From these drop-off points they steadily pick their individual ways on foot towards the centre of a city to which they have never been. Rather than facilitating escape the Münster land – what the Germans refer to as *Vorstadt* or 'pre-city' – here prepares the ground for these outsiders' respective

entries into 'the zone'. Structurally, the film inter-cuts the footage of their separate 'ways of approaching an unknown city', but their narrative paths never cross. Apart from the landscape itself, which gradually grows suburban, then urban, the focal point is provided by a fourth 'outsider', Andreas, whom Jouve encountered by chance as she was conducting in situ research for the film in Münster. Not an actor at all, he is a kind of 'stranger in his home town', who has effectively turned urban walking into a way of life. Or a means to survive. The modern-day western world's tamed incarnation of the hunter-gatherer, this slightly geeky-looking, youngish man makes a living tramping the streets of this genteel city, poking around in public bins for discarded glass bottles whose deposit – worth perhaps ten cent – he can claim from the supermarket. Though looking like any other 'normal citizen', his behaviour is clearly beyond the pale, figuratively speaking. In reality it is within it. More accurately perhaps it is that he hovers on its fringes, drifting in and out of 'respectability'. Though a nomad of sorts, he is not exactly homeless. He lives, in fact, in a pedestrian underpass at Hindenburg Platz, below the city centre's inner ring-road (a short hop from the Palace gardens where I succeeded in locating Wallinger's perimeter cord). Symbolically, it is the perfect dwelling-place for him: where members of the 're-spectable' commuting public hastily *pass through*, to and from their suburban homes, this itinerant comes to rest. It is also where Jouve's film effectively winds up, in two senses: on screen Andreas is seen arriving 'home', having hooked up with one of the French visitors; and, in reality, the underpass is where the film is projected to its audience. We view the film sitting sideways on in a couple of short rows of rickety old cinema seats.

As I watch the film in this slightly draughty, unlit tunnel with a mere handful of others, I gradually become aware of someone rummaging around in a 'chamber' next to the screen. A faint light escapes through a gap below the doorsill, which is raised approximately 20 centimetres off the floor. Having arrived earlier, the others in the audience complete their viewing of the loop before the actual end of

the film and gradually steal away, leaving me on my own in the dark. All of a sudden the door opens and a figure emerges, exiting the subway up one of the sets of stairs. Same woollen hat, same two-tone anorak: it is Andreas, as if he had just walked straight out of the film. Five minutes later he is back, carrying a carton of milk, and disappears once more into his chamber. There is more rummaging. I realise this is not some kind of contrived part of a performance, a staged surprise for this privileged audience of one. Except to a certain extent it is exactly that, because it brings sharply into focus the fact that the performance of the film *is* the performance of his life. Unlike the other 'characters', who do not *act* as such but who are nevertheless evidently engaged in the playing out of an 'exercise' – which is over now – what you see in the film is just what Andreas does and is still doing. When the film ends, he re-emerges from his bunker, slips unobtrusively round the back of the seating, and resets the DVD. So, he is the projectionist of his life, too, and we have been sitting in his living room watching a home movie of his itinerant life.[14]

I'm also thinking, as I approach the beginning-end of Althamer's path, how if I'd decided to carry on back there in that vaguely westerly direction, I may eventually have found myself in Coventry, were I live. I could even have lugged a couple of Gustav Metzger's stones with me for good measure. In a piece for *Skulptur Projekte* entitled *Aequivalenz-Shattered Stones* the London-based artist has organised the daily delivery by forklift truck of a pile of grey bricks to one of a hundred and seven possible locations in Münster, almost all of them as it happens within the confines of Wallinger's *Zone*. On each day the bricks concerned are arranged, according to instructions issued randomly by computer, in differing but very precise and discreet formations. Each new installation is photographed by the forklift truck driver and added to a website gallery.[15] So, brick by brick, image by image, they construct a ritual portrait of the city, rebuilding it in cyberspace. In fact, I don't notice a single one of these assemblages – sometimes involving as few as three bricks – until I consciously set out to follow the special map that is provided by the event organisers.

10. Gustav Metzger, *Aequivalenz-Shattered Stones*, Münster, 20 July 2007.

When I cotton on to their understated presence, it gives a particular thrill to try and locate them, as they send me orienteering in the streets of the city.

Metzger is well known for inventing the concept of auto-destructive art.[16] Formulating his first manifesto for this genre in 1959, he developed proposals towards three-dimensional monuments which, subject to a natural atrophying, would gradually (actively) 'disintegrate themselves'. Functioning as a form of slow-burn, kinetic art, inasmuch as it was dependent on its 'movement' within a certain lifespan, Metzger's work was concerned to show processes of trans-formation in material things, in which auto-destruction would come to be recognised in fact as a creative act. As such Metzger's ethos fits neatly, though inadvertently, into the evolution of the *Skulptur Projekte Münster* itself over its four decades of existence. As I have indicated earlier, several of the original *Projekte* works have undergone precisely such a transfiguration over time. Above all the artist sees his works as being infused by, as well as integral themselves to, socio-political, historical and environmental cycles. They are intended to

11. Gustav Metzger, *Aequivalenz-Shattered Stones*, Münster, 20 July 2007.

function as incursions into 'social practices' or 'how things work in society' – including the art world itself – involving a form of generative dissolution over time. The title of Metzger's Münster installation naturally references the minimalist classic that is Carl Andre's infamous 1966 'pile of bricks' work entitled *Equivalence (VIII)*. Thus, Metzger 'productively shatters' the neat order of this seminal piece by an artist who has, moreover, contributed to all three previous *Skulptur Projekte* (but not the one in 2007), dispersing and reassembling its fragmented components in the 'space around' the central zone of the city.

A time-based auto-destruction implies the antithesis, then, of sudden and outright obliteration. Whilst Metzger may not view *Aequivalenz-Shattered Stones* as subscribing precisely to the motives of his early manifestos, the work certainly reveals kindred precepts relating to the self-reflexive performance of materiality. The piece is premised on the reciprocal flattening of two cities on opposing sides of the Second World War. Coventry was destroyed on 14 November 1940, a devastating act which produced the highest number of casualties caused by a single German attack in England

and flattened almost the entire city.[17] It prompted Hitler to coin the verb 'to coventrate' (*coventrieren*) in a self-satisfied speech after the event. In direct response Münster was selected amongst several cities to be subjected to relentless RAF carpet-bombing. By 1945 Münster had been well and truly coventrated. Or 'equivalenced'. Metzger's installations are like temporary memorial shrines to buildings and cities 'undone'. In Münster this has a particular resonance, of course, since the city has been assiduously resurrected stone by stone, a historicist act of reconstruction that is not in fact to everyone's taste. The contrivance involved in replicating originality can often appear to end up emphasising artifice rather than the 'authenticity' it would seek to preserve: medieval or gothic buildings looking as if they were built as replicas in the twentieth century. A razed Coventry, by contrast, was built anew after the war, reinventing itself, cathedral and all. But, of course, that produced its own distasteful scenario of a construction process that occurred far too quickly and cheaply: rows and rows of flimsy terraced houses (I live in one of them), many built to house the workers of the city's burgeoning car industry, and, with deep irony, an inner-city ring road that is an invitation to crash with its sudden turn-offs, tight bends and misconceived traffic merging designs. Coventry was invited by Metzger to participate in a concurrent siting of bricks during the period of the *Skulptur Projekte*, but when I return to my home city and set out to find the counterparts to these antimonuments, they are nowhere to be found. No *Aequivalenz* there, then.

4 London playing fields

Mobile clubbing is an offshoot of flash-mobbing, a fad that was predicated on its ingenious pointlessness. The point of mobile clubbing is that an activity normally reserved for special occasions and places – parties, nightclubs – infiltrates daily life so thoroughly as to be indistinguishable from it. It has the guerrilla quality of illegal raves but is totally legal. It is, in short, a force for good. This has become more pronounced since the London bombings last year. Stations are prime terrorist targets. You are going about your business and, in an instant – boom! – everything is changed terribly and irreparably. Mobile clubbing is a mirror image of a terrorist outrage. It's organised with similar precision, the feeling of conspiracy is palpable, and at the allotted time there is a detonation. Of joy.

Geoff Dyer, 'An explosion of delight'

URBAN MOBILISATIONS

In case you are wondering what exactly Geoff Dyer is referring to above, the mobile clubbing event in question occurred at the

mainline Liverpool Street Station in east London on 11 October 2006. It entailed hundreds of people simultaneously breaking out into spontaneous dancing on a busy station concourse at the precise, prearranged time of 7.24pm. The point was, though, that whilst the music may have been turned up 'sound-system-loud', this was a *silent* rave in which participants each listened to their favourite dance tracks on their own private iPods. It is only when Dyer takes off his headphones that he registers the full energising effect of 'all these people [...] gyrating, smiling and jumping in virtual silence', something they sustain for the next one and a half hours or so (2006: 30 passim).[1]

Dyer raises several key points within the compressed space of the quoted extract. For one: his reference to flash mobs, of which mobile clubbing is supposedly an 'offshoot'.[2] Suggesting they are ingenious but pointless has all the appearance of being a back-handed compliment. In fact, though, it leads one to contemplate something that is undoubtedly true of the phenomenon: that the concept in itself is brilliant but that there are marked variations, first, of prescribed task or action and, second, of execution. Some briefs to participants are highly imaginative and their effects resonate far beyond the spatio-temporal parameters of the event itself, others simply fizzle out without consequence. Of course, 'highly imaginative' would need some definition: it is not merely the proposed activity in itself but also its pertinence *in context* that prove themselves to be significant here. Often the simplest tasks – single actions or basic 'things to do' – are likely to be the most successful, but they also need to occur in the right place. They also need to occur both at the right time and for the right length of time in order to make their mark. Thus, 'imagination' implies a canny 'thinking into' the specifics of location; by the same token, any proposed idea is dependent also on *capturing the imagination* of possible participants in the crucial mobilisation phase of the event. Nothing ensures a detonation of the proverbial damp squib more than sparse or even non-attendance at the designated point in time and place.

There will be more on the theory and practice of flash mobs gen-
erally later, but the main reason why the Liverpool Street event was,
for Dyer, merely an 'offshoot' of the form is the sheer length of its
occupation of public space. This far exceeded, and therefore coun-
tered (or reconceptualised) precisely the *flash* aspect of the customary
mobilisations, which – like the floods to which they doubtless owe
that particular description – ebb away and disappear as suddenly as
they have arisen. In one sense there is still clearly a 'flash moment'
in Dyer's account, the pay-off that is the 'detonation of joy' at the
outset, but it is the sustention of that 'orgiastic impulse' over some
90 minutes – 'by 9pm it was all over' – that is perhaps critical in the
playing out of a second key feature of his analysis: this event as a
'force for good'. In other words, it is simply an imperative that this
dancing – which might be said to be making a minor but not trifling
contribution to the general recovery of a traumatised city (after the
bombing incidents of the summer in 2005) – be permitted to run
its course as a spontaneous reclaiming of public space, in the name
of civilised pleasure and freedom: a mobile monument to those who
would not regret life.[3] And there are in this tacit celebration at least
three kinds of participants: those 'in the know', who arrive, on time,
specifically for the rave, and who stay and dance; those who happen
to be there and are moved to join in; and those who pass through,
commuters and spectators at the same time, who, as they hurry to and
from their trains, catch sight of – or, indeed, find themselves required
to squirm through – this incursion into the everyday of travel in the
city. But, as Dyer points out, in a further important observation, the
normally 'special activity' that is clubbing here 'infiltrates daily life so
thoroughly as to be indistinguishable from it'. Thus, there is a form
of 'everydaying' in operation that clearly marks its difference from
the terrible, extraordinary aftermath of the terrorist detonation, the
continuing threat of whose potential recurrence has hung over the
commuting public in London for over a year at this point in time.

Significantly, again, Dyer draws attention to what is one of the
axioms of the flash mob form: its *courting* of transgression. The variant

that is mobile clubbing possesses 'the guerrilla quality of illegal raves but is totally legal'. As with flash mobs generally, then, the tactic seems to rest essentially on engaging in relatively harmless *legal* activities which take on the *appearance* of being illegal. So, it may be that some kind of infrastructural breakdown or blockage occurs in the city – the traffic gets stopped, for example – but it is not because anything transgressive of the law has been committed. It is merely because large numbers of people have opted to engage in the same activity. Here, on the concourse of Liverpool Street Station, it amounts to an expression of the way public space can be commandeered positively to assert a point of view.[4] Where mobile clubbing may be 'organised with similar precision to the terrorist outrage', as Dyer puts it, its potency lies in its mere *flirtation* with the currency of conspiracy-making and transgression.

My several references in the chapter notes so far to YouTube footage of urban mass mobilisation events points to one of the significant structural components of this 'mob culture': its necessary dependency on digital information and communications technologies. As Jane McGonigal, one of the founder members of the flash mob phenomenon, outlines in her (appropriately) online paper 'Dark Play in Public Spaces: Confessions of a Flash Mob Organiser', there is a crucial 'before and after' aspect to the practice that actually makes it into much more than just an instantaneous moment of incursion into the life of a city.[5] Thus, the 'call to arms' that sets the event in train by announcing time, place and proposed action occurs via a range of social networking, texting or email modes of communication and implies, moreover, commitment to a second pre-event stage in the form of the 'meet-up' at which precise instructions are issued to performers. The aftermath of the flash mob, which, if it has been truly successful, will have attracted media coverage,[6] is characterised finally by a form of 'how was it for you?' pooling of experiences by participants, usually via blogging, thus ensuring a certain, variable degree of resonance beyond the live event.[7]

Several important points arise when it comes to this use of online technologies. First, though there is absolutely nothing that formally restricts flash mobs (and its derivative practices) to a particular social demographic, their assumption of 'living and breathing' ICT competency, coupled with the nature of the activities – clubbing, game-playing – is always more likely to align them in the first instance with the very broad category of 'the younger generation'. More specifically, perhaps, this might be narrowed down, *typically*, to a constituency of young adults not yet hardwired fully into a culture of salaried careers and responsibilities, and with an emerging sense of both their creative strengths and political rights. As such, the existence of the phenomenon can certainly be viewed as a significant attempt, predominantly by that loose pool of people, to assert its right not only to define how urban public space gets used but also to counter its perception of such space as bland, controlled and alienating – particularly at locations (such as stations) where it seems to be serving mainly the interests of a shopping and commuting 'ethic' – and therefore in need of some intelligent and imaginative 'livening up'.[8]

A second feature, following from this, relates to the fact of younger people devising their own *independent* organised entertainment, as opposed to being subject exclusively and continuously to the consumerist forms of corporate leisure. The utilisation, precisely, of digital technologies to institute 'free fun in the city' arguably represents a form of 'up yours' to the confining 'indoors enticements' of the gaming industry, for example. Youth culture's devising of its own diverse amusements in this way invariably produces corporate attempts to harness and exploit them to its own ends in whatever way it can. Thus, these commercial industries can be said to be both threatened by and grateful for the innovation of such independent innovations.

An example of precisely such corporate co-option is sent as a gift from heaven just as I write these words. At 9.10pm on Friday 16 January 2009 a major global telecommunications company *premiered* an extended advertisement on Channel 4 television based around

a choreographed – and not silent – dancing mob of 400 people at Liverpool Street Station. Not content with simply appropriating the idea as a 'standard commercial', then – though it was subsequently broadcast regularly in abbreviated form – the company clearly tried to replicate some of the conspiratorial 'flavour' of the flash event, simultaneously launching the advert on YouTube, a move doubtless calculated also to enhance its credibility with 'youth'. Without indulging here in a full-blown analysis, what is intriguing – though also obvious perhaps – about such co-options is the way the precepts of the original event are corrupted irretrievably to suit the ends of a selling agenda. As a company engaged centrally in promoting precisely the tools of communication frequently employed by flash mob culture (cell phone technology specifically, which is also often used to detonate bombs, of course), it obviously saw an opportunity to portray itself as the unsung, benevolent facilitator of such spontaneous, fun social networking activity. In truth, in order to *capture* the event, the commercial has to indulge in all kinds of controlled negations of particularly those rough-edged, 'uncontainable' elements of surprise, improvisation, unpredictable numbers of participants and silence that constitute the 'art' of the form.

The establishment of a necessary relationship between virtual space and real space is fundamental, then. It takes maximum advantage of new network technologies on the one hand, whilst asserting the need for public embodied space on the other. In its 'urban physicality on a social scale' the latter serves as a form of validation of the former's practical usefulness where its tendency might otherwise be towards abstraction and the isolated privacy of the screen. Thus, 'digital existences' are made to link up with and 'take shape' concretely within everyday urban environments. More specifically, as McGonigal points out, flash mobs show that 'social networks are real and performative'. In other words, participation in them has consequences in the actual world. The fact of considerable numbers of people – largely unknown to one another, but sharing a common purpose – being involved doubtless contributes a certain pleasurable

sense of momentarily 'seizing power'. Amounting to the unleashing of an unpredictable force – which, it should be said, really must have highly organised strategic and creative foundations in order to avoid the trap of tipping over into a pointless 'lemmings over the cliff' scenario in its realisation – such collective mobilisation also provides a comforting degree of protection to those implicated inasmuch as it is difficult for security officials to know where to begin arresting or even just 'moving on' participants should it come to it. However, as I have suggested, the true skill of any given mob action is, of course, to do no more than pose a logistical problem, usually by virtue of the volume of people involved, as opposed to contravening any actual laws.

McGonigal's paper differentiates importantly between two identifiable 'strains' of flash mob: the one of site-specific 'play' is intent on 'fun', whilst the other of site-specific 'performance' is more concerned, so it is implied, with instilling a deeper political or ethical consciousness. Or, I would suggest, in revealing the rich contradictions of agonistic urban space. Though it would be a mistake to dismiss the play strain as 'mere fun', its focus is 'self-contained': towards the interactivity of participants typically engaging publicly in some kind of familiar game, such as playing tig in the Jardin du Luxembourg in Paris, to use one of McGonigal's examples. Clearly this may still emerge as 'meaningful spectacle', on account of its unauthorised commandeering of formalised public space alone, for instance. But, unlike performance, its impulse is probably not to engage at a profound level with a 'contradictory problematic' arising specifically from the location in question and directed at an audience of casual witnesses who are, though it is difficult to generalise in this regard, real users of that space with a particular relationship to it. In some circumstances those witnesses can become 'secondary participants' if they are drawn into the activity in operation, and this may, of course, occur whether it is play or performance.[9]

In his recent book *The Ludic City* – which somewhat surprisingly signals no particular interest in flash mobs – Quentin Stevens usefully outlines a 'play continuum', derived from the sociologist Roger

Caillois, between *paidia* and *ludus* (2007: 33–4). The former is char-acterised by 'diversion, destruction, spontaneity, caprice, turbulence and exuberance', embodying 'human will without ethical delibera-tion', and involving 'improvisatory action, an escape from routine which explores other possibilities of social experience and develops new social forms' (33). The latter, by contrast, is 'play institutionalised as a game', requiring effort, patience and skill' and deriving satisfac-tion from 'discovering solutions within a set framework which is external to the demands of instrumental function' (33). Premised on their immediate 'escape from instrumentality and compunction', *both* poles of play can be said, though, to reveal 'educative' properties that are transferable to real situations. According to Stevens, Caillois's proposal is that 'social practices of play follow a general progression from *paidia* to *ludus*', whereby 'experiences gained through *paidia* stimulate the desire to "invent and abide by rules" which "discipline and enrich" it' (34). The ultimate instance of *ludus*, it would seem, is theatre, in which 'imitation "becomes an art rich in a thousand diverse routines [and] refined techniques"' (34). This conclusion is one that usefully leads us back to Lefebvre's critique of the institution and form of *theatre* as play subordinated to 'the "seriousness" of culturalism', a move that signifies that 'play has lost its place and value in society' as a whole (1996: 171). As we have seen in Chapter 1, Lefebvre's impulse is to redirect the art of theatre into the realm of the urban street where it may be subordinated to play and where it may take its place as a 'spontaneous theatre' of 'movement, the unpredictable, the possible and encounters' (171–2). Lefebvre's suggestion resonates as an articulation precisely of the flash mob principle. Rather than ask (academically), therefore, where on Caillois's 'non-instrumental axis' the strains of site-specific play and performance might be positioned respectively, it is perhaps more productive to ponder in more general terms what the machinery of the flash mob might usefully bring into play when it is put to work in urban space.

Saturday 16 February 2008, Trafalgar Square, London. A crisp, sunny winter's day. There always seem to be more people than pigeons

in the square these days, since its pedestrian-friendly reconfiguration, which, amongst other cunning tactics of urban planning, has removed the threat of snarling traffic on its northern, National Gallery side. Rather than being an island, strangulated by circulating vehicles, it has evolved into an inviting apron stage for members of the public. And on this weekend afternoon there are even more of them than one might otherwise expect, milling around, chatting and joking in small clusters. Not really a tourist crowd, judging by the way its casual conviviality seems to signal both familiarity and the intention of lingering for a while. Few seem to be showing too much concern with a freshly scrubbed Admiral Lord Nelson, up there atop his column, or with posing gamely at the foot of any of the war generals on their slightly more mortal plinths. Nor, on the other hand, are we talking the tell-tale placards and chants of a gathering protest demo, that other main reason why the square regularly fills up with masses of folk, particularly on a Saturday afternoon. This is more like a garden party at which the guest of honour has yet to arrive. The air of expectation is palpable and is cut at 3.30pm, right on cue, when a lone trumpeter strikes up on the steps at the base of Nelson's Column: a last post that is met promptly with a collective freeze. A sun-kissed but chilly Trafalgar Square simply stops moving. Wherever your gaze might fall there are stock-still tableaux or dramatic vignettes. Some are self-consciously struck poses – plenty of hugs and snogs, a sword fight, even a staged bike crash – others merely action paused in mid-flow. Living statues against an eerie, amplified sound-drop of splashing, gushing water from the two large fountains. In amongst this immobile mob, the odd ripple of activity: unwitting bystanders who haven't read the script, some tourists perhaps – others definitely pigeons – who find themselves literally frozen out. Trapped and exposed. What should they do? Join in the freeze, wriggle their way to the fringes as quickly as possible, or make the most of their unique state of 'otherness' by wandering around beholding the detail of the spectacle? And, as more and more of this stopped time elapses, it becomes clear that this is no mere minute's silence as seen occasionally at football

matches in honour of some legendary hero's passing. (The referees usually blow their whistles after only 30 seconds so laden with tension is the collective silence, and recently the Italian practice of applauding has become more common, in part no doubt because it is easier on the nerves.) In fact, it is a whole five minutes before the lone trumpeter intervenes once more and is greeted with an explosion of one thousand folk cheering and clapping: a kind of relief, but also a sense of exhilaration that eventually breaks into full-blown partying mode as a conga catches on and proceeds to snake its way round the square.

So, a further variant of flash culture, arguably its antithesis in terms of 'watery analogies': not flash but *freeze* mobbing (though that is probably not what it commonly calls itself). It has been replicated in cities around the globe, as YouTube testifies, though the Trafalgar Square event, which may not have been the first of its kind, has been particularly widely documented on this site. And watched.[10] It serves as a good example of how such interventions can 'hit the mark', and this occurs, I would argue, when the event succeeds in positioning itself within what might be called a rich matrix of urban-cultural existence, proving highly pertinent to *that* place and *that* moment in time. In other words, when it can be said to become performance or site-specific art.

Trafalgar Square is nothing if not overdetermined urban space. If London has a centre, and that is debatable, this is certainly a candidate with its conglomeration of key institutions, representing, inter alia, culture (The National Gallery), the colonialist Commonwealth (the high commissions of Canada and South Africa), the church (St. Martins-in-the-Fields), to say nothing of Whitehall's politics a few paces down one road and royal Buckingham Palace a few minutes down another. With its various statues and plaques and bronze panel depictions, commemorating imperialist power and victory in war, it is small wonder that the square has become in some sense the London visitor's 'home from home'. Here is where official England is staged in one of its most concentrated forms. At the same time, however, it has become subject to other forms of 'inscription', not least in its

functioning as a rallying point for all kinds of anti-government/anti-state protests from those against the siting of cruise missiles in the 1980s to the invasion of Iraq in the twenty-first century. In fact, it would not be exaggerating the matter to say that when Trafalgar Square surfaces in the consciousness of the broader British public, it is frequently in association with just such political agitation, which derives its potency precisely from performing its often peaceful message in this theatre to the memory of war.

In recent times the 'Fourth Plinth' project at Trafalgar Square, an initiative, in part, of the adjacent National Gallery, has also begun to make incursions into the collective psyche as 'art in the public imagination'.[11] Since 1999 a number of artists have sited sculptures on the empty plinth in the north-west corner of the square for differing periods of time, arguably providing a form of 'rolling counter-point' to the militaristic, nineteenth-century monuments adorning the rest of the site in their ponderous, immovable way. Formalised since 2004 as a changing programme of commissions, Marc Quinn supplied the first 'provocation' over a period of nearly two years, which clearly engaged with the concept of idealised-idolised figures. Making deliberate associative use of the smooth, perfect, peppermint white material feel of classical marble sculpture, which also contrasted markedly with the 'heavy black', bronze and granite of the Trafalgar statues, Quinn presented a much larger-than-life nude of the pregnant and profoundly disabled artist Alison Lapper.[12] In some ways it appeared to be rather an obvious work, graphically posing questions around hierarchies of sculptural representation, marginalisation and the idealised (male) body. But it also introduced perhaps, more easily, overlooked nuances of potential meaning such as the fact that 'our great national military hero' Nelson was 'similarly disabled', albeit as a consequence of wounds acquired in battle, with one arm missing rather than the two that Lapper's thalidomide condition had imposed on her from birth. Nelson's disability appears 'fitting', heroising him and confirming his 'manhood' up there atop his phallic column, where Lapper's may well render her above all a 'problem'

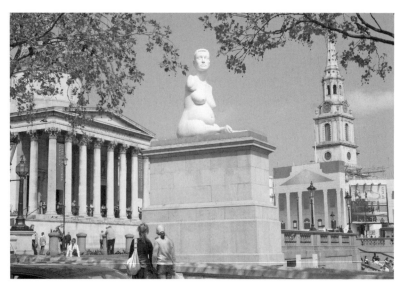

12. Mark Quinn, *Alison Lapper Pregnant*, Trafalgar Square, London, 20 April 2007.

for society. Arguably, then, her choice to 'soldier on' with life against all the odds, not only generating new life by becoming pregnant but also prepared to live with the consequences of raising a baby with her physical limitations, should also – or even *rather* – be worthy of idealisation.[13] (Some, of course, would condemn the choice on moral grounds as irresponsible.)

In a sense I am not too interested here in mining Quinn's installation for further possible meanings (valid as that may be as an exercise). What is more pertinent for my purposes is how the artwork has effectively instigated – or continued, in fact (see note 11) – an evolving trend of positioning the public to view Trafalgar Square as a whole as a space of contesting narratives. Arguably, then, the supposed 'readability' of *Alison Lapper Pregnant* is entirely apposite for a piece of public sculpture that will be experienced by most people – whether visitors or London residents – *in passing*. Its 'instantaneousness' as a resonant counterpoint to Nelson and company is, therefore, exactly its strength and, moreover, not necessarily the *only* level at

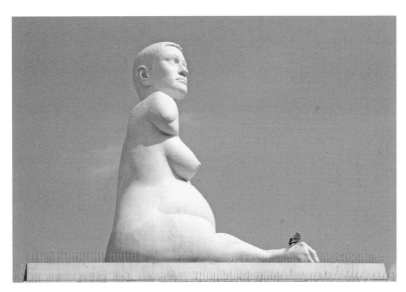

13. Mark Quinn, *Alison Lapper Pregnant*, Trafalgar Square, London, 20 April 2007.

14. Mark Quinn, *Alison Lapper Pregnant*, Trafalgar Square, London, 20 April 2007.

which one may wish to engage with it. But it gives momentary pause
for thought perhaps to the busy pedestrian around the themes I have
touched on above, in the same way that Thomas Schütte's *Hotel for
Birds*, which followed it, patently attempted to say something about
the 'tourists-and-pigeons syndrome' associated with the square. Its
specific critique of the 'place of statues' in London's performance of
the story of itself as a city could also be said to be the lingering trace
within the space of the public imagination – or perhaps it was the
public unconscious – that prompted the time-based Trafalgar Square
mob freeze: a theatre of mortal statues. In turn, Anthony Gormley's
commissioned proposal for the *next* fourth plinth installation, en-
titled *One and Other* (and imminent at the time of writing), has
promised to continue this ongoing conversation between the square,
its monuments to individual war heroes and 'ordinary city folk'. In
a staggeringly ambitious project 2,400 people will have signed up in
advance to spend one hour each on top of the plinth, doing what-
soever they wish in a continuous 24-hour regime lasting 100 days.[14]
As such, the fourth plinth has acquired the function of a 'popular
living stage', one which embodies and plays out through its form the
discursive tensions of Trafalgar Square itself 'as theatre'. There is,
moreover, a circular reciprocity to be detected in the implicit col-
lective assimilation and 're-presentation' by the London public of
Quinn's fourth plinth motif, as evidenced by the performing statues
of the February 2008 'flash freeze', and, in a similar echoing action,
the latter's effective reabsorption as 'people's plinth' into Gormley's
performing artwork.

RUNNING FREE

Where the previous section attempted to reveal something about the
nature and extent of organised urban game-playing en masse, this one
concentrates on the ever-growing plethora of creative engagements –
often highly skilled – occurring in small-scale pockets of activity

within city spaces. Whilst the sheer diversity of practices makes it difficult and, indeed, undesirable to conflate them into anything as confining as a generic form, there are perhaps certain common characteristics that can be identified and that begin to make a discussion possible. One of them is doubtless around the question of temporality, specifically *ephemerality*. Not only do many – perhaps all – of these incursions into the cityscape possess a 'temporary aspect' in their realisation – implying a form of movement that steers them towards performance – but frequently they seek out temporary spaces as their settings: liminal sites in a state of transition from physical decline to renewal – though the latter is by no means given – or whose complex sociocultural make-up renders them subject to continual fluctuations. As outlined in Chapter 1, Benjamin pointed to the revelatory nature of urban sites lingering on the brink of extinction, seeing in the decline of the nineteenth-century arcade, for instance, signs of capitalism's transciency and inherent 'will to decay'. Such in-between states hold the promise of certain potencies for the artist, a sentiment seized upon by Tim Etchells (director of the Sheffield-based Forced Entertainment) when he talks about that which inspires his company's making of performance work:

> We always loved the incomplete – from the building site to the demolition site, from the building that was once used and is no longer to the building that will be used [...] The fascination of ruined places, of incomplete places. It seems unethical to admit – the strange charge of buildings left to run down – but they always were the best places to play – stinking of previous use, ready for transgression.
>
> (1999: 78)

Less preoccupied with ruins specifically, Lefebvre too looks, in Highmore's words, to 'fissures in the urban fabric', those 'spaces of different temporalities, outmoded spaces with distinct cultural characteristics', as the locations of a potential interruption of the

'homogenising and hypnotising effects of capitalism's standardisation' (2002: 141). The situationists' impulse, meanwhile, to disrupt the urban spectacle, which implied, amongst other tactics, recovering lost energies in 'obscure places' (Sadler 1998: 76), is relevant here as well naturally. In particular, situationist strategies were premised on a form of re-signifying or re-inscribing urban space by 'reinstat[ing] lived experience as the true map of the city' (Hussey 2002: 218). This clearly suggests a form of embodied 'mark making', the effects of which are both ephemeral and elusive.

Within the context of the evolution of new, twenty-first-century urban practices there are two 'ancient forms' I wish to invoke first. Both are still popularly in operation in their pure states – testament in itself to their very particular resonance, which is widespread on a global scale – and both are forms of a temporary, though obviously durable, 'writing' of the city. I am talking of skateboarding and (modern-day) graffiti, which are generally recognised as having arisen and come into their own in 1970s California and New York City respectively.[15] Of course, there is much that distinguishes these practices from one another, not least the tendency of the former to be seen effectively as a skilled sport or art form – admired and allocated its own official public parks or indoor arenas in which to be performed – whilst the latter is consigned more often than not to the realm of criminality and is abhorred for its unsightliness more than it is appreciated for any aesthetic qualities it may have. But both skateboarding and graffiti can flip the other way in terms of public perception or, indeed, raison d'être. Skating in and amongst the unpredictable contours and textures of the built environment, which for many of its practitioners – and certainly its pioneers – constitutes the appeal of the exercise, often implies dangerous risk-taking – on roads, for example – or manoeuvres liable to provoke irritation with pedestrians and residents on account of the sudden physical threat (as speeding entities) or the 'racket' involved. Whilst skaters are not necessarily averse to the styled challenges of the skateboard park, the introduction of the phenomenon is also clearly bound up with

LONDON PLAYING FIELDS 113

attempts by civic officialdom to contain the practice for the safety of 'all concerned'.

Graffiti has been subject to similar and continuing attempts to channel its raw activities towards 'acceptable sites' (so-called halls of fame), whilst also making the move into the public and commercial art world context of the gallery. Both these 'redirections' are controversial, of course, viewed by purists as tamings or exploitations of the form, rendering them pointless or neutering any 'radical potential' they might have. The latter notion may simply be referring to the need for graffiti to remain a street art at all costs, taking place wherever it may locate 'canvases' adequate to its purposes, thereby asserting some form of right to the freedom of expression in public spaces. Where things get complicated is with the realisation that the central prerequisite of fulfilling 'radical potential' is in fact utterly bound up with transgressions of law, this almost always being the case. Graffiti as vandalism, then, rather than public art? Or, indeed, graffiti as art but nevertheless vandalism and, therefore, still irrefutably a criminal act?

It is worth distinguishing in this regard between the gratuitous, petty act that really does have defacement rather than creativity in mind – though even there, as a writing of urban exclusion and dispossession, it is still worth taking seriously perhaps – and those instances that are intent on displaying skill. Nevertheless, the latter is often similarly illegal. Where it may be viewed as radically creative as opposed to inanely destructive, however, is in its choice of location and its desire to be *witnessed* rather than merely condemned, though asking to be witnessed arguably still carries with it a necessary element of disapproval. As I have proposed elsewhere, in relation to the post-Wall 'Berlin school', graffiti is first an act of performance before it is one of drawing or painting (or spraying) (2005: 142–7). Its true potency resides not only in its seeking out of high-risk, forbidden places in the city but high-visibility ones, too. That is because the game it would play is, paradoxically, one of invisibility. The impact of what artists leave behind is far less resonant for its intrinsic aesthetics – though

its stylistic features remain significant as signs of a specific metropoli-
tan 'school' – than for the mystery of its executors' identity. They are
out there but you never see them carry out their work, so you neither
know who they are nor, often, how they managed to access the site
in question. As such, the pieces effectively *perform* their exponents'
disappearance. And that is perhaps the radical force or threat of their
practice: their sheer physical elusiveness.

The cultural geographer Tim Cresswell refers to graffiti as 'night
discourse': 'subversive messages which appear in the morning after
the secretive curtain of night has been raised' (in Fyfe 1998: 268).[16]
Supposedly, hardcore graffiti, carried out by 'taggers', 'writers' or
'sprayers' (depending on its generic style) known only within the
confines of their specific 'writing community', is not intended to
impress – or offend – the general public, but to gain the 'respect' of
fellow artists. In itself it isn't even seen as particularly territorial, in
the sense of demarcating a 'home patch' within the city. But it does
sometimes cover vast expanses of surface, be that building or train. Its
value to its executors lies more in a combination of quantity and risk,
the latter being defined by both daringness of location and length of
time spent completing a piece (which is consequently why quantity is
prized). As such artists can be said to be performing for the 'benefit' of
a general public, as much as they may be for their peers, because both
graffiti's illegality and its execution in inaccessible, risky locations
necessitates a form of subsequent sanctioning by everyday citizens *as
transgressive*. In other words, it must in some sense be *dis*approved.
So, in spite of its non-specific territorial function within the context
of the city, there is nevertheless an implied laying of claim to the built
environment in operation in the application of graffiti. It is an irritant,
an unwanted autograph or tattoo anonymously etched on to the body
of official urban culture, reminding it perhaps that 'all is *not* well'. It
is no coincidence, then, that graffiti artists utilise the vocabulary of
the terrorist: 'bombing' is to spray the whole expanse of a designated
surface, and the 'wholecar bombing' of trains is well known. Graffiti
poses the question, as Susan J. Smith does in her entry for the *City*

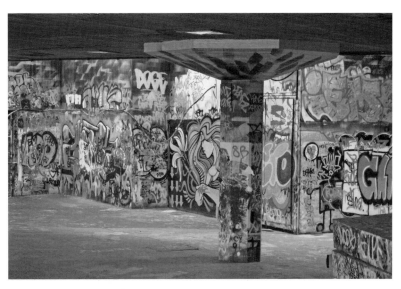

15. Graffiti at the South Bank Centre, London, 4 March 2009.

A–Z lexicon of urban phenomena: 'Whose city is this?' (Pile and Thrift 2000: 86). In a montage of citations and aphorisms, presented in various typefaces – the fact of which highlight graffiti's significance both as a *writing* of the city and as being spontaneous and fragmented in form – this is but the first of a series of key structural questions around ownership, art and vandalism. At the end Smith returns to the same question, twice; for her, the city is perhaps a 'place where we know the cost of so much and the value of so little' (89).

Arguably, skateboarding does not reveal quite the same dependency on making its mark as an 'outlaw practice'. Its performers are highly visible, as well as audible; on the other hand, it tends not to leave any trace of its activity – except where it may have caused unintentional damage to, say, street furniture – and so it emphasises ephemerality to a greater extent. However, it can also be seen as a significant writing of the city and, moreover, as Iain Borden observes in his contribution to *The Unknown City*, as a 'critical practice [. . .] directly confronting not only architecture but also the economic logic of capitalist abstract space' (in Borden 2002: 179–80).[17] Borden's

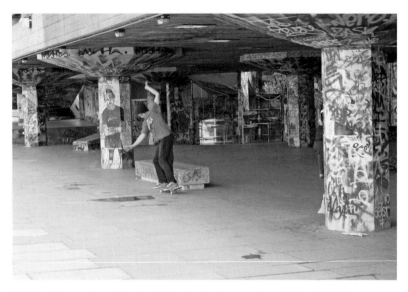

16. Skateboarder at the South Bank Centre, London, 4 March 2009.

chapter argues that 'skateboarders implicitly realise the importance of the streets as a place to act'. Thus, a contemplation of the form as art does not by any means limit itself to the formal aesthetics of movement but is 'an attempt to write anew [...] to insert meaning where precisely there was none' (182). Borden's prime example of this is the skateboarder's re-functioning of the handrail, ollie-ing up, then 'sliding down its length sideways [which] targets something to do with safety, with everyday security, and turns it into an object of risk' (186).

A key point of reference for Borden is Lefebvre's theory of rhythmanalysis, which, as more or less the last project the latter undertook in his lifetime, sought to develop an understanding of urban rhythms as intrinsic to how cities constitute themselves. As Stuart Eldon writes in his introduction to the edited volume *Rhythmanalysis*, 'Lefebvre uses rhythm as a mode of analysis – a *tool* of analysis rather than just an *object* of it – to examine and re-examine a range of topics' (in Lefebvre 2004: xii). In Lefebvre's own words, then: 'Everywhere where there is interaction between a place, a time and an expenditure of energy, there is rhythm' (2004: 15). In a similar way to Lefebvre's

harnessing of rhythm to 'sense' what is 'going on' in cities, for Borden the practice of skateboarding provides a means by which to calibrate the urban environment: 'the continual performance of skateboarding [...] *speaks* the city through utterance as bodily engagement [...] Skateboarders use themselves as reference to rethink the city' (2002: 195–6). As such, it is probably accurate to claim that skateboarding's relationship with the law tends towards 'flirtation' rather than the effecting of transgression, as I observed with regard to flash mobs.[18]

The same might be said of the phenomenon of *parkour* or free running whose exponents are *traceurs* – that is, tracers of urban textures and contours – and whose principles echo many of those applicable to skateboarding. Whilst the practice sprung up of its own accord in suburban France in the early years of the twenty-first century (though some maintain it was already being practised in Paris suburbs in the 1980s),[19] it can nevertheless be regarded as a form for which both graffiti and skateboarding paved the way. It too amounts to a momentary writing of the built environment: a highly skilled physical exploitation of the potentialities particularly of street furniture and inaccessible, liminal locations, which one might position somewhere between athletics, gymnastics and dance. Of course, many *traceurs* would consider it a philosophy and (sub)urban way of life. In fact, though its spelling differs slightly – a 'c' rather than a 'k' – *parcours* is the term used to mean an obstacle course or route. Furthermore, it is a word de Certeau employs in drawing his celebrated analogy in *The Practice of Everyday Life* between the practices of writing and urban walking: 'the act of "turning" phrases finds an equivalent in an act of composing a path (*tourner un parcours*)' (1988: 100). Such walks make use of 'spaces that cannot be seen', producing 'unrecognised poems' (93); the walker 'transforms each spatial signifier into something else' (98).

Free running has but one rule, that of forward movement. Thus, whilst ways of negotiating certain spatial configurations can be worked at and 'rehearsed' over and over (as skateboarders often do), the real challenge for the *traceur* is to pick an improvised route

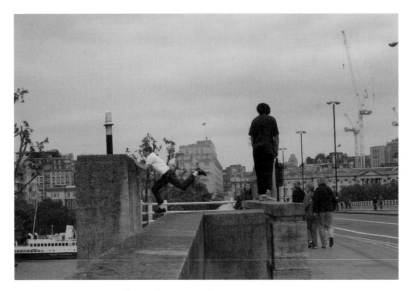

17. *Traceurs* on Waterloo Bridge, London, 26 May 2007.

through the city that avoids pausing or retracing steps. One of the
art form's co-founders, Sébastien Foucan, maintains, moreover, that
free running at its most rewarding is essentially a solitary 'writing',
but the rapid spread of its popularity – certainly within the context
of the UK – is undoubtedly down to both social networking sites and
small clusters of interested people meeting up and collaborating in
the practice.[20] Probably, the most decisive impetus to the practice in
the UK was given by a Channel 4 television programme in September
2003 entitled *Jump London*. Featuring a couple of Foucan's collab-
orators, including well-known co-pioneer David Belle, it was both
documentary – providing an introduction to free running – and special
commission. The second half of the programme presented the French
traceurs negotiating a high-risk, central London obstacle course, in-
volving, above all (as it were), the rooftops of major institutions such
as the Royal Albert Hall and the Royal National Theatre. With sev-
eral camera angles available, coupled with the benefits of retakes and
editing, such a filmed version of the form does not, of course, ac-
curately represent the experience of it in reality. Arguably, the film

succeeded in turning it into much more of a 'spectator sport', seizing upon and drawing out its highlights and, probably most importantly, presenting it as a continuous performance lasting approximately half an hour. It even ended with a moment of classic modernist closure, as the *traceurs'* performance came to a 'natural halt' on the rooftop terrace of Tate Modern, against the backdrop of a glorious Waterloo sunset. As an advert for free running, this programme was doubtless crucial to the form's subsequent adoption nationwide, since it was able to capture and indulge *filmically* all the danger, excitement and sheer athletic artistry involved in this negotiation of a familiar cityscape.[21] What it could not convey was the way that an ordinary urban citizen's witnessing of free running might be no more than a glimpse of a human figure executing an extraordinary leap between two buildings, tumbling down a flight of stairs or scything like some pickpocket through a crowd crossing a pedestrian bridge. The experience of such elusive moments – and to the film's credit it nevertheless succeeded in conveying *that they occur* – is arguably one of the most powerful aspects of *parkour* from a spectator point of view: momentary poetic interludes or urban will-o'-the-wisps that you might miss should you happen to blink. If you do not blink, you are likely to be grateful for them as unexpected and instantaneous interruptions of the urban everyday. A little gift for a commuting public in particular to savour, not least in the form's embodying *in one* of the romanticised effects of petty thieving on the one hand – the villain's artful fleeing across the rooftops – and the mythical powers of the heroic super-spiderman archetype on the other.

Such a conflation neatly brings into play one obvious 'flirtation' implicit in free running – and returns us to some degree to the relationship of the practice with the camera – namely that with the closed circuit television (CCTV) monitoring of inner cities. Increasingly, the centres of cities are becoming subject to privatisation and surveillance, not least in the UK, which has been officially identified as having, at this point in time, 'the most intensive concentration of electronic "eyes on the street" in the world' (in Lees 2004: 49).

In the year of the high-profile Beijing Olympics, Naomi Klein re-
ported, moreover, on a 'social experiment' to be launched in the
Chinese city of Shenzen (population 12 million) – but actually part
of a broader hi-tech surveillance and censorship programme in China
called 'Golden Shield' – in which 'Chinese security executives predict
they will install as many as 2m CCTVs [. . .] which would make
it the most-watched city in the world. Even security-crazy London
boasts only half a million surveillance cameras' (2008: 5).[22] Whilst
there are considerable differences of approach in cities around the
world, it is not exaggerating the matter to say that CCTV has ex-
perienced a general explosion of largely unopposed implementation.
Safeguarding the enjoyment of public space without fear of violence
has clearly won the day over any concerns around the sacrifice of or
affront to public freedoms – the operative sentiment being, of course,
why worry if you have nothing to hide? – and the creation of a so-
called criminology of intolerance that detects the possibility of foul
play wherever the camera happens to be pointing.[23] As I intimated
in my discussion of Richard Wentworth's work in Chapter 3, one ar-
gument against rolling over and basking in the warm glow of CCTV
security is that it has effectively stolen a vital component of the 'public
gaze'. In other words, the casual 'phatic communication' – a notion
invoked by de Certeau to refer to social interaction that is more
concerned merely with establishing a connection than exchanging
specific meaning (1988: 99) – that Jane Jacobs appeared effectively
to be promoting (by implication) as a model of informal security in
downtown neighbourhoods in New York City, has been withdrawn.
Importantly, Jacobs observes in the everyday comings and goings on
her Greenwich Village street not only something that can be called
an 'art form of the city' but also a kind of reassuring communication
between neighbours, who may nevertheless remain strangers to one
another: 'We nod; we each glance quickly up and down the street,
then look back to each other and smile. We have done this many a
morning for more than ten years, and we both know what it means:
all is well' (1993: 61–2). This form of social enactment appears to

have little purpose other than to acknowledge and thereby validate the presence of the other. Arguing against the regimentations of urban planning and policing, and for the diversity, randomness and informality of inner city neighbourhoods, Jacobs proposes, however, that such exchanges importantly bring with them their own implicit, but non-coercive, self-regulatory order: strangers looking out for one another as a matter of course.

Instead of such possibilities of inherent cohesion there is now an 'averted gaze' whose figurative trajectory leads us to surveillance technologies. Arguably, bringing about a displacement of the gaze in this way produces rather than diffuses a climate of fear and mistrust of strangers. A phenomenon like free running obviously causes CCTV surveillance a problem without necessarily setting out to be provocative. Its combination of nimble speed – who is to say the 'scything figure on the bridge' is not in fact a pickpocket? – sudden appearance, as well as disappearance, and its use of in-between or, indeed, forbidden spaces is, potentially, the monitoring security officer's nightmare (or delight if he or she relishes the challenge). Whilst I keep stressing the probable lack of intentionality on the part of the *traceur* in any conscious 'game of cat and mouse', there is nevertheless a powerful element of both innocently and expertly escaping existing prohibitions on movement in public space. As such, there is a form of street-level 'reclaiming of the gaze' in operation by virtue of *traceurs* implying in their movements: 'you can't capture me either on screen or in reality'. Free running may cock a snook at surveillance, then, but it is not *explicitly* playing to that particular gallery. However, its inherent elusiveness in the face of surveillance may well have contributed to a growing trend of creatively turning (or détourning, to part-anglicise the situationist term) the cameras of CCTV against themselves. The practice of deliberately performing to CCTV has begun to assert itself – including, as it happens, instances of staged free running – in locations of close-proximity, networked surveillance, such as shopping malls, where a continuity of coverage can be ensured.[24] The phenomenon of 'video sniffing' represents the latest

innovation in subversive film-making, involving the capturing of live feeds from CCTV networks with a handheld receiver (easily and cheaply available from high street retailers). Once an appropriate site has been established and mapped, and access to the network of cameras 'sniffed out', pre-scripted or improvised performances can begin.

A variant on the method, which is more cumbersome, is premised on the individual's right to demand a copy of any known CCTV footage of him or herself for a fee of £10, the results of which can then be edited into a film and posted on the Internet. Sean Dodson gives an example of the approach as carried out by the director Manu Luksch. Over a period of four long years he 'spent hours performing on London streets beneath the glare of CCTV cameras and then going through the protracted process of making formal requests to retrieve the images from the camera's owners. When the tapes arrive, the faces of the other passers-by are blanked out in order to protect their identities' (2008: 4). The resulting film makes a deliberate feature of these ominously blanked out identities that appear as characters with black cuboid heads. Again, the *dalliance* with criminality is interesting here. Actual technology-dependent criminal practices such as happy slapping (which uses a combination of cell phone cameras and the Internet), or the increasing tendency of 'young criminals committing offences as they wave brazenly at [CCTV] cameras' (Bowcott 2008: 3), display behaviours that seek to exploit and mock a culture of constant watching and being watched. They are indicative of the way the ubiquity of surveillance and 'democratising technologies' has paved the way for a destructive, dehumanising culture of instantaneous, notorious 'fame-seeking' via acts of gross violence or bravado. Video sniffing's form of 'parasitical subversion' by contrast is in itself legal – though the act of tapping into live feeds may not strictly be above board – and it is certainly not damaging to anyone. Its intentions are creative, clearly embodying, moreover, a critique of widespread and intrusive surveillance, which includes the attempt to claw back to some extent the individual's right to know how they have been recorded and archived.

This form of creative *détournement*, or deconstructive 'using against the edifice the instruments available in the house' (see Chapter 1), represents an ever-increasing trend within practices of urban incursion. There is also a discernible 'subtlety' in the approach and execution of these forms that implies a departure from the pioneering interventions of raw graffiti, for instance, towards an imaginative appropriation or *re-signing* of the city.[25] The anonymous, UK-based Banksy – whose cultish suppression of his 'true identity' has become paradoxical: a kind of fetishisation of authorship by denial – stands as one of, if not *the* exponent of 'artful', politically conscious graffiti. As such his work marks the transition towards the development of new underground forms.[26] Banksy's pieces distinguish their difference from customary graffiti not only by tending to incorporate a far greater site-specific factor into their aesthetic but also by relaying a witty, politically savvy statement in the ready-made, succinct style of the stencil. Where, specifically, Banksy throws up his work matters enormously, then. Following on from the discussion of CCTV, one of his pieces, at Marble Arch in London, simply stencilled the question 'What Are You Looking At?' on a section of blank white wall that he had calculated came within the sweep of one particular surveillance camera (see Banksy 2005: 76–7). Such a direct engagement with the sheer voyeurism of CCTV is in itself poignant – the question effectively seeking out a private conversation with whosoever may be monitoring that camera – but the piece simultaneously points to surveillance's inherent futility, first, by performing this forbidden act right under its nose without being fingered and, second, by pondering – as a straight reading of the question at face value – what on earth is supposed to be so interesting about monitoring a blank wall. Ironically, then, it is the illegal stencil that renders this ignored urban site worth looking at in the first place.

Of course, Banksy has been the subject, perversely, of an 'is it still graffiti, though?' style public debate, which has seen 'street purists' point not only to the graphic deviation of his pieces from customary graffiti fare but also to its linkages with mainstream art world contexts

in the form of gallery exhibitions and glossy publications. It is un-
questionably true that Banksy's impulses are distinct from those of
'your average tagger'. But the more usual 'is it art, though?' question
has been similarly and more vehemently levelled at his work, and so it
is probably more productive to recognise that he has come to occupy
quite new, interstitial territories in a way that makes claims neither to
being 'genuine graffiti' – though it clearly helps itself to radical aspects
of the practice – nor to being mainstream art. Instead, it attempts to
position art in the street as a deliberate way of challenging the formal
stranglehold of the subsidised and commercial gallery and museum
system.[27] As such, two significant avenues of development have been
opened up, which some, admittedly, might perceive to be at cross-
purposes. First, a 'new underground art' that comprises, as Francesca
Gavin's recent book *Street Renegades* makes clear, an impressive range
of practices displaying not only a greater sense of self-awareness on
the part of its practitioners but also a tendency towards creating site-
specific performance installations in the city: 'manipulating urban
architecture and interacting with the street furniture itself' (Gavin
2007: 6). One such example of a graffiti variant, not represented in
Gavin's publication but discussed by Madeleine Bunting in an article
that addresses directly the 'new policing' to which much of this work
is a subversive response, is the quirky practice of 'Chewing Gum
Man' Ben Wilson.[28] Picking up on the rash of discarded gum glob-
ules flattened permanently on to urban pavements – a phenomenon
that is, like graffiti, frequently condemned by officialdom as a blight
on public space – he has taken to painting on them in enamels: 'Each
picture tells a story as recounted by a passer-by [. . .] small signs of
personal connection, a humanising of an anonymous environment'
(Bunting 2007: 28). Crucially, Wilson 'paints the gum, not the pave-
ment' and so cannot, theoretically, be charged with criminal damage.
Arguably, then, used chewing gum takes on the virtual – or, indeed,
actual – status of an 'independent republic'. The act would also appear
to be performing a useful function of providing a bit of colour and
imagination to what is essentially discarded and immovable litter.

Far from protecting him, however, the article describes the '500–600 encounters with police' the artist has experienced, including 'being punched and dragged across a police cell' and being forced to provide a DNA sample which now sits in a national database (28).

The second main development concerning the declared Banksian project – shared, of course, by other high-profile advocates such as Keith Haring and Jean-Michel Basquiat before him – of bestowing credibility on street art has evidently struck a chord, to the extent that one of the most important international contemporary art houses, London's Tate Modern, felt moved to curate a major exhibition (entitled *Street Art*) for three months in the summer of 2008, including commissions to six artists for new work – displayed on the riverside facade of the building – and walking tours of nearby street works (see Lewisohn 2008). Whilst such a turn is bound to intensify accusations of artists selling out and mainstream galleries exploiting the popularity of a radical form (with a canny eye to pulling in a large 'youth audience'), at some point it is worth entertaining the possibility that this may also mark an important acknowledgement of the value of such 'renegade forms' and the need to open out a dialogue with practices whose motivations are not merely to end up sitting in a gallery.

ART AND PLAY

I'm sauntering through the Duveen Galleries of Tate Britain on a weekday afternoon. The last time I was here the ramshackle assembly of 'signage' that was Mark Wallinger's *State Britain 2007* shambled its way some 40 metres straight down the middle of this neoclassical exhibition hall. Now there appears to be nothing at all on display and I'm just reflecting on how bare and 'tidied up' the galleries are looking by comparison, when the figure of a young man with reddish hair flashes by me from behind. On he runs, looking as though he's bursting a gut, every so often checking his stride with a slight,

shuffling sidestep so as to avoid any collisions with pillar or person. A few moments later he's gone, slipping deftly round a corner at the end of the galleries. *What was that?* Before there's time to contemplate that question, another figure pops up near the entrance of the museum. A young woman this time whose rhythm is more measured: a smooth, considered action that gives her plenty of time to anticipate any obstacles. Serene face, elegant. Used to running distances perhaps.

There aren't too many visitors about today but, like me, they've all stopped in their tracks, a look of slight puzzlement on their faces. Is this supposed to be happening? Two gallery attendants at either end of the galleries calmly monitor the situation, ambling up and down, keeping an eye out for potential blockages. So, it must be above board. As if to confirm this another runner emerges. This one's going hell for leather, his straining face tilted to one side, as if being pulled by an invisible force attracted specifically to his right shoulder. Much huffing and puffing. People smiling now. Then it's the turn of the one with the dark, lank hair. Head forward, shoulders hunched, hands raised oddly high by his sides, paddling away. Something in his lolloping gait makes his trainers squeak every time they hit the floor. He's the last. Once he's disappeared we're back to the first one again, who must have made his way round to the front through the bowels of the building. This time I notice his low centre of gravity. His torso upright, the action all in his pumping legs.

And so it goes on, a continuous loop of runners, organised in small teams apparently, each doing two-hour shifts, eight hours per day over a period of some four and a half months. A sprint relay marathon. All the runners I saw looked very focused on the task – intense, inward – yet they're almost certain to have been rather self-conscious, not only running in public like that but in a gallery where running is categorically not permitted. (More than one witness to this running will initially have felt inclined to clutch their bag tighter or pat their pockets to check for their wallets and cell phones.) Cutting a weaving line through the central hall of Tate Britain in this way is not too far off completing a 100-metre dash and so likely to take

between, say, 10–15 seconds, depending on the individual runner. An extended portrait shot or 'over-exposure'. The only way to survive it perhaps, as a runner, is to commit yourself beforehand to adopting a certain 'demeanour': a pose, an attitude, a style. The problem is, once you start running, who knows what might happen? The bodily 'composition' you had in mind for yourself can so easily disintegrate as the accent is placed on speed at all costs. And who knows what obstacles will present themselves? But at least it only lasts as long as it lasts, as it were. No permanent record to live down. A series of live, living portraits, then, whose mortality is ensured by never standing still and, with each repeated exposure, never being exactly the same.

The artwork is by Martin Creed and is simply allocated a number for a title – *Work No.850* – as part of an expanding œuvre, some of which (not this one) have subtitles, too. Whether or not the artist is familiar with free running, I don't know, but it is also, in a way, neither here nor there. The interesting point of which to take note is the increasing sense of an *implicit* conversation taking place between contemporary artists and the 'street' and/or 'street art'. Wallinger's *State Britain* installation in 2007 had already swept a remake of Brian Haw's anti-war assemblage lock, stock and banner into the Duveen Galleries, forming but one, small visible segment of a circular zone whose radius was exactly one kilometre from the original Parliamentary Square site (as Chapter 3 explained). Creed's runners meanwhile appear, similarly, to have come breezing through the front door of the Tate – like lost joggers or, more aptly, a team of *traceurs* – tracking the exact same line and disappearing a few moments later out the back door. Of course, when it comes to free running there are evident differences. Whilst Creed's runners must also negotiate an unpredictable obstacle course of 'surprised pedestrians', they have no intention of interacting directly with the Duveen's architecture. No gymnastic flourishes as such. But, although Creed's runners keep coming back for more, the basic brief is the same: forward motion only, efficiently and at speed. And, not only is the weaving run quite possibly how a

traceur would also choose to negotiate the galleries – since there aren't too many obvious, high-risk 'turns' that offer themselves anyway – but the momentary 'switching on of a light' that is effected figuratively for the spectator replicates the intensity of *parkour's* 'poetic interludes' of which I spoke earlier.[29] Where the latter might make for a momentary 're-seeing' of the city, here, in the grand neoclassical interior of the Duveen Galleries, accustomed as they are to exhibiting formal, petrified figures in stone and bronze, it is art that you might see 'differently' for a (lasting) instant. Where normally the viewer moves, from sculpture to sculpture, here the sculpture moves and the 'shock' makes 'petrified' spectators of all of us: your reaction, in the first instance, is automatically to freeze your position. As Katharine Stout puts it in her short catalogue essay: 'Just like a performance, Creed sees looking at art as a theatrical experience, a kinetic activity that relies just as much on the live presence of the viewer as on the existence of an object in time and space' (Tate Publishing 2008: no page numbers). Not unlike the runner, then, the spectator too is momentarily 'exposed', jogged perhaps into self-conscious uncertainty, even crisis, over what constitutes the province of *art*. Interesting, following from this, that the art critic Adrian Searle should happen, in his review of the piece, to make use of vocabulary very similar to Dyer's description of flash mobs and its variant, mobile clubbing (with which the chapter commenced): 'The great thing about Creed's *Work No.850* is that it is gloriously pointless, a repeated explosion of vitality' (2008: 11). As we saw with Dyer's 'ingenious pointlessness', Creed's artwork acquires its point – indeed, becomes an artwork – at the moment of contact with a witnessing public, in the reaction it elicits in context. And one of those responses, incidentally, may well be *conversation*.

I have mentioned the various possible conversations between artworks and the city, artworks and artworks, artworks and the public, and so on. There is also, though, the important instance of that which Stevens refers to in his analysis of the ludic city as 'triangulation', which he derives from the sociologist W.H. Whyte: 'that process

by which some external stimulus provides a linkage between people and prompts strangers to talk to each other as though they were not' (in Stevens 2007: 62). In other words, the powerful urge is stoked to 'commune' with a fellow stranger over the otherness of a 'third stranger' (in the form of an occurrence or event). Not being in the habit of drawing gallery attendants into conversation, I surprised myself a little by ending up in a protracted and, by turns, informative and amusing dialogue with one of them in the Duveen Galleries, which seemed in its revelatory tenor to confirm exactly the 'glorious vitality' of Creed's performance.

To pursue the conversation on triangulated conversations, Creed's *Work No.850* seems also to shout down the road to Gormley's artwork *One and Other* – mentioned earlier – for Trafalgar Square's fourth plinth in both its durational and time-based aspects: a prolonged series of short-lived, living portraits or performances, involving a controlled regime of rotating, signed-up members of the public. Where Creed's work takes risks in giving licence to an act normally prohibited within the day-to-day functioning of the museum – one which *could* lead to collisions and injury, for example – Gormley's also seeks to challenge an ever-growing, stultifying tendency to take measures to guarantee personal health and safety at all costs. In Gormley's own words: 'We live in a totally risk-averse culture and time, where people want to be insured against everything. Part of my proposition – or my provocation – is to say, let's do something that is about exposure of vulnerability, that actually does put people on the line' (in Barkham 2008: 24).

Gormley's plinth – upcoming at the time of writing – which effectively will have offered members of the public the opportunity for just one hour to 'perform their own space' in the city – to take themselves outside of themselves or be both 'one and other' – seems, in turn, to act as a playful interlocutor for his own major 2007 installation *Event Horizon* over the river at the Hayward art gallery. Or, more accurately, precisely not *at* but *around* the Hayward. This was an ensemble of some 30 human-size – or at least Gormley-size at six foot

18. Antony Gormley, *Event Horizon*, South Bank Centre, London, 26 May 2007.

four inches – fibreglass or cast iron standing figures, dotted mainly in and around the rooftops of London's South Bank Centre complex, though a few found themselves on the other side of the Thames and some were 'grounded' (on Waterloo Bridge, for example). To bring the triangle full circle, as it were, I could not help – being familiar with the footage – but be reminded uncannily of Sébastien Foucan et al. in *Jump London*, working over the very same terrain with their stunning turns: a similar calibration of the human figure – of human *size* – in relation to the built environment of the city.

Where some may have seen the sinister anonymity of urban surveillance evoked in these inscrutable, sentinel-like figures watching from above, others may have perceived a form of exhilarating humanisation of grandiloquent architecture, not least the 1960s brutalist concrete of institutions such as the National Theatre and the Hayward itself. Others yet may have sensed the creepy chill of an alien threat: invaders from beyond the uncharted territories of the 'event horizon' (or the boundary of the observable universe).

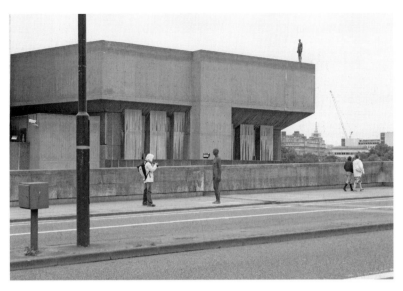

19. Antony Gormley, *Event Horizon*, Waterloo Bridge, London, 26 May 2007.

Whatever the case may have been, these figures exuded their extraordinary presence – and this is where they differ from the free runners – through *stillness* and through their seeming ubiquity. Once you found yourself within the environs of the South Bank complex, they just seemed to keep popping up here, there and everywhere. Eventually, intrigued by them, you might have begun to seek them out, counting them perhaps, delighted when you spotted one way over the other side of the river. An urban network of coordinating figures, not exactly signalling to one another – like Trish Brown's rooftop dancers in Manhattan once did[30] – but clearly connected by virtue of their studied *thereness* as an ensemble and, as you realised when you visited the Gormley exhibition in the Hayward itself (entitled *Blind Light*), their *gaze*: looking out towards the London skyline from the gallery's sculpture terraces, it became apparent, gradually, that these figures were all looking towards the Hayward and, by implication, *you*.

Just as Creed's runners proposed a form of repeatedly disappearing kinetic sculpture that momentarily turned visitors into stock-still

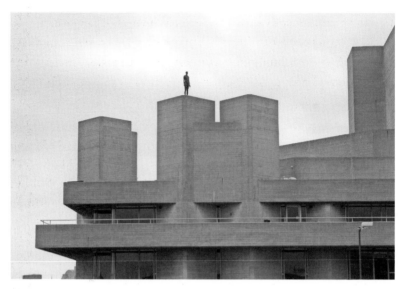

20. Antony Gormley, *Event Horizon*, Royal National Theatre, London, 26 May 2007.

'objects', Gormley's figures implicate the viewer. The sculptures you might customarily find exhibited on the terraces have been displaced to the rooftops of the city and you, the spectator, have taken their place at the epicentre of this invisible web that has been spun. Thus, you are effectively being invited to position yourself in relation to the urban horizon demarcated for you. Your being there, looking out, *is* the event in question. And the city these figures accentuate is no mere backdrop – a dull, flat 'panorama' to be stared at blankly, to be consumed – but a dynamic spatial configuration that implies an exchange of looks. As Anthony Vidler suggests, then, with regard to the effect of this reflexive relationship with Gormley's figures: 'we are, one by one and together, constructed as architects of our own spaces and thus invested with the analytical and constructive power both to think as well as to create space' (in The Hayward 2007: 84). But it is also important to recognise the relationship is not an encounter with a dramatic 'other', for these are not personalised statues. In fact, their appearance, depending on the conditions of light and their

proximity, is frequently that of silhouettes, inviting an inquisitive projection beyond the outer limits of the observable city. As figures they 'produce' space, enabling the observable city to be fore-grounded, but as bodies they disappear – like *traceurs* – luring you into their 'black holes', as if they were asking you what it is that you want from the city.

A year after *Event Horizon*, one of the Hayward sculpture terraces had turned into a pond. Not the result of heavy rainfall and blocked drains but an artwork by the Austrian collective Gelitin in an exhibition entitled *Psycho Buildings: Artists Take on Architecture*. The artists are renowned for their creation of 'anarchic art events' or 'demented playgrounds' that situate spectator-participants in 'psychic environments'. In 2000, they illicitly installed a temporary balcony from the 91st floor of one of the World Trade Center towers in New York.[31] As Matsui explains, for the visitor to this 'artist residence', as it was called, the effect was intended to turn the tables on them from the safety of a voyeuristic viewpoint to acute exposure:

> The act of standing for a few minutes on the balcony made them physically experience the precariousness of their condition, which they had created but could not control. By changing the spectator's position from the inside to the outside, the performance transformed the effect of overlooking the world from a high window from a sense of omnipotence into feelings of vulnerability.
>
> (in The Hayward 2008: 75).

Entitled *Normally, Proceeding and Unrestricted With Without Title* (2008), the Hayward 'pond' was in fact a boating lake. Visitors were able to clamber into small, makeshift rowing boats, just big enough for two, and go for a quiet little paddle in the shadow of the South Bank complex's surrounding buildings. Paradoxically, then: an island of water engulfed by concrete jungle. The effect

was truly bizarre, not least for the implied danger of simply drift-
ing over the edge, since the surface of the water was on a level
with the very rim of the terrace. Psycho terror: like dropping off
the edge of the world. Compounding this sense of surrealism was
the calm serenity with which people seemed to commit to the ac-
tivity in spite of the distinctly home-made, wonky feel of the little
wooden 'tubs' that had been cobbled together out of found materi-
als. Of course, despite the ramshackle appearance of the operation,
and the fact that water could indeed be seen spilling over the rim
of the terrace from below, the real challenge for the participant was
whether or not they wished to perform on this floating stage. Shades,
then, of Gormley's fourth plinth conceit. With only three boats per-
mitted at a time the pond's open and central positioning in this
crucible of London's performing arts world represented consider-
able exposure. Above all, the real vertiginous terror that had to be
confronted was the possibility of making an utter fool of oneself:
getting stuck on the outer rim of the pool, failing to master the oars,
falling in.

Shades of Gormley, but shades too of Carsten Höller's astound-
ingly popular *Test Site*, which had taken place a little further along
the South Bank, a commission for Tate Modern's Turbine Hall in
2006-07. Five shiny slides – stainless steel and glass tubes in effect –
normally associated with playgrounds or amusement parks, spiralled
their way down from the building's several levels. Queuing to re-
serve a time slot, the decision for the visitor was which level they
would dare to slide down from. Before that, though, there was the
key conundrum of whether or not to take part at all. Many contented
themselves with merely beholding the spectacle at one remove, rather
than donning the few precautionary items of safety gear – protective
cap and elbow pads – and poking their feet into a form of 'sack mat'
to ensure adequate 'slipperiness' on their way down. The last thing
the operation wished to countenance was a mid-slide collision – ef-
fectively mid-air, if you think about it – owing to someone getting
stuck. In fact, given the sheer turnover of participating members of

the public, the hazards, particularly from the highest slide on Level 5, which performed four main snaking turns, seemed considerable. On the other hand, it was probably nothing that careful organisation and monitoring couldn't handle. Once you were on your way the loss of control was palpable, though: not only was there no going back but no slowing down or stopping either, at least until you arrived at the bottom. My personal experience in those few seconds – the longest slide was 58 metres long – of subjection to this centripetal force was that of my entire body coming apart: the carapace containing my sense of self, my physical composition, being stripped away mercilessly. And that 'lost composure' reached its highest intensity, its maximum exposure, just as I 'came home', as I rounded the final bend to be met by a sea of gawping faces. If ever there was a moment for the ground to open up and swallow me that was it. Hurriedly I joined the crowd myself, in order to disappear but also to relish the next victim's self-consciousness as they were catapulted into the limelight. And, yes, you could definitely see the signs of their 'inner dying', mainly in the tactics they employed to 'save face', but probably only because you'd been there yourself.

Test Site represents a challenging experiment premised on 'dangerous play'. Like the risk-taking adventures of childhood it offers itself as a means of testing the ground of your place in the world – of determining the kind of person you wish or dare to be – beginning with the fundamental, yea or nay-saying question of whether to take part or observe: are you a performer or spectator in your everyday life? But the artwork was also an experiment for the artist to see whether such 'fun slides' could feasibly be adapted and integrated into the urban landscape as functional modes of conveying members of the public. A kind of prototype, then, which, if it worked successfully, could serve as a fantastic advertisement for the proposal. As it happens, Höller had already tried out such slides in several real contexts – a small office block in Milan had one in an enclosed courtyard, involving minimal use – but the Turbine Hall installation effectively afforded the possibility of seeing whether it was viable with a mass public

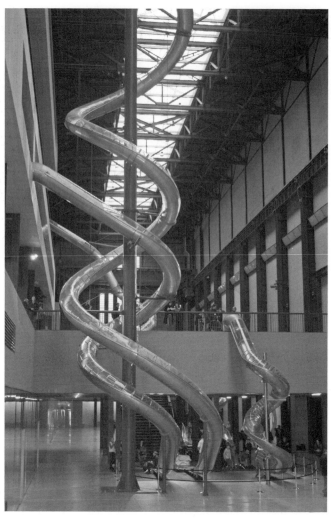

21. Carsten Höller, *Test Site*, Tate Modern, London, 9 December 2006.

on a large scale, and the accompanying catalogue provided several hypothetical instances of its application in London sites, as well as a full-blown feasibility study for a comprehensive implementation of Stratford town centre in east London.[32] The intriguing point about a potential development such as this, between artwork and urban functionality, is the way participatory play, incorporating members

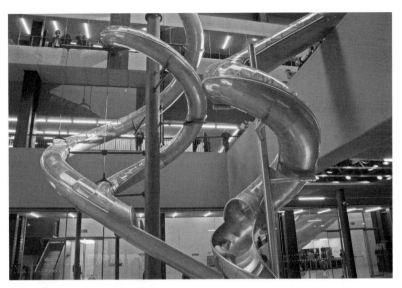

22. Carsten Höller, *Test Site*, Tate Modern, London, 9 December 2006.

of the public, becomes the inherent motor for a radical shift in the culture around pedestrian mobility in the city. As such the artwork's twin, democratising premises of participants engaging in a process of risk- and responsibility-taking, as a prerequisite of its functioning, stand to become absorbed productively into public spatial practices.

What I have tried to show with all of the artworks discussed in this section – if not the chapter as a whole – is the growing extent to which a highly dynamic relational exchange exists between art, play, a participating public and the built environment of the city. As Rancière's identification of the four main types of contemporary art – 'the game, the inventory, the encounter and the mystery' (in Bishop 2006a: 88) – suggests, increasingly various aspects of play, located somewhere along Caillois's continuum from *paidia* to *ludus*, are being absorbed into art practices. And central to their realisation is the viewer's positioning: the implications of the relationship he or she chooses to take to the artworks in question. Not only that, but

to a significant extent the spatio-scopic arena or point of reference for the performance of this relationship is the 'urban playground'. Thus, art serves as the medium by which to interrogate and negotiate your place in the city as well as to recognise the city's place in you.

5 Berlin, Vienna: Performing Holocaust memory

In the Eisenman project, as in Whiteread's, the concern seems not so much to iconically represent "memory" as to emulate its process. But where Whiteread inserts her work into the processes of everyday experience, acting on and within a subject/viewer's own memory work, Eisenman emulates those processes of remembering and forgetting in the generation of the architectural object itself, leaving traces of this generation as clues wherein the subject/viewer, attempting to reconstitute the process of generation, will by analogy, so to speak, exercise its memory. Whiteread, so to speak, turns to the memory of life, Eisenman to a figurative emulation of that memory in the parallel memory of the architectural object.

Anthony Vidler, *Warped Space: Art, Architecture and Anxiety in Modern Culture*

NOT JUST A GAME

It is early April 2007. I descend on Berlin in sparkling, late-afternoon sunshine, but it is chilly. The last days of an eastern German winter,

the first of spring. It's five years since I was here last and there seems to me to be a certain *quietness* in the city. As if the excitement were all over. Perhaps it is just a seasonal thing. Long Berlin summers are renowned to be the time of year when the city really gets going. Without hesitation my first port of call later that same day is Peter Eisenman's *Memorial to the Murdered Jews of Europe*, situated centrally between Potsdamer Platz and Brandenburg Gate. Finally unveiled – if that's what you do with a site the size of three football pitches – in 2005, it is without question the most significant development in Berlin of recent times: a 'late arrival' you might say after the 'heady decade' of rapid-fire urban change that followed the reunification of Germany. In fact, the story of the memorial's 'hold-up' is truly protracted, given the initial campaign towards its realisation began in 1988, before the Wall had even fallen. Like the city's battle over the future of the former East German Palast der Republik about a kilometre away[1] – in which it was the complex narrative of East-West relations, past, present and future, that was at stake – the agonised, drawn-out nature of proceedings involving the Holocaust memorial was indicative of the occurrence of a profound collective 'unearthing': how a reunified Germany – which wasn't exactly unified as yet – wished to memorialise the sinister Nazi legacy.[2]

It is late evening now, but the memorial site is commonly known to be open and accessible at all times, and my urgency to witness it first thing is driven partly by a curiosity over what happens to it in darkness. Alighting at Potsdamer Platz – the one-time 'Piccadilly Circus' of pre-Second World War Berlin – my sense of 'nothing happening' seems to be confirmed. The huge station is bereft of travellers and, above ground, the new super-architecture, with its cheerless, windswept expanses of built space, is – more predictably perhaps – similarly abandoned. Unlike Eisenman's memorial, this very high-profile complex of buildings, involving several internationally renowned architects, emerged with extraordinary haste after the fall of the Wall. The prime 'no-man's land' on which it was constructed was snapped up and distributed by developers and major

global corporations respectively, before even the city authorities could step in and properly assert the building principles of 'critical recon-struction', as they were to insist upon elsewhere in the city.[3] At night the glittering lights are certainly on in this part of town, but no-one appears to be partying. A zone strictly for big business and daylight shopping it would seem.

As I make my way north towards Brandenburg Gate, I am met presently – on the corner of Hannah Arendt Street to be precise – by a vast expanse of hushed darkness. Before me lies a shadowy, gen-tly undulating sea of some 2,700 oblong, concrete blocks (or stelae). Crossing the street, I notice that the narrow, rising and dipping paths of its grid structure are lined east to west with footlights that emit a faint, ghostly glow. Every so often eerie bursts of hysterical squealing and screeching puncture the night air. Some teenagers – French-speaking by the sound of it – are trying to scare one another somewhere in the middle of this concrete ocean. As I catch glimpses of their shadows flitting about, I am surprised by the sudden ap-pearance of two uniformed guards, skirting the perimeter of the site. Just as I was thinking that the youths' implicitly irreverent behaviour was the price you have to pay for permitting continuous unrestricted access. But the guards amble by in quiet conversation, merely doing their rounds it would seem, unperturbed by the mucking about. This act of tolerance takes me aback all the more when I stumble upon a plaque of 'commandments', literally set in stone in the pavemented ground on the fringes of the memorial site: 'Rules of Etiquette for Visitors to the Field of Stelae'. They clearly state, amongst other stip-ulations: no noise-making, no climbing on or jumping between the concrete blocks. When I return in daylight the following morning there is another small group of mildly exuberant youngsters – also French-speaking as it happens – similarly playing a form of hide-and-seek without restraint. In addition, at various points during my visit, individuals could be seen clambering or standing on the stelae as well as leaping between them, again without any noticeable security intervention.

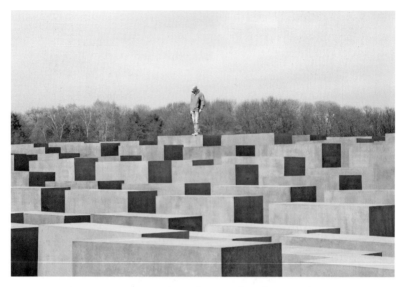

23. Peter Eisenman, *Memorial to the Murdered Jews of Europe*, Berlin, 5 April 2007.

I find myself torn. My physical instincts suggest to me that this is the perfect site for improvised movement. Dancers or, above all perhaps, free runners would have a field day here (as I'm sure some have). Structurally, it presents a veritable *invitation* to play. Moreover, being a public site with unconstrained access at all times, how valid – let alone feasible – is it to seek to control behaviour? More to the point: how valid is it to invoke the spectre of 'German-speaking uniforms' rounding up perceived 'trouble-makers', backed by stated decrees of permissible behaviour in public? (The rules that purport to curb such activity are only relayed in German incidentally, which is unusual for such sites of international significance and strangely oblivious to the high volume of foreign visitors.) On the other hand, lest we forget, this is a memorial to the murdered Jews in Europe. And many voices have been raised since its inauguration in protest at 'unseemly behaviour'.

In considering the question of etiquette, I would like to em-phasise, first, the participatory premise of Eisenman's site. This is a

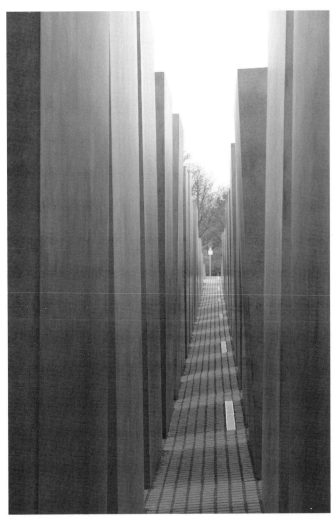

24. Peter Eisenman, *Memorial to the Murdered Jews of Europe*, Berlin, 5 April 2007.

walk-in installation for *people*. Its functioning is contingent, in fact, upon the desire of visitors to enter the network of axes, 87 (east-west) by 54 (north-south), and to *explore*: to savour if not *make something* of the experience. It is neither, as is often thought, according to Christoph Heinrich, 'an impenetrable chaos, nor an oppressive

labyrinth' (in Schlör 2005: 38). Its grid layout, which is reminiscent to some extent, though not by design, of an abstracted Manhattan in small, with its pattern of high- and low-rising blocks – a kind of city within a city, then – is, in itself, transparent as well as open-ended on all its flanks. You are hardly likely, therefore, either to lose your bearings or to perceive as 'monumentally overbearing' the effect of finding yourself in the midst of this nearly two-hectare field of concrete stelae, even when they seem to engulf you, as they certainly can in places. Nevertheless, its narrow paths – affording passage for no more than one person at a time, unless you happen to fancy attempting an intimate 'squeeze past' with a stranger – its multiple options to turn left or right, to retrace your steps or carry on, and the undulating nature of the ground on which you tread do all generate a sense of temporarily submitting to a 'different order' of interaction, one which implies a certain adjustment of 'public interface'.

Whilst one of the undoubted rewards of the memorial for the visitor is *watching*, with detachment, as the chance choreography of people combing their way through it unfolds – the urge you feel to gain a panoptic view of this is palpable, but not really possible – it is also noticeable how your own movements fall into a form of ongoing game-playing: an implicit peek-a-boo of appearance and disappearance brought about by the need to negotiate the constricted spaces of the installation. Parties of people – friends, family, school groups – inevitably lose sight of one another and can frequently be observed turning the act of tracking down their acquaintances into a pleasurable, repeated activity. But individual strangers become engaged in a quite curious, almost disconcerting game of territorial negotiation: if, as you stop at one of the many intersections and peer down a particular axis, someone walks into view and your gazes momentarily meet, either one or the other invariably feels compelled immediately to move on. In other words, in order to dispel the sense of uncertainty that arises around the status of the exchange, and so as not to be 'misunderstood', something has to give way. The available space – and this can even happen at some distance – is too confined,

rendering any such meeting of gazes 'unbearable', but somehow the weight of that which haunts the scene makes it all the more so. A trigger reaction to a prevalent sense of both unease and not-quite-knowing-what-to-think which to some extent determines the route you end up taking through the grid, and which is surely replicated over and over. Observing these negotiated interactions on a motion-capture screen, for instance, they would doubtless appear as random movements, as chaos, whereas it can be argued there is actually a barely perceptible, kinaesthetic 'ordering mechanism' that is driving them.[4]

The general point I am trying to make, though, is that Eisenman's site provokes various forms of physical and behavioural response but does not seek to prescribe any of them specifically. Nor, going by what I witnessed, does it appear to curb any of them (though excessive abuses would, I suspect, be subject to a formal intervention by security). The premise of such a position seems to imply that you cannot enforce remembrance as such – far less the exact content and tenor of that which you would seek to have remembered – particularly if it relates to memory of something that is 'cultural': inherited 'memory', at one remove, rather than memory of first-hand experience. And that is precisely the site's *gift*. It is not a shrine or monument in the customary sense: a place neither of mourning (*Denkmal*) – amongst other things, somewhere for 'esteemed visitors' to dump tokenistic commemorative wreaths, as was one of the main fears in the debate over whether to countenance such a memorial – nor of warning (*Mahnmal*), but an integrative presence in the centre of Berlin.[5] A quiet, rippling *force*; quiet, but difficult to ignore. It has no need to signal, monumentally, what it is because that is already *known*. Its reputation precedes it. As such, the memorial quite patently pertains to the Holocaust, but it does not aim to *represent* or stand in for the memory of it. The site is an abstract one, open to interpretation – and, importantly, *use* – in a whole range of ways. But it is also pre-coded: as visitors we know what it is we are supposed to be dealing with here, which sign we are under so to speak, and our behavioural

responses are calibrated accordingly. If it turns out that our homage takes the form of spitting on the stelae and snapping the branches of some of those saplings growing amongst them, then this act of vandalism speaks volumes about the existence of certain prevalent attitudes to the national socialist legacy in Germany. And we should know about them. If, as a younger generation, we are impelled to play hide-and-seek (or whichever game) at this site, then perhaps this is not as disrespectful or incidental as it appears. Perhaps it has everything to do with the inherent function of such games to 'play safely with fire': a sanctioned courting – pleasurably resolved – of fundamental human anxieties and emotional pains around loss, failure, abandonment, disappearance and death. And if our inclination is to wander silently in private prayer, but we are disturbed in this activity, it is indeed unfortunate, but our complaints can be heard and therefore contribute to an 'emerging picture' of the central question of what the Holocaust means in contemporary Germany and, moreover, what it means to perform its memory. Eisenman's memorial should, and indeed does, allow these agonistic narratives to be played out. To give an example of one such narrative 'in play': one of the most poignant ironies of the new site was the discovery, at a very late stage in its construction, that the graffiti-busting chemical being used to treat the stelae had been produced by one of Hitler's 'model companies' Degussa. My point is not that this kind of controversial 'overlaying' of the site is 'all fine' – as 'fine' as the graffiti would have been that might have adorned the stelae had they not been treated[6] – that things change and we have to move on. Instead it is that such occurrences are indicative of and instructive about the Germany of today, and this includes the public response of being outraged by such scandals. In other words, they reveal, in this particular case, that such ex-Nazi companies were not disbanded, that they are indeed still very much alive and well, not exactly run by Nazis (as GDR officialdom was content to claim), but certainly free to turn huge profits in a way that sticks in the craw given that they were not really taken to task for their wartime activities in the form of reparations, for instance.[7]

It is important, nevertheless, to reiterate that a standpoint which allows for the kind of 'open play' I am talking about is really not meant in the colloquial sense of 'anything goes' or an indifferent 'whatever': a wilful turning of Eisenman's installation into a play-ground, which suppresses the seriousness of what is at stake. Instead it is made on the basis of an understanding of *this site as designated Holocaust memorial*. Thus, the way the site works implies the implementation of a form of self-regulating ethical practice and responsibility-taking. As I have suggested, participants know under which sign they 'perform'; they are 'forewarned', as it were, but given licence to act as they see fit under those terms. But it also suggests the embodiment precisely of the spirit of some graffiti sprayed on to the earmarked site's temporary fencing in 1997, which declared: 'The debate is the memorial!'[8] However, it is, paradoxically, a 'reverse embodiment' inasmuch as the slogan would now read: 'the memorial is the debate'. In other words, the sentiment expressed by the graffiti of keeping the debate alive, fluid and public has ended up being enshrined in Eisenman's design in defiance of the graffiti's obvious fear that no memorial *site* would be able to do this. The latter position had been advocated first and foremost by the influential American academic James E. Young, whose strict view early on in the lengthy debate had been that there should be no physical memorial at all:

Rather than looking for a centralised monument, I was perfectly satisfied with the national memorial debate itself. Better, I had thought, to take all these millions of Deutsch marks and use them to preserve the great variety of Holocaust memorials already dotting the German landscape. Because no single site can speak for all the victims and perpetrators, the state should be reminding its citizens to visit the many and diverse memorial and pedagogical sites that already exist. [. . .] With this position I had made many friends in Germany.

(2000: 193–4)

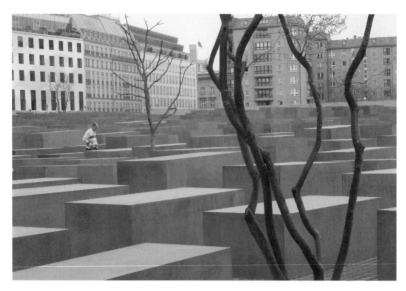

25. Peter Eisenman, *Memorial to the Murdered Jews of Europe*, Berlin, 5 April 2007.

For Young, rather than provoking memory of murdered Jews, a 'great burial slab' (as he put it) would instead 'be a place where Germans would come dutifully to *unshoulder* their memorial burden, so that they could move freely and unencumbered into the twenty-first century. A finished monument would, in effect, finish memory itself' (194). However, he subsequently reversed his view when he recognised, 'What had begun as an intellectually rigorous and ethically pure interrogation of the Berlin memorial was taking on the shape of a circular, centripetally driven, self-enclosed argument. It began to look like so much hand-wringing and fence-sitting, even an entertaining kind of spectator sport' (195). This led to Young's appointment as a member of the jury for the recast competition launched in 1997.[9] For him, 'the missing Jewish part of German culture remained a palpable and gaping wound in the German psyche – and it must appear as such in Berlin's otherwise reunified cityscape' (196).

In that sense, then, Eisenman's memorial emerges not only as the physical manifestation of an ongoing, polyphonic, sometimes

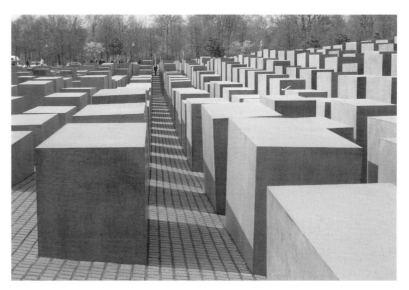

26. Peter Eisenman, *Memorial to the Murdered Jews of Europe*, Berlin,
5 April 2007.

amplified, conversation – a public forum where accumulated actions
speak louder than words – but also as the demarcation – the conscious
occupation, if you will – of a highly codified, conflicted central urban
location. The site's built form as a whole evokes a gentle fluidity. The
stelae, all the same size, 'grow' at differing heights from the undulat-
ing terrain, although they do so proportionate to one another, which
produces the effect of surface ripples. (Some stelae on the fringes
are, in fact, wholly interred). An emergent groundswell, if not mild
tidal wave, sweeping through the centre of Berlin in a manner that is
indicative of the ebb and flow of both history and debate in this city.
At the same time the memorial's structure suggests a kind of 'hori-
zontal striation': a criss-cross of rectilinear axes whose rhythmic order
is subtly irregular – caused by stelae that appear not quite straight or
upright – and whose lines can be visualised, given the site's openness
on all sides, to cut beyond the memorial and deep into the sur-
rounding urban landscape. With occasional saplings dotted around
the memorial's western flank, the adjacent Tiergarten – Berlin's vast

'Central Park' – looks to have encroached upon it, a gradual *growing into* the site, which enhances the sense of its 'coming integration' into the city. Its other flanks situate it, of course, between the post-1989 Potsdamer Platz business and shopping hub, Brandenburg Gate and the Reichstag Parliament: iconic landmarks of Berlin history and the evolution of German nationhood as a whole. This is the exact terrain of Cold War separation and deadlock: the former death strip (*Todesstreifen*), in fact, between eastern and western walls. This zone is the only possible place where the physical joins of a reunified cityscape *can* be located. But it is also the exact site of Germany's one-time centre of governmental power and, therefore, inevitably ground tainted by national socialism. The memorial location itself was flanked by several 'ministries of the Reich', which as governmental buildings preceded the Nazis, of course, but nevertheless later came to epitomise Hitler's rule, not least the Chancellory that was his formal headquarters. Embedding the memorial *here* amounts to an extraordinarily powerful, palimpsest-like rewriting of this critical urban site. It not only proposes an engagement with both Nazi and Cold War pasts but also acknowledges the legacy of the Holocaust as a phenomenon that must be allocated central importance in Berlin's emergence as Germany's seat of government and capital city of choice after reunification.[10] Here is where the orders of war and mass extermination emanated from. Here is also where disillusioned GDR citizens stood to be executed as they made their vain bids for western freedom. And here is where these histories now lie entombed in Eisenman's stelae where they are subject, though, to myriad performances of continuing human life as a multitude of bodies filter through the spaces between them. These are not performances of absolution or 'reckoning', penance or purging, but of 'keeping alive', of survival: a remembrance of things present.

I have deliberately steered clear of the specific detail of the 'protracted debate' around the development of a Holocaust memorial in Berlin, partly because this is already well documented and discussed elsewhere,[11] and partly because its true force and complexity naturally

preceded the construction of the memorial itself (as public installation). The latter may sound like rather an obvious point to make, but in fact there are more public artworks and sites than not where the discussion and controversies around them are *instigated* by the 'thing itself', rather than merely the proposal or *idea* of its implementation. My focus has attempted to work from the final realisation of Eisenman's site as an interactive, memorial artwork, including naturally my own encounters with it. One thing that is important to recognise about that preceding debate, though, is its systematic working through of an enormously comprehensive and involved list of factors relating to fundamental questions around *who* exactly the memorial should be for (including whether it should incorporate non-Jewish constituencies that were persecuted, such as homosexuals and gypsies), *what* exactly the act of remembrance entailed (and how that might relate to matters of healing and forgetting), whether another memorial was even necessary (given the perceived abundance of existing ones in the city, let alone Germany), *where* it should appropriately be located, whether it would do adequate justice to its cause, and so on. Apart from the institution of two major rounds of competition and the general twists and turns of the debate, the importance of what was at stake is reflected in the fact that the final go-ahead for the memorial was dependent upon the German Parliament – the new one, itself only ensconced in the Reichstag in Berlin for a matter of weeks at the time – passing a resolution of principle sanctioning its construction (which it finally did on 25 June 1999). But it was not merely a discussion about historical and political issues. It was also one of aesthetic form, specifically as this related to the performance of memory. So, although the artwork as such was in absentia, a rich conversation about the nature of public art also took place, initially facilitated and given urgency to no small degree by the sheer volume of proposals submitted. In other words, there was some positive understanding in the debate, as it proceeded, of past failures (as well as perceived successes) and the need to interrogate, as well as disagree about, what actually *works*. The downside of this, of course, is

that artists in particular can feel their ideas are utterly compromised by being made subject to the decisions and stipulations of a committee and the variously opined public that stands behind it. It was no surprise that the sculptor Richard Serra withdrew from his joint proposal with Eisenman when a condition of winning the competition was to make all manner of adjustments, not least to integrate more obviously commemorative and educative features.[12] (Arguably architects like Eisenman are more amenable to negotiation and consensus decision-making, accustomed as they are to working to strict commission and with several contributing partners.) Under such circumstances of public scrutiny and sensitivity, the fact that Eisenman was able to hold out with such an open, abstract design concept, which emphasises the legacy of the Holocaust as a collective matter for contemporary Germany to weigh as a phenomenon that *happened* and not one that is usefully served by emotively polarising victims and perpetrators, could be seen as a minor miracle (though, of course, it has its formal detractors too).[13]

THE SILENT 'H' WORD

Rachel Whiteread spent 16 months living and working in Berlin in the early 1990s at the absolute height of the city's post-reunification delirium. I have no idea to what extent she will have tuned into the specific debate over what was eventually to emerge as Eisenman's Holocaust memorial, but she has certainly acknowledged the importance to her as an artist of immersing herself in both the literature and the 'haunted sites' of the Nazi past whilst she was there, not least with visits to concentration camps in the 'newly opened' eastern block.[14] As such she saw herself as 'equipped', to some degree, to accept an invitation not long after this sojourn to submit a proposal for a Holocaust memorial in the Austrian capital Vienna, though in truth she harboured no expectation whatsoever of actually winning the closed competition (which, as it happens, Eisenman had also been

invited to enter). The awarding of the commission in 1996 marked the onset of another Holocaust memorial drama of agonised wrangling, although, with the installation's inauguration taking place on 25 October 2000 in the city's Juden Platz (literally, Jews Square), not one that was anywhere near as drawn out as the public discussions in Berlin. More to the point, as the artist herself is quick to admit, 'I had never been to Austria, and I looked at this project and thought, very innocently, that Vienna would be an equivalent to Berlin, and it would be an interesting place to try to make a memorial to such atrocities. [. . .] When I went to Vienna, I didn't realise that the politics would be so different from the politics in Berlin' (in Dailey 2001: 58). Although one of the key questions of the Berlin debate had revolved around the danger of 'saturation' and 'fatigue' when it came to the public reception of Holocaust memorials in the city, Whiteread's intervention in Vienna demonstrated vividly that no single context produces the same set of circumstances as another, even if it is the same 'governing event' or slice of history that serves as the point of departure. In other words, there certainly is no such thing as a generic template that might be applied to the performance of Holocaust memorialisation, far less one leading to a quantitative calculation that a limit had been reached. Each context has its specificities, not least in terms of who and what the subjects of memorialisation are. The formal title of the Vienna installation, *Memorial to the 65,000 Murdered Austrian Jews*, in itself exemplifies the particularity of which I am speaking.

A decisive factor in Vienna, one that truly highlights the importance of instigating the siting of such contemporary artworks in contested urban locations, is, as James E. Young points out, that

> unlike Germany's near obsession with its Nazi-past, Austria's relationship to its wartime history has remained decorously submerged, politely out of sight. Austria was a country that had (with the tacit encouragement of its American and Soviet occupiers) practically founded itself on the self-serving myth that

it was Hitler's first victim. That some 50% of the Nazi SS was composed of Austrians, or that Hitler himself was Austrian-born was never denied. But these historical facts also never found a place in Austria's carefully constructed post-war persona.

<div align="right">(in Townsend 2004: 169)</div>

If I talked of events around the Berlin memorial as a metaphorical process of 'unearthing', that term is all the more apposite here inasmuch as it applies in both literal and figurative senses of the word. Although, as Whiteread explains, 'it was always clear that the archaeological remains of the former synagogue, which burned to the ground in 1421, lay under the site', a factor that the 'initial proposal took into account' (in Searle 2000: 12), one of the sticking points, which ironically resulted in some members of the Jewish community resisting the construction of the memorial, was that these vestiges of the medieval synagogue – the flooring and foundation being freed up and made visible by excavation work for Whiteread's installation – would not be accessible to the public in the long term. The artist's reference in passing to the synagogue's burning down doesn't exactly convey the profound seriousness of what had been a series of pogroms sweeping the fifteenth-century city: 'a campaign of violent persecution by the Catholic Church had led dozens of Jews to commit suicide inside the synagogue, rather than renounce their faith' (Connolly 2000: 5). To this day, moreover, there is a celebratory, anti-Semitic plaque set into the facade of the oldest house in the square, which was 'added in 1497 as a reminder of the efficient eradication of the city's Jews during the pogroms of 1420–21' (Pages 2005: 109). Although the appropriateness of overlaying the subterranean remains with Whiteread's memorial continued to be disputed within the Jewish community itself, a compromise was eventually reached on the basis of moving the artist's installation one metre, thus freeing up the synagogue's foundations for public viewing. Access was facilitated and a display of related artefacts made available to the public

via the Museum Judenplatz situated at one end of the square: the so-called Misrachi House which had existed since 1971 as a small Judaic information and research centre.

Figuratively speaking, however, the disinterment provoked by the memorial was far more earth-shattering in this 'Freudian city': a retroactive unsettling of the 'collective psyche' of Vienna, whose mindset – that of the historical myth of Austrian non-complicity and innocence, even victimhood – was etched into the very built environment of the city. The matter of the medieval synagogue was one complicating factor, but there were several other 'players' in this performance of memorialisation, which, turned more and more into an uncanny enactment of undigested, repeating pasts in the present. From the workaday protests of local shops and businesses plying their trade in the square, whose principal objection appeared to be that the restriction of parking and proposed pedestrianisation would jeopardise custom, to the preservationists who argued for the retention of the square's 'original art historical and architectural integrity' at all costs, to the contemporary political reality of a powerfully emergent far-right nationalist Freedom Party (FPO) – welcomed into a national coalition government in Austria precisely in the year 2000 – the enclosed Juden Platz rapidly turned into a fraught, agonistic site of epic proportions that was emblematic of the conflicted state of the capital city and country as a whole.

As in my discussion of the Berlin memorial, though, my focus will tend to be the sited artwork itself rather than the twisting and turning details of the antagonism that preceded and eventually 'produced' it. Unlike Eisenman's proposal, which entered the Berlin debate at a later stage in proceedings – given that it resulted only from the rerun of the competition – in Whiteread's case it was far more the memorial design itself that seemed to stoke the debate in the first place (though that may well have been a smoke-screen relating to the disinclination to have a memorial at all). Moreover, where Eisenman was prepared to suffer all manner of conditions, which reflected a decade of public discussion, Whiteread was unwilling to compromise in any way when

it came to the form of the installation, categorically rejecting the idea of producing 'public sculpture by consensus', as she put it (in Searle 2000: 12). Nevertheless, it is worth pointing out that however much the artist may have stuck with her aesthetic concept, the narratives of controversy preceding its eventual siting inevitably became written into and embodied by the artwork, since it can only really be said to exist in its relational context. Implicitly, then, these 'writings' have played their part in producing what the memorial now is. The artist's own relationship to the work is quite interesting in this regard because it is fairly evident from Whiteread's comments in several interviews that she did not really wish to get caught up personally in the local or, indeed, national politicking.[15] Though by no means entirely detached from the situation, with the controversy having gone through several stages and the project as a whole looking time and again as though it might be pulled altogether, Whiteread did reach the point where she simply left matters to run their own course come what may. Far from placing a question mark over her commitment to the cause of her work – though she had every right to be 'fed up' – this attitude would seem to me to be premised more on the astute recognition of the fact that the artwork had done, and was still doing, its work in provoking debate. As such there really was no more she could do as an artist, perhaps particularly as a British artist in a highly contentious Austrian situation.[16] If the project did not in the end materialise in concrete form, that in itself 'spoke volumes' about the Holocaust legacy in the city (if not country). In fact, Whiteread's view in this respect is best exemplified perhaps by her position on the possibility of its defacement by 'undesirable tags' at a point where the memorial had finally been installed: 'A few daubed swastikas would really make people think about what is happening in their society, their culture. I certainly don't want to encourage it, but if it happens, it happens' (in Searle 2000: 12).

My interest resides, then, in considering how Whiteread's work functions as a construction in and of the present. This includes taking into account, first, the 'deferred action' of Freudian *Nachträglichkeit*

on a public scale, which Hal Foster describes as 'an event [that] is registered as traumatic only through a later event that recodes it retroactively' (1996: xii). And, second, the related idea of the 'return of the repressed' or the experience of the uncanny, which, as Victor Burgin puts it, encompasses 'what appears to come to us from the outside [but] is often the return of that which we ourselves have placed there – something drawn from a repository of suppressed or repressed memories' (1996: 95). The uncanny is a particularly relevant notion here because of the manner in which it effectively incorporates simultaneously – as Freud argues in his celebrated essay, and as several commentators have elaborated upon[17] – antithetical concepts of the 'homely' (*heimlich*) and 'unhomely' (*unheimlich*). The argument turns really on the fact that *heimlich* also means 'secret' (in fact, that is its more usual sense in everyday usage) and therefore suggests the 'warm familiarity' of homeliness, or the home as the protector *as well* of 'ugly secrets'. For Freud, then, 'it may be true that the uncanny [*Unheimlichkeit*] is something which is secretly familiar, which has undergone repression and then returned from it, and that everything that is uncanny fulfils this condition' (1990: 318). The architecture theorist Neil Leach provides an illuminating instance of the dialectic in operation, one that is particularly pertinent here: 'within the *heimlich* of the homeland there lurks the *unheimlich* of nationalism' (1999: 159).

Perhaps it's because I've just left behind me nearby Stephans Platz – site of Vienna's famous gothic cathedral of the same name, as well as a variety of stores and cafés and, therefore, a zone teeming with tourists and shoppers – but the first thing that strikes me as I enter Juden Platz is an innate sense of intimacy, of compact cosiness. Its location is central – in Vienna's 'first district' or 'old town' (*Altstadt*) – and you can approach it from as many as five different directions, but it feels self-contained and calm, pedestrianised and enclosed, as it is, by a 'pleasingly preserved' ensemble of largely Baroque build-ings. Sitting outside in one of its cafés, I am surprised to observe people behaving as if this were the square of, say, a small market

town: a mixture of purposeful and convivial activity in circumstances of familiarity. Near my table two elderly women have parked their shopping bags on the cobbled ground and are exchanging tales of their grandchildren. People hail their neighbours across the square or nod amiably as they pass one another. Clearly a *local* scene, a place of residents and quotidian business, despite the 'noble' appearance of its facades. Whiteread herself has referred to it as 'a domestic square amidst very grand buildings' (in Dailey 2001: 60). A cyclist rattles by and I watch as the youngster riding it pulls up alongside the *Memorial to the 65,000 Murdered Austrian Jews*, hitches it up on to its stand, clicks the lock into place and disappears through a doorway. Somewhere to park your bike, obviously. What strikes me, in turn, about Whiteread's installation – effectively an 'inverse library' on a slightly raised concrete dais – is the way its neat shoebox proportions (it measures ten by seven metres and is nearly four metres high), its material and colouring (a kind of off-white concrete), and its location towards the western end of Juden Platz, together propose a reassuring sense of 'blended rightness'. It seems at first glance to fit in, to chime well with its immediate surroundings. If you run your hand over its surfaces, moreover, as anyone can, it seems quite warm to the touch: not rough-edged concrete-cold at all, but more like stroking the smooth cardboard cover of a hardbound book.

Whiteread's memorial revolves around books, of course. In fact, it *is* books: shelves and shelves of them, stacked eleven high, far less *lining* walls than constituting, in themselves, the four walls of a room. It is not the hardback spines you are staring at, though, with their titles and authors, but the opposite: the exposed side of the books' leaves, where you might stick your thumb to prise them open.[18] The only 'names' to be seen, in fact, are inscribed in short lists in the flooring of the surrounding dais and refer to locations, some familiar, others less so: Stutthof, Theresienstadt, Trawniki. The rows and rows of books are interrupted on one side, that facing the main body of the square. Here the supposed entrance to the library is to be found: what appears to be panelled double-doors from the inside, with the handles

missing. Negative doors, designed to be neither entered nor exited; unreadable books, whose chapters are all closed. A silent library that speaks volumes. The book analogy has been taken, commonly, to reference the Jewish community as the 'people of the book'. As Young explains, what made the Jewish people a *people* in the first place was: 'their shared relationship to the past through the book. For it was this shared relationship to a remembered past through the book that bound Jews together, and it was the book that provided the site for this relationship' (in Townsend 2004: 170). In an article entitled 'The Exile's Library', Alberto Manguel relates this view to the motif of the 'eternal wandering Jew', describing the book effectively as the only place that might be called home: 'Long after the destruction of the Temple of Jerusalem, Jews in scattered lands continued to carry out the appointed rituals, moving about in a space that no longer existed in stone and mortar, but only in the words set down for their guidance. That is the nature of all exile: it affirms the perseverance of all memory' (2009: 20). More specifically, as Young points out elsewhere, 'in keeping with the bookish, iconoclastic side of Jewish tradition, the first memorials to the Holocaust period came not in stone, glass, or steel but in narrative' (1994: 22). He is referring to the *Yizkor Bikher*, or 'memorial books', which, 'recalled both the lives and the destruction of European Jewish communities according to the most ancient of Jewish memorial media: the book' (22). Reading these books is intended, as one of the books' prefaces points out, to perform the act of standing by the graves denied the victims by their murderers: 'The stetl scribes hoped that when read, the *Yizkor Bikher* would turn the site of reading into memorial space. In response to what has been called "the missing gravestone syndrome", the first sites of memory created by survivors were thus interior, imagined grave sites' (22).[19] So, if Whiteread's memorial refers to the 'people of the book', it also invokes those 'books of the people', the nameless 65,000 who disappeared to the death camps. Though frequently referred to as a 'bunker' – by the artist as well, as it happens (in Searle 2000: 12) – it seems to me rather to have both the appearance and effect of a temple.

Whiteread herself has identified it as a 'place of pilgrimage': 'People come into the city and go to Juden Platz specifically to see the memorial [. . .] leaving candles, stones and flowers' (in Dailey 2001: 61).

On a more general level, though, one might extrapolate the notion of the book as emblematic signifier of civilisation: a positive embodiment of what humanity as a whole has achieved in the realms of knowledge creation and 'culturalisation', as well as the place of a specific Jewish contribution in the making of that humanity. The very city of Vienna itself – in particular the 'pre-Holocaust era' of the late nineteenth and early to mid-twentieth centuries – encompasses such a view, of course, not least in terms of its 'Jewish participants', covering the range of civilisation's 'fields of practice'. In fact, the metonymisation of the book as civilisation in this way is nowhere more graphically – and tragically – evoked than in Micha Ullman's 1996 'sunken library' memorial at Bebel Platz in Berlin, which is worth dwelling on for a moment for the sake of comparison with Whiteread's installation.[20] This large, exposed square off the main Unter den Linden artery running eastwards from Brandenburg Gate is often to be identified in the daytime by a small, enigmatic huddle of people at its centre, with their heads bowed as if at a graveside. By night a faint phosphorescent light can be seen hovering above the same spot. When you reach it, you find a pane of glass, perhaps a square metre or so in size, embedded in the cobbled stones. Through it – and the best time for this is really in darkness – you can spy the peppermint white, empty shelves of a subterranean library. The installation commemorates the events of 10 May 1933 when national socialist students from the University right next door executed a planned burning of some 20,000 books belonging to 'undesirable authors' – poets, philosophers and scientists alike – from Marx to Freud. And to Heinrich Heine. The latter, one of the foremost German poets of the nineteenth century, is quoted prophetically in a plaque set in the ground nearby: 'This was merely the prologue, for what starts off as the burning of books, ends with the burning of people'.

Back at Juden Platz another towering figure of German literary history stands as an intriguing complement to Whiteread's memorial on the opposite side of the square. It is the statue of Gotthold Ephraim Lessing, an Enlightenment thinker who made a significant, if somewhat under-acknowledged, contribution to the development of German theatre in the eighteenth century. Being of an older generation to Goethe and Schiller, it is doubtless in part precisely on account of their radical interventions into the theatre scene with their stirring *Sturm und Drang* plays – just as Lessing was breathing his last in 1781 – that his influence has been overshadowed. Importantly, however, he produced the *Hamburg Dramaturgy* (1768), a manifesto for a new approach towards creating a national theatre in the highly fragmented Germany of the time, one which preferred the 'warm humanity' of Shakespeare's plays – a factor seized on by *Sturm und Drang* – to the rigid strictures of a French neoclassicism that had dominated up to that point.[21] According to Lessing, drama could fulfil a social function by concentrating on arousing compassion and his final play, *Nathan the Wise* (1779), which probably accounts for his honoured presence in Juden Platz, witnesses its eponymous protagonist – modelled on the Berlin-based Enlightenment philosopher Moses Mendelsohn[22] – plead implicitly for tolerance of all religions and peoples in its thematic handling of the relationship between Christian and Jewish faiths in the Middle Ages.

Just as the books of 'enlightened authors' were burnt by Nazi students in Berlin, Lessing's bronze was removed from Juden Platz in 1938 – having been in place a mere three years – and melted down, not returning in recast form till 1982. So, like Whiteread's installation, it too reflects a history of civilisation under attack. However – and here we touch again on the continuous agonistic dramaturgy of the square – as Neil Pages suggests, Whiteread's present-day intervention 'performs a stand off' with the Enlightenment 'man of the book':

Where the traditional bronze 'Denkmal' would invoke through its representation of Lessing an access to reason, to the light

of Enlightenment thought, the minimalist concrete 'Mahnmal'
it faces underscores the impossibility of reasoning the Shoah.
Lessing's return to the Juden Platz has been blocked – the figure
no longer enjoys a sovereign overview of the square and must
share the limited space with a concrete structure that points to
an utter failure of Enlightenment reason.

<div align="right">(2005: 111)</div>

The library is closed. And it is not only the narrative of Less-
ing's well-meaning, liberal tolerance that begins to be called into
question by the interjection of Whiteread's work, but the desire to
preserve the integrity of Juden Platz's 'historical heritage'. Used as
an argument against the memorial's introduction, Pages details as-
pects of the impulse to create 'a public perception that the square
must be maintained at all costs in a supposedly "original" condi-
tion' (108). Typically, then, a building such as the former Bohemian
Court Chancellory, designed by the celebrated Fischer von Erlach
in 1710, creates, with its ornate facade 'the symbolic presence of
an official Austrian architectural and civic patrimony, particularly
through its invocation of a lost empire and the very name of its ar-
chitect, the most beloved builder of the Austrian Baroque' (109).
Now the Constitutional and Administrative Court in Vienna, the
building also functioned as the seat of the Nazi administrative courts
in Austria. The desire to preserve or, indeed, 'hide behind' a 'façade
of history' is embodied, then, in the very built environment of the
square. It is a view that tends to see history as a fixed condition,
effectively suppressing undesirable, uncomfortable or 'less important'
narratives, as opposed to acknowledging the patchwork of diverse,
conflicting and changing points of departure at various moments
in time: a 'sum of ruptures, each marking the new, not a supposed
continuum', as Kähler puts it (in Kahlfeldt 2000: 383). The attempt
to legitimise the 'rightness' of history's signification in the square is
effected, moreover, by references to both rhetorics of architectural
order and pragmatics of urban planning, to necessary stabilising

harmonies of scale and form as well as to supposed imperatives of public use.

This is where one might say that the uncanny guile of Whiteread's neo-minimalist intervention comes into play. The 'negative space' form of artworks such as the infamous *House* (1993) in London's East End have always suggested a raw, brutalist exposure of 'stripped façades': at once a solidifying of the departed past – or 'thickening of the air of history' – that insists upon the continuing spectre of its presence, and an imprint of the interior turned outwards. In Juden Platz Whiteread plays on the notion of the square's supposed 'correct proportionalism'. The dimensions of the library correspond to those of a room in one of the surrounding Baroque buildings and account, along with its colouration, for that initial impression of 'belonging', of taking its place in the *mise en scène*. In effect, though, this is a room that has been displaced: figuratively stripped bare, skinned and torn from the building that would house it. Thus, it is implied, the facades of Juden Platz can no longer conceal what lurks behind them, for right in their midst there now sits an awkward interruption of their symmetry: an impenetrable, unreadable, out of place room of name-less books that makes its devastating mark via minimalism's 'natural elegiac poetry', as Jonathan Jones has suggested of such Holocaust installations (2007: 7). If such an observation is true, it would be important, though, to salvage something *specific* from the pure ab-straction this might suggest. At a physical distance you may, indeed, see nothing more than a stacked-up extension of Carl Andre's fa-mous 'pile of fire bricks' piece, *Equivalent VIII* (1966), in which it was the metaphysical 'space around' them that you were supposed to be provoked into contemplating. Whiteread's memorial *does* more, though, not in the sense of signifying memory but in facilitating its performance. By that I mean that it implicitly engages with the conflicted context of its siting, enabling the contradictory narratives of Juden Platz to be drawn out into the open and urging the pub-lic of Vienna to participate in a debate that is not pre-empted or prescribed by representation. It provokes without asserting and can

ensure, therefore, as Eisenman's memorial site does in Berlin, that
the conversations continue. The 'silence' of its impenetrability, which
implicitly poses an unresolved 'conundrum' or secret of sorts, cou-
pled with its 'aesthetics of inversion', suggests there is an 'other side'
that should reveal its hand or 'come out' in the form of a talking
citizenry.

An instructive counterpoint to such a view of Whiteread's in-
stallation, one which provides a further component of the agonistic
drama, is seen in the controversy its introduction produced with
Vienna's already existing – and nearby – *Monument against War and
Fascism* by the popular 'native son' and 'respected Austrian sculptor'
Alfred Hrdlicka (Pages 2005: 103–5).[23] Originally unveiled in the
1950s, it was augmented in 1988 when the municipality was alerted to
the fact that the existing ensemble of expressionistic granite and mar-
ble statues, wearing gas masks and striking contorted horror poses,
made no reference whatsoever to the deportation and extermination
of the Jewish community. As a result, Hrdlicka sculpted the figure of
'an old bearded Jew in traditional garb and cap', as Sylvère Lotringer
describes it (Lotringer/Virilio 2005: 97). Hrdlicka was outraged by
Whiteread's proposed memorial, evidently seeing it as a threat to
the prominence of his own piece. But what is interesting, above all,
is the way that this epitome of 'turd-in-the-plaza' public memorial
sculpture became subject to an inversion of its positivistic intentions
via the 'use' it provoked from a public that was evidently indifferent
to the horror it was seeking to convey so dramatically. Lotringer cites
this shocking but revealing example in the context of a conversation
with Paul Virilio about 'negative monuments', which might be said
to refer to works like Whiteread's that point implicitly to the impor-
tance of bringing into play uncomfortable, submerged 'memories of
evil', but not as histrionics:

> The old man is shown sweeping the floor with a broom, his back
> bent pretty low. It was so low that tired tourists got into the
> habit of sitting on it. A new row of complaints ensued and the

hard-pressed municipality decided to deal summarily with this embarrassing situation. They surrounded the Jew with barbed wire. To me this desperate attempt to repair the desecration by committing a new one was the best possible memorial to what had been done to the Jews and they should have kept the barbed wire right there. Possibly unroll it round the entire city of Vienna while they were at it. It took a long time for Austria to face up to its own responsibilities in the war and this turned out to be the perfect monument to what they had done *because they had done it again.*

(2005: 97)

Many commentators have, of course, seen the emergence of Jörg Haider's ultra-right, nationalist Freedom Party in the 1990s as precisely the 'doing' or 'coming again' of suppressed pasts that, importantly, had not been registered – either adequately or *at all* – as traumatic in their first coming. Two thousand marked the year in which this element in Austrian politics was invited to become part of the ruling coalition government. When Rachel Whiteread's *Memorial to the 65,000 Murdered Austrian Jews* was inaugurated with great civic fanfare on 25 October that year, on the eve of Austria's annual National Day celebration – which 'marks the date in 1955 when the country's official neutrality became law' (Pages 2005: 106) – the Freedom Party was conspicuous by its absence, in spite of the installation being a government commission.

Notes

1 Abramovic's lecture, which was entitled 'Seven Easy Pieces or How to Perform' (13 October 2006), described her 're-enactments' in the Frank Lloyd Wright rotunda of the Guggenheim Museum, New York City over seven consecutive nights (9–15 November 2005).

2 For a useful and recent anthology of key texts documenting the debate around the 'everyday turn' in contemporary art see Johnstone (2008).

3 Jane Rendell cites a 'two-way street of identification' relating to 'experiencing' as theorised by Kaya Silverman: '"heteropathic", where the subject aims to go outside the self, to identify with something/someone/somewhere different, and "cannibalistic", where the subject brings something other into the self to make it the same' (in Blamey 2002: 259). The source for this is Silverman's *The Threshold of the Visible World* (London and New York: Routledge, 1996: 23–4).

4 See Goldberg for a brief summary (1988: 7–9).

5 For a detailed discussion about definitions of live and performance art, see Kaye (1994b). Heathfield's more recent *Live Art and Performance* (2004) highlights the continuing use of both designations.

6 The major area of growth will occur in the so-called developing world. Thus, a city such as Lagos in Nigeria, with a current total of just over

ten million is expected to have doubled in size by 2020, making it the third largest city in the world. By contrast, London will maintain the equilibrium of its present population of some eight million, and an advanced mega-city like Tokyo, which already has a staggering population of 35 million – the world's largest at the time of writing – is set to rise by a mere million in the same period (UN-HABITAT 2006: 8).

7 In his 1974 reportage, *Soft City*, Jonathan Raban's was perhaps one of the first narrative voices to pick up on both 'urban intangibility' and city living as a form of art: 'it seems to me that living in cities is an art, and we need the vocabulary of art, of style, to describe the peculiar relationship between man and material that exists in the continual creative play of urban living. The city as we imagine it, the soft city of illusion, myth, aspiration, nightmare, is as real, maybe more real, than the hard city one can locate on maps in statistics, in monographs on urban sociology and demography and architecture' (Raban 1998: 4).

8 Aspects of this and the previous paragraph appear in the main introduction to Whybrow (2010: 3).

CHAPTER 1 THE FUTURE OF ART IS URBAN

1 As we shall see later in this section, Nicolas Bourriaud believes the situationists' project 'intended to replace artistic representation' (2002a: 84).

2 See Knabb (2006: 152–3).

3 See inter alia Knabb (2006), McDonagh (2004) and Ford (1995) for documentation of situationist material.

4 See inter alia Tester (1994), Solnit (2002) and Küppers (1999) for accounts of reconceived theories of *flânerie* and urban walking.

5 See the introduction to Part 2 Drifting/Things in Whybrow (2010: 88–91).

6 See Sadler (1998: 1–4).

7 Plant's book *The Most Radical Gesture* (1992) establishes the relevance of situationism in a postmodern age.

8 See the introduction to Part 3 Sounding/Rhythms in Whybrow (2010: 144–9).

9 My profound thanks to Carl Lavery – who by his own admission 'has sympathies with situationism but is not a Situationist' (2005a: 238) – for

drawing my attention to Lefebvre's statement. In Patrick Keiller's film *London*, his protagonist Robinson, a modern-day *flâneur*, bewails the contamination effected by investors and speculators as he searches the narrow alleys around St Paul's for a former 'conviviality of café life'. In an empty bar in Fleet Street he predicts that 'as the City decayed, it would be reclaimed by artists, poets and musicians, the pioneers of urbanism, as the docks and markets had been twenty years before' (Keiller 2005: Scene 14).

10 Kofman and Lebas suggest that 'the relationship between Lefebvrian and situationist concepts awaits serious study' (in Lefebvre 1996: 13), whilst Highmore points out that Kristin Ross' subsequent 1997 piece 'Lefebvre and the Situationists: An Interview' (in *October*, 79: 69–83) covers the alliance from Lefebvre's point of view (Highmore 2002: 138).

11 Benjamin's *Arcades Project* (2002) was, of course, an attempt to enact such a practice textually.

12 Bourriaud appears to be suggesting something similar in his considera-tion of the place of artworks in the overall economic system governing contemporary society: 'Over and above its mercantile value and its se-mantic value, the work of art represents a social *interstice*. This *interstice* term was used by Karl Marx to describe trading communities that elude the capitalist economic context by being removed from the law of profit [. . .] The interstice is a space in human relations which fits more or less harmoniously and openly into the overall system, but suggests other trading possibilities than those in effect within the system. This is the precise nature of the contemporary art exhibition in the arena of representational commerce: it creates free areas' (Bourriaud 2002a: 16).

13 See Whybrow (2005: 69–72).

14 Kwon is quoting from Van Den Abbeele's introduction to *Community at Loose Ends*, (ed.) Miami Theory Collective (Minneapolis: University of Minnesota Press, 1991: xiv). See also Jean-Luc Nancy (1991).

15 For an exemplification of this process, see Rosalyn Deutsche's exhaustive analysis of Wodizcko's *Homeless Projection* proposal for Union Square Park, New York City. In it she identifies the truly restorative aspect of an official public redevelopment programme of historical statues to be the artist's agonistic exposure of a *lacking* social cohesion (see 1996: 3–48). Wodiczko's practice could be viewed as an instance of situationist

détournement in the way it reconfigures institutional signifiers 'against themselves' as a means of drawing attention to ironies and contradictions within public sculpture and built form.

16 Specifically Lefebvre's *The Production of Space* (1991).

17 There is a partial link to be made here perhaps with Jane Jacobs' recognition in her classic *The Death and Life of Great American Cities* (1961) of the complex order of 'intricate interplay' (as Finkelpearl puts it) in city space: 'It is an order composed of "movement and change" – what she calls the "art of the city". Outside the rigid geometric order of the Modernist city, individuals take part in an "urban ballet", in which each understands his or her part but is able to improvise in relation to the others' (Finkelpearl 2000: 16). Of course, Deutsche's concerns are more overtly 'political', but Jacobs' aesthetic insights are no less relevant in terms of the significance of spatial practice.

18 This position is exemplified by the oft-cited case of Richard Serra's *Tilted Arc*, in which the artist declared that the proposed translocation, under highly controversial circumstances, of his work from Federal Plaza in New York City would effectively destroy it. For a full discussion, see amongst others: Deutsche (1996: 257–68), Clara Weyergraf-Serra and Martha Buskirk's *The Destruction of Tilted Arc: Documents* (Cambridge, MA: MIT Press, 1991), Douglas Crimp (interview) in Finkelpearl (2000: 60–79), and Harriet F. Senie, *The Tilted Arc Controversy: Dangerous Precedent?* (Minneapolis: University of Minnesota Press, 2001).

19 Both the terms 'plop art' and 'turd in the plaza' are attributed to the architect James Wines of Sculpture in the Environment (see Eccles 2004: 8, 19, n.3 and 37, n.7).

20 See Heiferman (2005).

21 To be clear, transitivity here implies that if one 'party' or 'phenomenon' bears a relationship to a second that simultaneously bears a relationship to a third, then the first can be said also to bear some form of relationship to the third.

22 The ball was set rolling by Claire Bishop in *October*, 110 (2004), followed by responses and counter-responses in (at least) *Artforum*, *Performance Research*, *Third Text* as well as later issues of *October* itself. See Bishop (2006b), Gillick (2006), Jackson (2006) and Downey (2007).

23 The following three paragraphs appear in the introduction to Part 5 Visioning/Flows in Whybrow (2010: 245–7).

24 The artist Keith Piper, whose work is concerned with the intersection of the 'physical and social landscape of the city [and] the parallel landscape of cyberspace', has argued that the 'new virtuality' replicates not only the 'orderly city' but also (or therefore) 'the social and economic interests of the enfranchised white status quo' (in Tawadros 2004: 38 and 41).

CHAPTER 2 RELATIONAL WRITING

1 See Rendell (2006: 213, n.4). See also Rendell's book *Site-Writing: The Architecture of Art Criticism* (London and New York: I.B.Tauris, 2010).
2 Lefebvre concedes that when there is no balcony, the frame provided by a window may have to suffice, 'on condition it does not overlook a sombre corner or a gloomy courtyard' (2004: 28).
3 Regarding Barthes's influence, see Ulmer on 'post-meaning' (1989: 94–101).

CHAPTER 3 WALKING WITH WENTWORTH ET AL.

1 Ackroyd is probably the most comprehensive and consistent historical chronicler of 'London life', most obviously in the weighty *London: The Biography* (London: Vintage, 2001).
2 See Battista et al., 'Exploring "an Area of Outstanding Unnatural Beauty": A Treasure Hunt around Kings Cross, London' in Pinder (2005b: 429–62).
3 Richard Wentworth, *Making Do and Getting By* and *Occasional Geometries 1973–2007*, Tate Britain, London, 2007.
4 See Catharine Arnold's recent history *Bedlam: London and its Mad* (London: Simon and Schuster), 2008 in which one of the author's main points is that 'the true story of a city is found at its fringes' (reported in the *Guardian [Review]*, 16 August 2008: 11).
5 See Michel Foucault's *The Birth of the Clinic* (London and New York: Routledge, 1973) and *Madness and Civilisation* (London and New York: Routledge, 1967) for accounts of the way illness and madness have been constructed historically through discourse.
6 See Deutsche's essay 'Agrophobia' (1996: 269–327).

7 Bishop goes on to relate her analysis to what she sees as the failings of relational aesthetics which 'are not intrinsically democratic, as Bourriaud suggests, since they rest too comfortably within an ideal of subjectivity as whole and of community as immanent togetherness' (2004: 67).

8 In the same breath Mouffe likens this to Lyotard's *differend*, which Belsey defines neatly as the instance of 'a difference that cannot be resolved because no metalanguage embraces both terms' (2005: 129).

9 See Alÿs et al., *The Modern Procession* (2004).

10 As the driving force behind Münster's *Skulptur Projekte*, Kaspar König, explains: 'At the 1997 *Skulptur Projekte* it was fortunate that Documenta X had been postponed a year, so that the two exhibitions took place simultaneously. The 1997 edition of *Skulptur Projekte* got a lot of international attention and became a hot tip for insiders' (in Seijdel 2008: 85–6).

11 For documentation of *State Britain 2007*, see Tate Publishing (2007).

12 It is worth pointing out here, as Belsey explains, that '[s]ublimity is in the first instance a measure of height: *sub limen*, up to the lintel above the door' (2005: 141).

13 For Ulmer it is no coincidence that radical theorists as diverse as Montaigne, Heidegger, Wittgenstein and Derrida 'all spoke of their method in this way, having to do with journeys, paths, maps – especially with journeys off the beaten track or highway' (1989: 168).

14 It intrigues me to discover subsequently that Joseph Beuys used the actual form of a section of this very underpass construction as the mould from which to make a tallow cast back in 1977. He simply called this 'negative space' *Tallow* and possibly wasn't thinking about dwelling places at all. Grasskamp refers to it as 'left-over space' and 'a *black hole* of haphazard planning' in his introduction to *Sculpture Projects in Münster 1997* (in Bußmann 1997: 22–3). Beuys may well have been interested in the possible associations of this material with properties of warmth and 'healing' in the context of such a dark and draughty, brutalist location. From a material point of view Beuys's work could certainly be said to capture the 'merely temporarily solid state' of Andreas's living conditions. Fittingly, in this regard, *Tallow* (or *Unschlitt* in German) was subject itself to controversy relating to the location and terms of its exhibiting in Münster. Moreover, whilst it was intended to be housed eventually in the Hamburger Bahnhof museum of contemporary art in

Berlin, according to Kasper König it is now in the Museum Abteiberg in Mönchengladbach (see Seijdel 2008: 86).

15 See www.aequivalenz.com.

16 For a recent retrospective appraisal of Metzger's work, see Breitwieser (2005).

17 Total casualty figures were 554 dead, 1,024 injured (Peace and Reconciliation Centre, The Herbert Art Gallery, Coventry).

CHAPTER 4 LONDON PLAYING FIELDS

1 In fact, though watching fragmented YouTube footage of this event is no substitute for witnessing it first-hand, it is fairly obvious that the rave was anything but silent. Audible music may have been absent, but such dancing masses – where individuals are oblivious largely to one another's noise, of course – inevitably generate their own sounds: uninhibited whoops, cheers and singing along, or just ravers chatting away to one another.

2 Silent raves or mobile clubbing events have become very popular in recent times, as a quick trawl through YouTube alone testifies.

3 The Liverpool Street Station silent rave was in fact coordinated to coincide with similar events in 'afflicted cities', those of New York, Madrid and Paris.

4 It is important perhaps to note that Dyer's enthusiasm for the event, whose 'magic', as he puts it, sees him attempting to encompass 'Everyone who was there – the dancers, the commuters; even, I suspect, the police', is quite likely to have been an 'optimistic' assessment. In awareness, again, of the inadequacies of second-hand YouTube documentation, the exasperation of station staff at the blockage caused is fairly plain to behold in one video and some commuters will doubtless have been inconvenienced, even intimidated, by having to battle their way through the scrum of ravers. There is also often a strong 'student prank' flavour to such interventions – at least in the dismissive way they are perceived – which threatens to predominate particularly when the event is not terribly successful in its conception and realisation.

5 See McGonigal (2004). This paper, by virtue of being written and presented at a conference in Singapore, deliberately outed the author as one of the founders of flash mobs.

6 The media coverage aspect is dependent to a degree on 'self-promotion' inasmuch as it is participants (or sometimes witnesses) who will have to have documented the event and passed it on to the media. In other words, the necessarily clandestine nature of the operation and its instantaneousness precludes any direct media involvement (unless they happen to have picked up on its blogged 'call to arms'), which is one of its 'weapons', of course. How it gets reported is naturally another matter entirely.

7 To give a fairly amusing example of post-event blogging, a student of mine (at the time) recorded the following exchange between two elderly citizens witnessing a flash mob occurring in a supermarket in Leamington Spa (in 2008): 'They must be high on something . . .', to which the reply was, 'Don't be silly. The only thing they're high on is life!' Here, then, Dyer's positivistic evaluation is indeed borne out.

8 In his afterword to Augé's *In the Metro*, Tom Conley refers to this phenomenon as 'the narcosis of life lived within a symbolic triangle defined by *métro, boulot, dodo* (subway, job, sleep)' (Augé 2002: 81).

9 This possibility of audience involvement takes us towards the anthropological concept of 'dark play' in public spaces, which McGonigal invokes as part of her analysis as something that may occur on occasion. Corresponding to a form of 'invisible theatre' dark play is 'play based on *deception* and *subversion*, in which some players may not be aware they are playing' and would apply here to instances in which secondary participants do not realise they are actually party to or taking part in a 'fictional' or contrived situation: in other words, they are 'playing in the dark'. Naturally, there are ethical implications to this, but, as Richard Schechner seems to imply, dark play's tendency towards 'playing with fire' and 'getting away with murder' are also precisely the risk factors that potentially reap insightful rewards (2002: 106–9). For him 'dark play is truly subversive, its agendas always hidden' (107). The two 'realities' that can be said to be in operation at once in dark play, and that ensure this covert aspect, offer all manner of possibility to 'subvert orders, dissolve frames and break its own rules – so much so that the playing itself is in danger of being destroyed, as in spying, double-agentry, con games and stings' (107).

10 One particular video, *The Great Trafalgar Square Freeze*, of 2:36 minutes duration, had attracted nearly three million hits at the time of writing (mid-January 2009).

11 The Fourth Plinth initiative, which marked the first attempt to fill the space of the 'empty plinth' (as it had always been known) since 1841, began with three prototype installations by Mark Wallinger (*Ecce Homo*, 1999), Bill Woodrow (*Regardless of History*, 2000) and Rachel Whiteread (*Monument*, 2001). The success of these public sitings prompted the founding of a commissioning committee. The other three plinths in the square are occupied by King George IV and Generals Napier and Havelock.

12 *Alison Lapper Pregnant*, as the sculpture was entitled, was 3.55 metres high and weighed in at 13 tonnes. For full documentation of the artwork by the artist himself see Marc Quinn, *Fourth Plinth* (Göttingen: SteidlMACK, 2006).

13 Quinn has continued his interrogation of body image and the beauty ideal in his bronze of the supermodel Kate Moss, entitled *Sphinx* (2006).

14 Gormley's work commenced on 6 July 2009. See www.oneandother.co.uk.

15 I am aware that forms of graffiti (or hieroglyphics) predate 1970s New York by centuries. I am concerned, of course, with the particular, unmistakable 'New York school' that evolved and was replicated subsequently, if in local adaptations, in many cities of the globe.

16 Cresswell's book *In Place/Out of Place* (1996) contains a more exhaustive critique of graffiti. Please note: the paragraph that follows here appears in a slightly different order in the introduction to Part 4 Playing/Place in Whybrow (2010: 196–7).

17 Borden has written a whole book, entitled *Skateboarding, Space and the City* (2001), exhaustively theorising skateboarding as a critical practice. The definitive skateboarding documentary is Stacey Peralta's *Dogtown and Z-Boys* (2001). The director himself was a member of the Californian Z-Boys and a pioneer of the practice. Aspects of this and the following paragraph have appeared in the introduction to Part 3 Sounding/Rhythms in Whybrow (2010: 148–9).

18 It should be said, though, that potential effects such as damage of street furniture or risk-taking on busy roads do steer skateboarding outside the realm of law on occasion.

19 See Robert Booth, 'Freerunning goes to war as marines take tips from EZ, Livewire and Sticky', *Guardian*, 12 January 2008: 13.

20 See the following websites: www.parkour.org.uk, www.urbanfreeflow.com and www.northernmonkeys.co.uk. Urban Freeflow is the world's largest free running organisation at the time of writing.

21 A Channel 4 follow-up programme entitled *Jump Britain*, shown on 2 July 2006, captured the extent of and wildfire speed with which free running caught on in the UK, producing a plethora of websites and groups of *traceurs*.

22 Westminster Council has installed a CCTV control room in a bunker beneath Piccadilly. A wall of 48 monitors can provide instant panoramic views of any central London street (Lewis 2009: 13).

23 For a full discussion of this tension, see Nicholas Fyfe's chapter in Lees (2004: 40–56).

24 See *The Duellists*, a free running performance recorded in the Arndale Centre, Manchester in 2008.

25 See Matt Mason, *The Pirates Dilemma: How Hackers, Punk Capitalists and Graffiti Millionaires are Re-Mixing our Culture and Changing the World* (London: Allen Lane, 2008) for a recent account of the practices of such 'culture jamming'.

26 See Banksy's *Wall and Piece* (2005) for comprehensive documentation of key works.

27 Banksy has famously enacted 'guerilla sitings' of 'spoof exhibits' in many of the most renowned metropolitan art houses, including the Louvre in Paris, the Museum of Modern Art in New York and Tate Britain (see Banksy 2005: 138–55).

28 I have drawn on this example in the introduction of Part 4 Playing/Place in Whybrow (2010: 198).

29 Creed famously won the Turner prize in 2001 for a piece in which the lights simply went on and off in one of the galleries at Tate Britain. (*Work No.227: The Lights Going On and Off.*)

30 Brown's fascinating 1973 *Roof and Fire Piece* involved dancers, clothed in distinctive red garments and dotted around the rooftops of various skyscrapers in Manhattan, executing a sequence of movements. The effect was of a kind of 'semaphore of the rooftops': marooned figures seeking some form of human contact from within the anonymous, concrete jungle of the metropolis.

31 See *Psycho Buildings: Artists Take on Architecture* exhibition pamphlet, The Hayward, 28 May–25 August 2008. Inevitably, since this artwork

preceded the events of 9/11, there are all kinds of complex perspectives that can be said implicitly to have been emplaced upon the piece subsequent to those events, upon which there is no space here to elaborate. The same can be said, of course, of de Certeau's famous utilization of the view from the 110th floor of the World Trade Center at the beginning of his chapter 'Walking in the City' (1988: 91–110). It is also surely no coincidence that the retrospective documentary film *Man on Wire* – with its conquering, creative, humanising narrative – materialised several years after 9/11 (in 2008), despite the extraordinary high-wire act itself (between the two towers) having taken place in 1974.

32 See Tate Publishing (2006: 55–116).

CHAPTER 5 BERLIN, VIENNA: PERFORMING HOLOCAUST MEMORY

1 See Whybrow (2005: 197–200). The German Parliament voted in 2002 to tear down the controversial Palast der Republik or 'people's palace' and replace it with a replica of the Prussian Stadtschloss belonging to the Hohenzollern dynasty (which the East Germans had blown up in 1950). The Palast had become a symbolic 'last line of resistance' for former East Germans who were distinctly wary of every single aspect of the country's legacy being erased after the fall of the Wall. The building's status as a place of great pride and pleasure for East Berliners – it had incorporated public leisure facilities – doubtless became overstated in the drive to retain it.

2 It should not be forgotten that considerable ideological discrepancies existed in the Germanys of East and West regarding perceptions of the legacy of national socialism. In essence West Germany saw itself as willing to confront and work through the Nazi past (and even had a term for it: *Vergangenheitsbewältigung*) – though many, not least the Baader-Meinhof terrorists and their many sympathisers, would cast serious doubt over the extent to which that was occurring – whilst East German officialdom denied there was anything with which it had to deal as a state, since all the unreconstructed ex-Nazis had ended up in the West. Hence, the GDR's official designation of the Wall as an 'anti-fascist protection barrier'.

3 As I have explained elsewhere, what critical reconstruction enshrined
 in essence was 'a conforming to certain conditions of building in the
 centre of the city based on historical ground plans: height limits, street
 patterns and building "lines", fixed proportions of residential provision,
 and maintenance of the "character" of an urban building. Whilst its ret-
 rospective pre-modernity appeared to lean towards outright nostalgia,
 the point according to its defenders was that it should be *critical*, imply-
 ing the application of a contemporary interpretation. It was, moreover,
 viewed by the city authorities as an important controlling device in the
 rampant property speculation promised by the collapse of the Wall'
 (2005: 160). See also Balfour (1995) and Ladd (1998) for illuminating
 accounts of the rapid reconstruction of Potsdamer Platz.

4 To illustrate the point this puts me in mind of an artwork set up as
 part of an exhibition at the Serpentine Gallery, London in 2005 by the
 artist Tomoko Takahashi. It involved quite simply a game of public
 tig on the lawn outside, which Rochelle Steiner describes thus in the
 exhibition catalogue: 'the game is played at dusk under ultraviolet light
 and projected onto a large screen. The players wear white hats so they
 appear on the screen as dots that form seemingly random patterns as
 they move. Since the rules of the game are well defined, what appears
 to be chaos actually follows a prescribed plan' (2005: no page numbers).

5 I have inserted the German words here partly to make the point that
 German has a range of very specific terms for monuments or memorial
 sites and partly to be slightly provocative because *both* those designations
 form part of the installation's official name: *Denkmal für die ermordeten
 Juden Europas, Holocaust-Mahnmal*. See Schlusse (2006: 128). *Denkmal*
 is, literally, a mark at which you think (*denken*), whilst *Mahnmal* suggests
 a form of exhortation: *(er)mahnen* means both to admonish and to give
 a strong reminder. See also Whybrow (2005: 126).

6 Jochen and Esther Gerz's celebrated *Monument against Fascism* (1986–
 93) at Hamburg-Harburg forms a resonant counterpoint to the Eisen-
 man memorial inasmuch as it was a single stele that not only actively
 encouraged a form of tagging by the public but also, as its surfaces filled
 up with writing, gradually sank into the ground until it had disap-
 peared entirely, leaving only a plaque documenting this staged process.
 See Gerz, *Res Publica: The Public Works 1968–1999* (Ostfildern: Hatje
 Cantz, 1999: 52–7), Schmidt-Wulffen's 'The Monument Vanishes: A

Conversation with Esther and Jochen Gerz' (in Young 1994: 68–75) and Young (2000: 120–51).

7 The artist Hans Haacke's 1990 death strip installation at Stallschreiber Strasse, entitled (in English translation) *Freedom Will Now Be Sponsored – By Petty Cash*, drew attention to Daimler Benz's 'vigorous promotion of Hitler's rise to power'. See *Die Endlichkeit der Freiheit Berlin 1990: ein Austellingsprojekt in Ost und West* (ed) W. Herzogenrath et al. (Berlin: Edition Hentrich, 1990: 87–104).

8 See Till (2005: 161–8).

9 The first round of competition in 1994, which had attracted well over 500 proposals and had yielded a winner, was cancelled after a rowdy public debate over the terms of its realisation and an eventual intervention by the then chancellor Helmut Kohl. See Till (2005: 171).

10 After reunification had been agreed between East and West Germany in 1990, the Parliament in Bonn voted to relocate to Berlin in June 1991, finally opening in the former Reichstag building in April 1999. See Michael Wise's *Capital Dilemma: Germany's Search for a New Architecture of Democracy* (New York: Princeton Architectural Press, 1998) for full details of the debate around Berlin being nominated as the new capital city.

11 See Young (2000: 184–223), Till (2005: 161–88), Schlör (2005), Cullen (1999) and Stiftung Denkmal für die Ermordeten Juden Europas (2005).

12 See Young (2000: 209). One of the stipulations of Parliament accepting Eisenman's design was that it had to have an information centre on site.

13 See Till (2005: 180–6).

14 Interview with Carl Hauser in Dailey (2001: 47–62).

15 See Searle (2000: 12) and interviews with Hauser (ibid.) and Melvyn Bragg, *South Bank Show*, ITV 1, 28 October 2001. Whiteread's sensitivity to the politics of public art sitings, particularly a sense of ultimate helplessness perhaps, had doubtless been intensified by the traumatic events surrounding *House* in 1993, which ended, of course, with the installation's brutal removal by Tower Hamlets council. See Lingwood (1995).

16 Unlike the artist Christo, who makes a feature of the 'software stage' – as he calls it – of intense negotiation with officialdom in securing the right to institute his wrappings of public sites and buildings, Whiteread

does not appear to be very interested in the notion of integrating that as an aspect of the artistic process. For Christo the 'event of the artwork' begins with the dialogue over its implementation, seemingly relishing the potential upheaval it might cause, in part because of what this might reveal about the politics of the situation. See Whybrow (2005: 179–82) on Christo and Jean-Claude's Reichstag wrapping in Berlin in 1995.

17 See Freud (1990: 335–76) for his original essay on the uncanny, Vidler (1992: 17–44) and Leach (1999: 150–62) for discussions of its relationship to the built environment.

18 Despite appearances the Vienna memorial is unlike, say, Whiteread's *House* in this regard. The latter revealed a 'negative imprint' of the inside walls of the building. In Juden Platz, on the other hand, although you are witnessing that side of the books customarily turned inward (to the inside wall), it is not a negative cast as such.

19 Daniel Libeskind's complex Jewish Museum design concept (in Berlin) was based in part on the drawing up of a graphic matrix of addresses and locations. These were the homes and final destinations of deported Berlin Jews and were culled from the so-called memorial book (*Gedenkbuch*), two volumes containing 'lists and lists of names, dates of birth, dates of deportation, and presumed places where these people were murdered [. . .] in Riga, in the Lodz ghetto, in concentration camps' (Libeskind 2001: 26). See *Gedenkbuch – Opfer der Verfolgung der Juden* (Koblenz: Bundesarchiv and Avolsen: Internationaler Suchdienst, 1986).

20 Ullman's inconspicuous installation, *Library*, was one of those frequently cited in Berlin debates as performing a far more effective memorial function in the city than any large-scale Holocaust site might achieve, owing not least to the specificity of its point of reference.

21 Michael Patterson's *The First German Theatre* (London and New York: Routledge, 1990) records Lessing's contribution to the attempted creation of a 'national theatre movement' in Germany that eventually spawned the likes of Goethe, Schiller, Kleist and Büchner.

22 As one of the 'wise men' of his Berlin community, Mendelsohn urged his fellow Jews to adopt the customs of the country in which they had chosen to be resident and to converse in 'secular German'.

23 Hrdlicka's memorial is at Albertina Platz.

Bibliography

Alÿs, F. and Weber A. (eds.). (2004). *The Modern Procession*, New York: The Public Art Fund.

Alÿs, F., Lampert C. and Lingwood J. (eds.). (2005). *Francis Alÿs Seven Walks, London, 2004–5*, London: Artangel.

Anton, S. (2003). 'One more step', *Parkett*, 69: 34–8.

Augé, M. (1995). *Non-Places: Introduction to an Anthropology of Supermodernity*, trans. J. Howe, London and New York: Verso.

Augé, M. (2002). *In the Metro*, intro. and trans. T. Conley, London and Minneapolis: University of Minnesota Press.

Auster, P. (1988). *The Invention of Solitude*, London: Faber and Faber.

Balfour, A. (ed.). (1995). *World Cities: Berlin*, London: Academy Editions.

Banksy (2005). *Wall Piece*, London: Century.

Barber, S. (1995). *Fragments of the European City*, London: Reaktion Books.

Barber, S. (2001). *Extreme Europe*, London: Reaktion Books.

Barber, S. (2006). *The Vanishing Map: A Journey from New York to Tokyo to the Heart of Europe*, Oxford and New York: Berg.

Barkham, P. (2008). 'Wanted: 8,760 living statues', *Guardian (G2)*, 10 January: 23–5.

Barley, N. (ed.). (2000). *Breathing Cities: The Architecture of Movement*, Basel, Boston and Berlin: Birkhäuser.

Barthes, R. (1982). *Empire of Signs*, trans. R. Howard, London: Jonathan Cape.

Barthes, R. (1989). *The Rustle of Language*, trans. R. Howard, Los Angeles and Berkeley: University of California Press.

Belsey, C. (2005). *Culture and the Real*, London and New York: Routledge.

Benjamin, W. (1997a). *One-Way Street*, trans. E. Jephcott and K. Shorter, intro. S. Sontag, London and New York: Verso.

Benjamin, W. (1997b). *Charles Baudelaire: A Lyric Poet in the Era of High Capitalism*, trans. H. Zohn, London and New York: Verso.

Benjamin, W. (1999). *Selected Writings Volume 2 1927–1934*, (ed.), M.W. Jennings, H. Eiland, G. Smith; trans. R. Livingston et al., London and Cambridge, MA: The Belknap Press of Harvard University.

Benjamin, W. (2002). *The Arcades Project*, (ed.), R. Tiedemann, trans. H. Eiland and K. McLaughlin, London and Cambridge, MA: The Belknap Press of Harvard University.

Berger, J. (2001). Untitled column, *Guardian (G2)*, 25 October: 7.

Bishop, C. (Fall 2004). 'Antagonism and relational aesthetics', *October*, 110: 51–79.

Bishop, C. (ed.). (2006a). *Participation*, London: Whitechapel Gallery and Cambridge, MA: MIT Press.

Bishop C. (2006b). 'The social turn: Collaboration and its discontents', *Artforum*, 44 (6): 178–83.

Blamey, D. (ed.). (2002). *Here, There, Elsewhere: Dialogues on Location and Mobility*, London: Open Editions.

Borden, I., Kerr J., Pivaro A. and Rendell J. (eds.). (1996). *Strangely Familiar: Narratives of Architecture in the City*, London and New York: Routledge.

Borden, I. (2001). *Skateboarding, Space, and the City: Architecture and the Body*, Oxford and New York: Berg.

Borden, I., Kerr J., Pivaro A. and Rendell J. (eds.). (2002). *The Unknown City: Contesting Architecture and Social Space*, London and Cambridge, MA: MIT Press.

Bourriaud, N. (2002a). *Relational Aesthetics*, trans. S. Pleasance and F. Woods with M. Copeland, Dijon: les presses du réel.

Bourriaud, N. (2002b). *Postproduction*, trans. J. Herman, New York: Lukas and Sternberg.

Bowcott, O. (2008). 'Why doesn't CCTV cut crime?' *Guardian (G2)*, 7 May: 3.

Breitwieser, S. (ed.). (2005). *Gustav Metzger History History*, Vienna: Generali Foundation and Ostfildern-Ruit: Hatje Cantz Verlag.

Bridge, G. and Watson S. (eds.). (2003). *A Companion to the City*, Oxford: Blackwell.

Brockes, E. (2006). "'I'm sure they were thinking it was time a woman won'", *Guardian (G2)*, 6 December: 23.

Brouwer, J., A. Mulder and L. Mertz (eds.). (2002). *TransUrbanism*, Amsterdam: V2_Publishing/NAI Publishers.

Bunting, M. (2007). 'The policing of the artist' *Guardian*, 11 December: 28.

Burgin, V. (1996a). *Some Cities*, London: Reaktion Books.

Burgin, V. (1996b). *In/Different Spaces: Place and Memory in Visual Culture*, Berkeley and Los Angeles: University of California Press.

Buβman, K., König K. and Matzner F. (eds.). (1997). *Sculpture Projects in Münster 1997*, Stuttgart: Verlag Gerd Hatje.

Butt, G. (ed.). (2005). *After Criticism: New Responses to Art and Performance*, Oxford: Blackwell.

Calvino, I. (1997). *Invisible Cities*, trans. W. Weaver, London: Vintage.

Coles, A. (ed.). (1999). *The Optic of Walter Benjamin (de-, dis-, ex-,)*, 3, London: Black Dog Publishing.

Coles, A. (ed.). (2000). *Site-Specificity: The Ethnographic Turn (de-, dis-, ex-)*, 4, London: Black Dog Publishing.

Connolly, K. (2000). 'Closed books and stilled lives', *Guardian*, 26 October: 5.

Cresswell, T. (1996). *In Place/Out of Place: Geography, Ideology and Transgression*, London and Minneapolis: University of Minnesota Press.

Cullen, M. S. (ed.). (1999). *Das Holocaust-Mahnmal: Dokumentation einer Debatte*, Zürich: Pendo Verlag.

Dahlgren, K. (ed.). (2005). *Universal Experience: Art, Life and the Tourist's Eye*, Chicago: Museum of Contemporary Art and New York: Distributed Art Publishers.

Dailey, M. (ed.). (2001). *Rachel Whiteread: Transient Spaces* (exhibition catalogue), New York Guggenheim Publishing.

Davis, M. (2008). *Buda's Wagon: A Brief History of the Car Bomb*, London and New York: Verso.

Dean, T. and Millar J. (eds.). (2005). *Place*, London: Thames and Hudson.

Debord, G. (1994). *The Society of the Spectacle*, trans. D. Nicholson-Smith, New York: Zone Books.

De Certeau, M. (1988). *The Practice of Everyday Life*, trans. S. Rendall, London and Minneapolis: University of Minnesota Press.

Derrida, J. (1982). *Margins of Philosophy*, trans. A. Bass, London and Chicago: University of Chicago Press.

Deutsche, R. (1996). *Evictions: Art and Spatial Politics*, London and Cambridge, MA: MIT Press.

Dodson, S. (2008). 'The secret art of "video sniffing"', *Guardian (Review)*, 25 April: 4.

Doherty, C. and Millar J. (eds.). (2000). *Jane and Louise Wilson*, London: Ellipsis.

Doherty, C. (ed.). (2004). *Contemporary Art: From Studio to Situation*, London: Black Dog Publishing.

Doherty, C. (ed.). (2009). *Situation*, London: Whitechapel Gallery and Cambridge, MA: MIT Press.

Downey, A. (2007). 'Towards a politics of (relational) aesthetics', *Third Text*, 21 (3): 267–75.

Dyer, G. (1992). *But Beautiful*, London: Vintage.

Dyer, G. (2005). *The Ongoing Moment*, London: Little, Brown.

Dyer, G. (2006). 'An explosion of delight', *Guardian*, 14 October: 30.

Eccles, T., Wehr A. and Kastener J. (eds.). (2004). *PLOP: Recent Projects of the Public Art Fund*, London and New York: Merrell.

Etchells, T. (1999). *Certain Fragments: Contemporary Performance and Forced Entertainment*, London and New York: Routledge.

Ferguson Fisher J. and Medina C. (2007). *Francis Alÿs*, New York and London: Phaidon Press.

Ferrell, J. (2003). *Tearing Down the Streets: Adventures in Crime and Anarchy*, Basingstoke: Palgrave Macmillan.

Finkelpearl, T. (ed.). (2000). *Dialogues in Public Art*, Cambridge, MA: MIT Press.

Ford, S. (2005). *The Situationist International: A User's Guide*, London: Black Dog Publishing.

Foster, H. (1996). *The Return of the Real: The Avant-Garde at the End of the Century*, Cambridge, MA and London: MIT Press.

Franzen, B., König K. and Plath C. (eds.). (2007). *Sculpture Projects Muenster 07*, Köln: Verlag der Buchhandlung Walther König.

Freud, S. (1990). 'The uncanny' in *Art and Literature*, 14, trans. J. Strachey, Harmondsworth: Penguin: 335–76.

Frisby, D. (2001). *Cityscapes of Modernity: Critical Explorations*, Cambridge: Polity Press.

Fyfe, N. R. (ed.). (1998). *Images of the Street: Planning, Identity and Control in Public Space*, London and New York: Routledge.

Gavin, F. (2007). *Street Renegades: New Underground Art*, London: Laurence King Publishing.

Gibson, A. and Kerr J. (eds.). (2003). *London: from Punk to Blair*, London: Reaktion Books.

Gillick, L. (Winter 2006). 'Contingent factors: A response to Claire Bishop's "Antagonism and Relational Aesthetics"', *October*, 115: 95–107.

Gilloch, G. (1996). *Myth and Metropolis: Walter Benjamin and the City*, Cambridge: Polity Press.

Glendinning, H., Etchells T. and Forced Entertainment. (2000). *Void Spaces*, Sheffield: Site Gallery.

Goldberg, R. (1988). *Performance Art: From Futurism to the Present*, London and New York: Thames and Hudson.

Grand, P. (ed.). (2001). *Francis Alÿs* (exhibition catalogue), Antibes: Musée Picasso.

Hall, S. (2004). 'Museums of modern art and the end of history', *Changing States: Contemporary Arts and Ideas in an Era of Globalisation*, (ed.) G. Tawadros, London: inIVA: 286–91.

Haydn, F. and Temel R. (eds.). (2006). *Temporary Urban Spaces: Concepts for the Use of City Space*, Basel, Boston and Berlin: Birkhäuser.

Hayward, The. (ed.). (2007). *Antony Gormley: Blind Light*, London: Hayward Publishing.

Hayward, The. (ed.). (2008). *Psycho Buildings: Artists Take on Architecture*, London: Hayward Publishing.

Heathfield, A. (2004). *Live Art and Performance*, London: Tate Publishing.

Heiferman, M. (ed.). (2005). *City Art: New Yorks's Percent for Art Programme*, London and New York: Merrell.

Helmer, J. and Malzacher F. (eds.). (2004). *Not Even a Game Anymore: The Theatre of Forced Entertainment*, Berlin: Alexander Verlag.

Highmore, B. (2002). *Everyday Life and Cultural Theory*, London and New York: Routledge.

Hoffman, J. and Jonas J. (eds.). (2005). *Perform*, London: Thames and Hudson.

Hopkins, D. J., Orr S. and Solga K. (eds.). (2009). *Performance and the City*, Basingstoke: Palgrave Macmillan.

Hussey, A. (2002). '"The map is not the territory": The unfinished journey of the Situationist International', *Urban Visions: Experiencing and Envisioning the City* (ed.) S. Speir, Liverpool: University Press and Tate Publishing: 215–28.

Jackson, S. (2006). 'Social practice', *Performance Research*, 11 (3): 113–18.

Jacobs, J. (1993). *The Death and Life of Great American Cities*, New York: Random House (Modern Library).

Johnstone, S. (ed.). (2008). *The Everyday*, London: Whitechapel Gallery and Cambridge, MA: MIT Press.

Jones, J. (2007). 'Too many memories?' *Guardian (G2)*, 26 January: 4–7.

Kahlfeldt, P., Kleihues J. P. and Scheer T. (eds.). (2000). *Stadt der Architektur/Architektur der Stadt: Berlin 1900–2000*, Berlin: Nicolai.

Kapur, G. (2007). 'subTerrain: Artworks in the cityfold', *Third Text*, 21 (3): 277–96.

Kaye, N. (1994a). *Postmodernism and Performance*, Basingstoke: Macmillan.

Kaye, N. (ed.). (1994b). 'Live art: Definition and documentation', *Contemporary Theatre Review*, 2 (2): 1–7.

Kaye, N. (2000). *Site-Specific Art: Performance, Place and Documentation*, London and New York: Routledge.

Keiller, P. (2005). *London* and *Robinson in Space*, DVD and sleeve notes, London: BFI.

Kester, G. (2004). *Conversation Pieces: Community and Communication in Modern Art*, Berkeley, CA: University of California Press.

Kingsnorth, P. (2008). *Real England: The Battle Against the Bland*, London: Portobello Books.

Klein, N. (2008). 'Police state 2.0', *Guardian (G2)*, 3 June: 4–9.

Knabb, K. (ed.). (2006). *Situationist International Anthology* (revised and expanded edition), Berkeley: Bureau of Public Secrets.

Krauss, R. E. (1986). *The Originality of the Avant-Garde and Other Modernist Myths*, London and Cambridge, MA: MIT Press.

Küppers, P. (1999). 'Moving in the cityscape: Performance and the embodied experience of the *flâneur*', *New Theatre Quarterly*, 15 (4): 308–17.

Kwon, M. (2004). *One Place After Another: Site-Specific Art and Locational Identity*, London and Cambridge, MA: MIT Press.

Lacy, S. (1995). *Mapping the Terrain: New Genre Public Art*, Seattle, WA: Bay Press.

Ladd, B. (1998). *The Ghosts of Berlin: Confronting German History in the Landscape*, Chicago and London: University of Chicago Press.

Lavery, C. (2005a). 'Teaching performance studies: 25 instructions for performance in cities', *Studies in Theatre and Performance*, 25 (3): 229–38.

Lavery, C. (2005b). 'The Pepys of London E11: Graeme Miller and the politics of *Linked*', *New Theatre Quarterly*, 21(2): 148–60.

Lavery, C. (2006). 'Situationism', *Performance Research*, 11 (3) (September): 111–13.

Leach, N. (ed.). (1997). *Rethinking Architecture: A Reader in Cultural Theory*, London and New York: Routledge.

Leach, N. (ed.). (1999). *Architecture and Revolution: Contemporary Perspectives on Central and Eastern Europe*, London and New York: Routledge.

Leach, N. (ed.). (2002). *The Hieroglyphics of Space: Reading and Experiencing the Modern Metropolis*, London and New York: Routledge.

Lees, R. (ed.). (2004). *The Emancipatory City?: Paradoxes and Possibilities*, London: Sage Publications.

Lefebvre, H. (1991). *The Production of Space*, Oxford: Blackwell.

Lefebvre, H. (1996). *Writings on Cities*, (ed.), trans. and intro. E. Kofman and E. Lebas, Oxford: Blackwell.

Lefebvre, H. (2004). *Rhythmanalysis: Space, Time and Everyday Life*, trans. S. Elden and G. Moore, intro. S. Elden, London and New York: Continuum.

Lewis, P. (2009). 'Every step you take: UK underground centre that is spy capital of the world', *Guardian*, 2 March: 13.

Lewisohn, C. (2008). *Street Art: The Graffiti Revolution*, London: Tate Publishing.

Libeskind, D. (2001). *The Space of Encounter*, London: Thames and Hudson.

Ligget, H. (2003). *Urban Encounters*, London and Minneapolis: University of Minnesota Press.

Lingwood, J. (ed.). (1995). *Rachel Whiteread: House*, London: Phaidon Press.

Lotringer, S. and Virilio P. (2005). *The Accident of Art*, New York and Los Angeles: Semiotext(e).

MacDonald, N. (2001). *The Graffiti Subculture: Youth, Masculinity and Identity in London and New York*, Basingstoke: Palgrave Macmillan.

Manguel, A. (2009). 'The exile's library', *Guardian (Review)*, 21 February: 20.

Matzner, F. (ed.). (2004). *Public Art: A Reader*, Ostfildern-Ruit: Hatje Cantz.

McDonagh, T. (ed.). (2004). *Guy Debord and the Situationist International: Texts and Documents*, London and Cambridge, MA: MIT Press.

McGonigal, J. (2004). 'Dark play in public spaces: Confessions of a flash mob organizer', http://www.avantgame.com/McGonigal%20DARK%20PLAY%20IN%20PUBLIC%20SPACES%20PSi.pdf

Merrifield, A. (2002). *Metromarxism: A Marxist Tale of the City*, London and New York: Routledge.

Miles, M. (1997). *Art, Space and the City*, London and New York: Routledge.

Miles, M. (2007). *Cities and Cultures*, London and New York: Routledge.

Mitchell, W. J. T. (1992). *Art and the Public Sphere*, Chicago: University of Chicago Press.

Morgan, J. and Muir G. (eds.). (2004). *Time Zones: Recent Film and Video* (exhibition catalogue), London: Tate Publishing.

Mouffe, C. (2000). *The Democratic Paradox*, London and New York: Verso.

Nancy, J.-L. (1991). *The Inoperative Community* (ed.) P. Connor, trans. P. Connor, L. Garbus, M. Holland and S. Sawhney, Minneapolis and Oxford: University of Minnesota Press.

Pages, N. C. (2005). 'Architectures of memory: Rachel Whiteread's "Memorial to the 65,000 Murdered Austrian Jews,"' *Austrian Studies*, 11 (1): 102–21.

Pearson, M. and Shanks M. (2001). *Theatre/Archaeology*, London and New York: Routledge.

Pietromarchi B. (ed.). (2005). *The [Un]common Place: Art, Public Space and Urban Aesthetics in Europe*, Rome: Fondazione Adriano Olivetti and Barcelona: Actar.

Pile, S. (1996). *The Body and the City: Psychoanalysis, Space and Subjectivity*, London and New York: Routledge.

Pile, S. (2005). *Real Cities: Modernity, Space and the Phantasmagorias of City Life*, London: Sage Publications.

Pile, S. and Thrift N. (eds.). (2000). *City A-Z*, London and New York: Routledge.

Pinder, D. (2005a). *Visions of the City: Utopianism, Power and Politics in Twentieth-Century Urbanism*, Edinburgh: Edinburgh University Press.

Pinder, D. (ed.). (2005b). *Cultural Geographies* (journal issue on 'Arts of Urban Exploration'), 12 (4).

Plant, S. (1992). *The Most Radical Gesture: The Situationist International in a Postmodern Age*, London and New York: Routledge.

Puchner, M. (2004). 'Society of the counter-spectacle: Debord and the theatre of the situationists', *Theatre Research International*, 29 (1): 4–15.

Raban, J. (1998). *Soft City*, London: Harvill Press.

Read, A. (ed.). (2000). *Architecturally Speaking: Practices of Art, Architecture and the Everyday*, London and New York: Routledge.

Rendell, J. (2006). *Art and Architecture: A Place Between*, London and New York: I.B.Tauris.

Rogoff, I. (2000). *Terra Infirma: Geography's Visual Culture*, London and New York: Routledge.

Rule, V. (2008). Review of M. Davis, *Buda's Wagon: A Brief History of the Car Bomb*, *Guardian (Review)*, 16 August: 13.

Sadler, S. (1998). *The Situationist City*, London and Cambridge, MA: MIT Press.

Saunders, L. (ed.). (2005). *Richard Wentworth* (exhibition catalogue), Liverpool and London: Tate Publishing.

Schechner, R. (2002). *Performance Studies: An Introduction*, London and New York: Routledge.

Schlör, J. (2005). *Denkmal für die Ermordeten Juden Europas, Berlin*, London and New York: Prestel.

Schlusse, G. (ed.). (2006). *Architektur der Erinnerung: NS-Verbrechen in der Europäischen Gedenkkultur*, Berlin: Nikolai Verlag.

Searle, A. (2000). 'Making memories', *Guardian (G2)*, 17 October: 12.

Searle, A. (2008). 'An electrifying gesture', *Guardian*, 1 July: 11.

Seijdel, J. (ed.). (2008). 'Art as a public issue: How art and its institutions reinvent the public dimension' (themed issue), *Open*, 14, Rotterdam: NAi Publishers.

Sennett, R. (1992). *The Conscience of the Eye: The Design and Social Life of Cities*, New York: Norton.

Sennett, R. (1996a). *The Uses of Disorder: Personal Identity and City Life*, London: Faber and Faber.

Sennett, R. (1996b). *Flesh and Stone: The Body and the City in Western Civilisation*, Harmondsworth: Penguin.

Shusterman, R. (2000). *Performing Live: Aesthetic Alternatives for the Ends of Art*, Ithaca and London: Cornell University Press.

Sinclair, I. (1997). *Lights Out for the Territory*, London: Granta Books.

Sinclair, I. (2002). *London Orbital: A Walk Round the M25*, London: Granta Books.

Solnit, R. (2002). *Wanderlust: A History of Walking*, London and New York: Verso.

Speir, S. (ed.). (2002). *Urban Visions: Experiencing and Envisioning the City*, Liverpool: University Press and Tate Publishing.

Stevens, Q. (2007). *The Ludic City: Exploring the Potential of Public Spaces*, London and New York: Routledge.

Stiftung Denkmal für die Ermordeten Juden Europas (ed.). (2005). *Materialien zum Denkmal für die Ermordeten Juden Europas*, Berlin.

Suderberg, E. (ed.). (2000). *Space, Site, Installation: Situating Installation Art*, London and Minneapolis: University of Minnesota Press.

Tallack, D. (2005). *New York Sights: Visualising Old and New New York*, Oxford and New York: Berg.

Tate Publishing. (2006). *Carsten Höller, Test Site*, London: Tate Publishing.

Tate Publishing. (2007). *Mark Wallinger, State Britain 2007*, London: Tate Publishing.

Tate Publishing. (2008). *Martin Creed, Work No.850, 2008*, London: Tate Publishing.

Tawadros, G. (ed.). (2004). *Changing States: Contemporary Arts and Ideas in an Era of Globalisation*, London: inIVA.

Tester, K. (ed.). (1994). *The Flâneur*, London and New York: Routledge.

Till, K. E. (2005). *The New Berlin: Memory, Politics, Place*, Minneapolis and London: University of Minnesota Press.

Townsend, C. (ed.). (2004). *The Art of Rachel Whiteread*, London: Thames and Hudson.

Ulmer, G. (1989). *Teletheory: Grammatology in the Age of Video*, London and New York: Routledge.

UN-HABITAT. (2006). *State of the World's Cities 2006/07: The Millenium Development Goals and Urban Sustainability*, London: Earthscan.

Van Noord, G. (ed.). (2002). *Off Limits: 40 Artangel Projects*, London and New York: Merrell.

Van Treeck, B. (ed.). (1999). *Street-Art Berlin: Kunst im Öffentlichen Raum*, Berlin: Schwarzkopf und Schwarzkopf.

Vidler, A. (1992). *The Architectural Uncanny: Essays in the Modern Unhomely*, London and Cambridge, MA: MIT Press.

Vidler, A. (2000). *Warped Space: Art, Architecture and Anxiety in Modern Culture*, London and Cambridge, MA: MIT Press.

Virilio, P. (1991). *Lost Dimension*, trans. D. Moschenberg, New York and Los Angeles: Semiotext(e).

Whybrow, N. (2005). *Street Scenes: Brecht, Benjamin, and Berlin*, Bristol: Intellect Books.

Whybrow, N. (2006). 'Streetscenes: The accident of where we walk', *Performance Research*, 11 (3): 123–6.

Whybrow, N. (ed.). (2010). *Performance and the Contemporary City: An Interdisciplinary Reader*, Basingstoke: Palgrave Macmillan.

Young, J. E. (ed.). (1994). *The Art of Memory: Holocaust Memorials in History*, New York and Munich: Prestel Verlag.

Young, J. E. (2000). *At Memory's Edge: After Images of the Holocaust in Contemporary Art and Architecture*, New Haven: Yale University Press.

Index